W9-BDS-267

BALDWIN-WALLACE COLLEGE

RITTER LIBRARY
GIFT OF

THE FAWICK FUND

# Philip Guston

[library stamp, illegible]

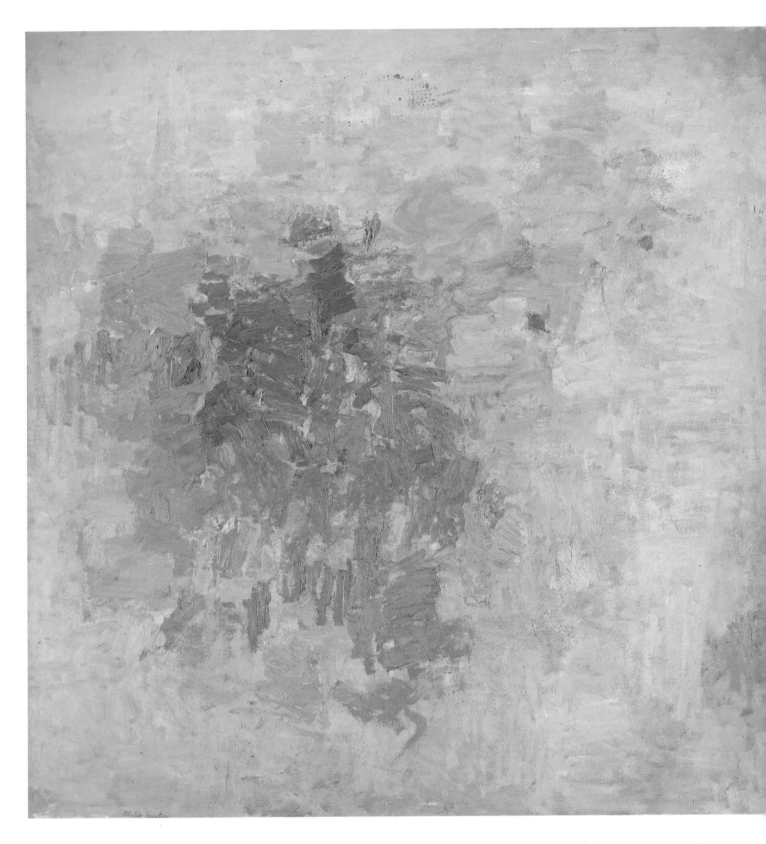

*Beggar's Joy,* 1954–55
Oil on canvas, 71⅛ x 68⅛ in.
Boris and Sophie Leavitt

ND 237 G8 S76 1966
Storr, Robert.
Philip Guston
WITHDRAWN

# Philip Guston

Robert Storr

ABBEVILLE PRESS · NEW YORK

RITTER LIBRARY
BALDWIN-WALLACE COLLEGE

*Philip Guston* is volume eleven in the Modern Masters series.

ACKNOWLEDGMENTS: In addition to those critics mentioned in the footnotes I would like to acknowledge my debt to the writings of Joseph Ablow, Ross Feld, Norbert Lynton, Francis V. O'Connor, Carrie Rickey, and Roberta Smith. I also want to thank those of Philip Guston's friends and associates with whom I talked or who wrote in answer to my questions or who made correspondence with the artist available to me: Bill Berkson, James Brooks, John Cage, Herman Cherry, William Corbett, Elaine de Kooning, Morton Feldman, Stephen Greene, John Imber, Philip Roth, and Irving Sandler. I want to thank as well Sheila Beardslee, Robert Dash, Elizabeth Frank, Joan Simon, and Peter Soriano, who gave much-needed encouragement along the way. Finally, I wish to express my appreciation for the assistance given by David and Renee McKee and the staff of their gallery and my special gratitude to Musa Guston and Musa Mayer for the information and support they provided and for the warmth and hospitality they extended to me.
This book is for Rosamund Morley with all my Baroque love.

Art director: Howard Morris
Designer: Florence Mayers
Editor: Nancy Grubb
Picture researcher: Laura Yudow
Production supervisor: Hope Koturo
Chronology, Exhibitions, Public Collections, and Selected Bibliography compiled by Janis Ekdahl

FRONT COVER: *Head and Bottle*, 1975. Oil on canvas, 65 ½ x 68 ½ in. Sally Lilienthal, San Francisco.

BACK COVER: *Sleeping*, 1977. Oil on canvas, 84 x 69 in. Estate of Philip Guston; Courtesy David McKee Gallery, New York.

END PAPERS: Philip Guston in his studio in Woodstock, New York, April 1980.

Marginal numbers in the text refer to works illustrated in this volume.

*Library of Congress Cataloging-in-Publication Data*

Storr, Robert.
  Philip Guston.

  (Modern masters series, ISSN 0738-0429; v. 11)
  Bibliography: p.
  Includes index.
  1. Guston, Philip, 1913–1980.   2. Painters—United States—Biography.   I. Title.   II. Series.
  ND237.G8S76   1986   759.13   86-1030
  ISBN 0-89659-665-6
  ISBN 0-89659-656-7 (pbk.)

First edition

Copyright © 1986 by Cross River Press, Ltd. All rights reserved under International and Pan-American Copyright Conventions. No part of this book may be reproduced or utilized in any form or by any means, electronic or mechanical, including photocopying, recording, or by any information storage and retrieval system, without permission in writing from the Publisher. Inquiries should be addressed to Abbeville Press, Inc., 505 Park Avenue, New York 10022. Printed and bound by Toppan Printing Co., Ltd., Japan.

# Contents

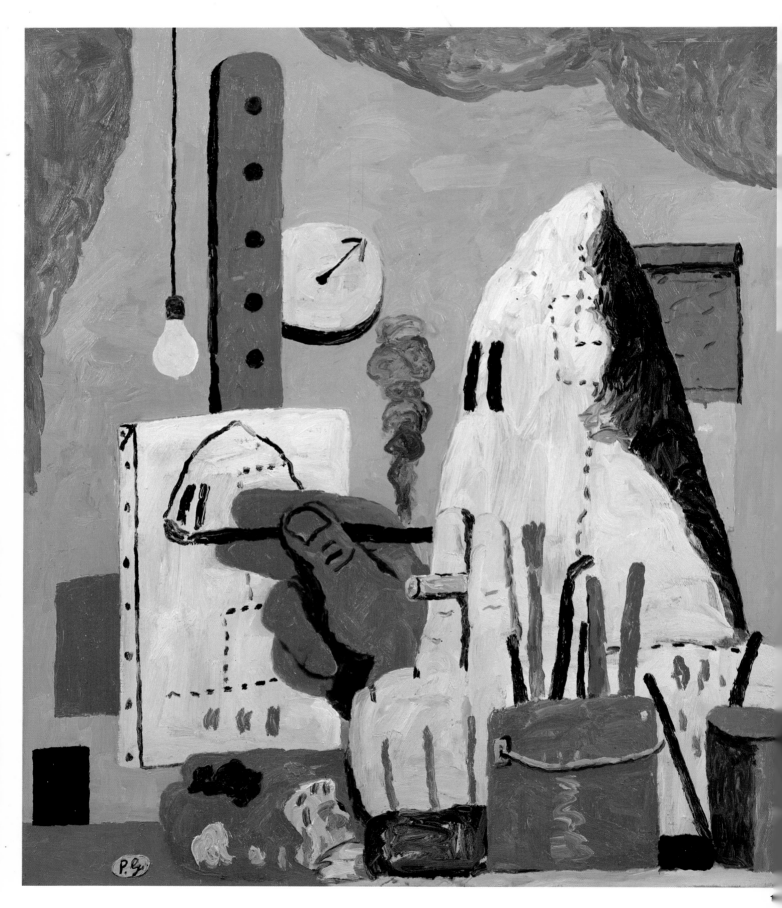

# Introduction

Although only sixty-six when he died, Philip Guston was active as a painter for nearly fifty years and a leading figure of the artistic vanguard for most of that long career. In many respects the story of his life is a chronicle of the ideas and events that transformed American painting in this century. A political muralist in the 1930s, by the 1940s Guston had turned away from public art to explore a more private vision in haunting tableaux of children and sideshow performers acting out costume dramas of war and dislocation. In the 1950s the classical figuration of these pictures gave way to purely nonobjective paintings that represent one of the most poetic contributions to Abstract Expressionism. In the last and most important decade of his life Guston's work changed yet again. Drawing on the imagery of his murals and paintings of the 1940s and on the formal language of his abstractions, during the 1970s Guston articulated a fantastic and apocalyptic vision that was as monstrously comic in initial impact as it was complex and ambiguous in its fundamental meanings.

The combined boldness and subtlety of these paintings embody the constants of Guston's sensibility. Throughout his career the apparent contradiction between Guston's large ambition and huge appetite for art and ideas and his instinctive anxiousness and the almost exquisite subtlety of his painterly approach confounded the artist's critics and, on occasion, his admirers. A great talker, he was, in the 1940s and '50s, the most reticent of painters; a formidable and discriminating intellect, he made work in the 1970s with a syntax and imagery that struck many observers as willfully crude. In the effort to come to terms with Guston's dichotomous nature writers have often concentrated upon one aspect of it at the expense of the rest, some emphasizing his refinement or erudition, others his emotional intensity or theatricality. A third tendency, useful but nonetheless problematic, has been to explain the evolution of his work by drawing direct connections between it and the artist's broad literary and art historical interests. But there are misunderstandings inherent in any treatment of Guston's work that separates the part from the whole or attempts to describe it by external influences. Guston was not just a stylist nor was he primarily a synthesizer. The expression of a comprehensive aesthetic and exis-

1. *The Studio*, 1969
Oil on canvas, 48 x 42 in.
Musa Guston

tential vision, his art defies easy classification as it challenges many of the dominant orthodoxies of recent American painting.

In his brief essay *The Eye and the Mind*, the French philosopher Maurice Merleau-Ponty wrote, "Science manipulates things but refuses to inhabit them."[1] To the degree that much postwar art has distanced itself from its sources or sought to emulate the objectivity of science by confining itself to the task of isolating painting's essential properties, the same might be said of it, that it "manipulates things but refuses to inhabit them." Guston, however, did not conceive of painting as an essentially formal enterprise, nor did he simply "borrow" ideas and images from the various traditions on which he drew. For Guston, painting was not so much made as lived; it was a process of perpetual metamorphosis that revealed and transformed the identity of the artist as he confronted the mutable reality of his materials and of the world that surrounded him. In the late 1960s, ignoring the prevailing taste for Minimal or antiform abstraction, Guston set out in his late figurative paintings to describe that relation between the artist and his work. The painter's alter egos, a hooded figure or a bloated but vigilant head, and the antic but mysterious images that besiege them are the emblems of that vital tension. In the end, Guston seemed both to completely inhabit and to be completely inhabited by his creations. The work that resulted from this uneasy symbiosis not only reflected Guston's own past and idiosyncratic makeup, it spoke for the present and changed the future direction of American painting.

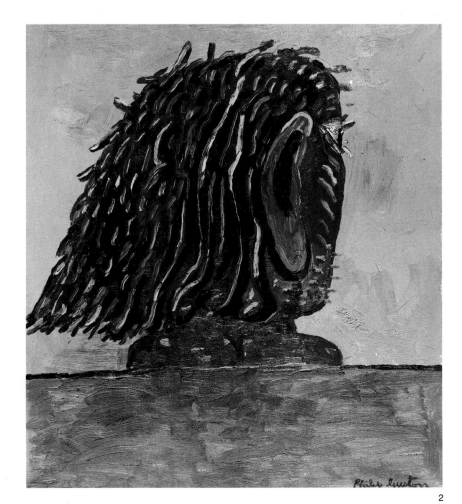

2

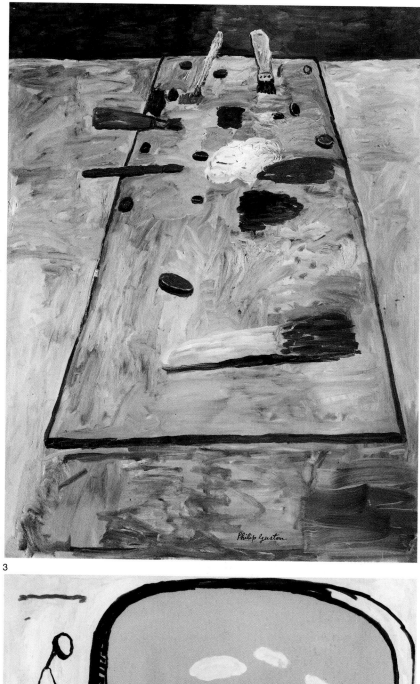

3

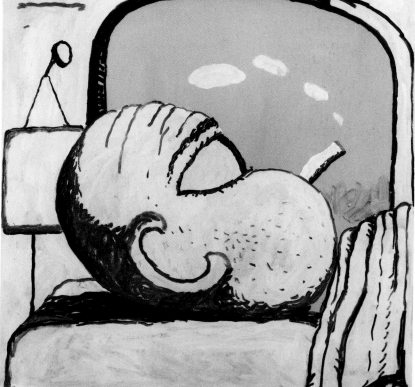

2. *Untitled*, 1979
Oil on canvas, 36 x 32 in.
Estate of Philip Guston;
Courtesy David McKee Gallery, New York

3. *Painting Table*, 1975
Oil on canvas, 81 x 61½ in.
Estate of Philip Guston;
Courtesy David McKee Gallery, New York

4. *Smoking I*, 1973
Oil on canvas, 52¾ x 54 in.
Estate of Philip Guston;
Courtesy David McKee Gallery, New York

4

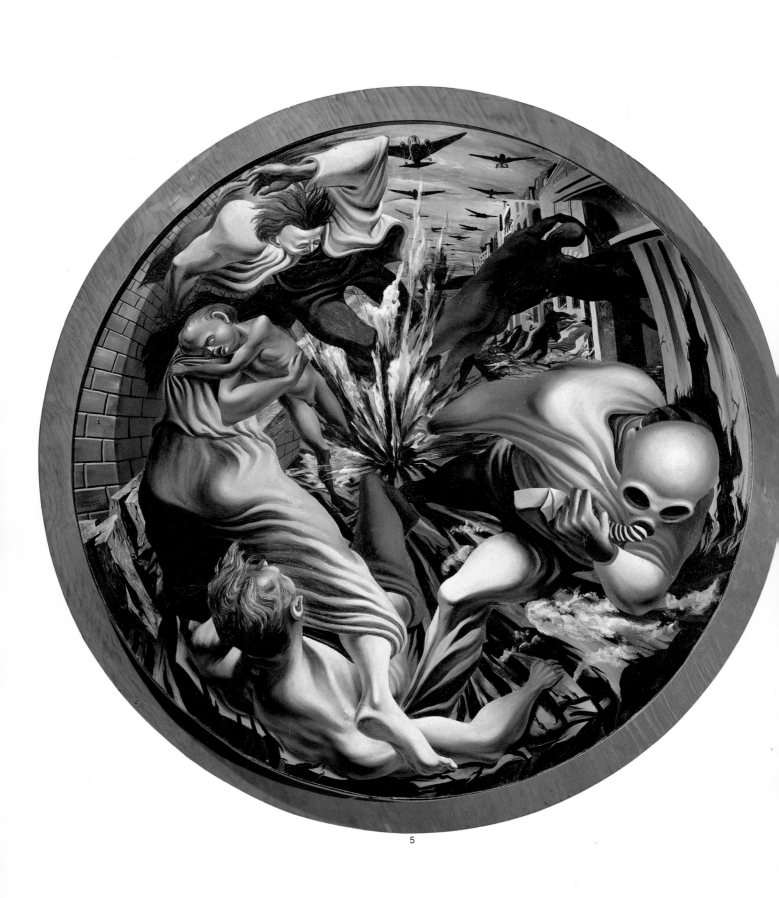

5

# 1 Beginnings

Philip Guston was born June 27, 1913, in Montreal. His family had emigrated from Odessa around the turn of the century and landed in Montreal, which, like New York at that time, was a major port of entry for Jewish refugees fleeing Russia. In 1919 the family moved again, this time to Los Angeles. The financial security that Guston's father had hoped to find there continued to elude him, however, and the following year he committed suicide. But the new world that had remained closed to the father opened itself to the son, and growing up in it Guston seemed to overcome the trauma of his loss and, for the time being, to leave behind his identification with his family's emigrant past.

By age thirteen Guston had begun to draw profusely. Often secluded in a large closet illuminated by a single hanging light bulb—a ubiquitous image in his paintings of the 1970s—Guston took his inspiration from the bold slapstick narratives he followed in the funny papers. With his mother's encouragement, Guston briefly enrolled himself in a correspondence course with the Cleveland School of Cartooning, but he soon found himself bored by the routine mechanics of commercial illustration. It was only after entering Manual Arts High School, in downtown Los Angeles, that Guston had his first real contact with painting and with a friend equally interested in art. The friend was Jackson Pollock. Together they fell under the tutelage of a gifted but eccentric teacher, Frederick John de St. Vrain Schwankovsky, who instructed them in the mysticism of Ouspensky and Krishnamurti, and, through his collection of art magazines and literary journals, introduced them to modern art, in particular the work of the Cubists. Though intrigued by Schwankovsky's pacific philosophy, Guston and Pollock had an incorrigible rebelliousness, which they vented by publishing a broadside that satirized the conservatism of the English department and the school's preoccupation with sports. They were promptly expelled. Pollock was eventually readmitted to school but Guston went his own way.

While continuing to draw on his own, Guston earned his living by working at a variety of odd jobs, one of which brought him to the back lots of Hollywood. Strikingly handsome and something of a dandy, Guston was soon hired as an extra, playing everything

5. *Bombardment*, 1937–38
Oil on wood, diameter: 46 in.
Estate of Philip Guston;
Courtesy David McKee Gallery, New York

from an African witch doctor to an artist in a garret. His lifelong passion for film, marked not only by his delight in Hollywood extravaganzas but also by an early interest in the radical cinema of Alexander Dovzhenko and Sergei Eisenstein, thus had its origins in the firsthand experience of watching movies be made.

By 1930 Guston was ready to try school again, but once more his enthusiasm was thwarted. Granted a scholarship to the Otis Art Institute, he discovered that instead of being allowed to study the Renaissance painters on whose work he then modeled his own, he was expected to do academic cast drawings and to imitate the suave painterly manner of Frans Hals; in other words, to undertake the training of the conventional portrait artist. Frustrated by this regimen and determined to make his task more visually demanding—or simply to lampoon it—Guston one day piled all the plasters he was to copy in a huge heap and drew from that.[2] It was a "motif" that prefigured the inchoate heaps of objects that were to fill his paintings of the 1970s.

Not long after this incident Guston left school for good. Through a friend, Reuben Kadish, he met the older and more established artist Lorser Feitelson. Assuming the role of Guston's mentor, Feitelson strongly encouraged his interest in the sculptural figuration of painters such as Paolo Uccello, Masaccio, Luca Signorelli, Andrea Mantegna, Michelangelo, and, most important, Piero della Francesca, whose poised, almost weightless but nonetheless monumental compositions seemed to anticipate Cubism. Piero's work was to remain a touchstone for Guston throughout his life. Feitelson also introduced Guston to Surrealism, to the sharp-focus realism of Germany's Neue Sachlichkeit, and to the work of the Italian Metaphysical painters, whose Neoclassical-inspired modernism had exerted a powerful influence on Feitelson's own work. Along with his other protégés, Feitelson took Guston to the home of Walter Arensberg, who had amassed one of the few comprehensive collections of modern painting in America at that time. There Guston, still in his teens, had his first direct contact with works by Pablo Picasso, Fernand Léger, and Giorgio de Chirico.

Although Guston shared Feitelson's taste, he was ambivalent about his social outlook, a vague, conservative humanism heavily influenced by the reactionary ideas of de Chirico, who after World War I had not only turned his back on modernist aesthetics but seemed to advocate a wholesale return to the past. Having witnessed strikebreakers in action while working part-time at a factory, Guston realized that his sympathies were with the Left, and together with Kadish and the painter Herman Cherry (who in 1931 gave him his first exhibition at the Stanley Rose bookshop and gallery), he began to attend the meetings of the Marxist John Reed Club.[3]

It was not only the pressure of worldly events that drew Guston away from the ideal of "art for art's sake." There were aesthetic motives as well. In 1932 Guston and Pollock watched José Clemente Orozco paint his *Prometheus* fresco at Pomona College and listened to the garrulous and charismatic David Alfaro Siqueiros lecture on muralism while working on an outdoor wall in downtown Los Angeles. While hostile to the illustrative quality of Diego Rivera's work and skeptical of the expressionism of Orozco and Siqueiros,

6

Guston was nonetheless captivated by the thought of creating a new art on the heroic scale of the Renaissance, as the Mexicans were attempting to do.

But these encounters only confirmed Guston's commitment to a direction he had already taken. By 1931 Guston had executed his first public work, a series of portable panels based on the notorious racist trial of the Scottsboro Boys. He then watched in anger and amazement as the panels were mutilated by members of the Police "Red Squad" and a gang of American Legionnaires, who took particular pleasure in using the eyes and genitals of the black figures in the paintings for target practice. The persecution that Guston had only imagined thus became all too terrifyingly real.

The greatest restriction that Guston faced, however, was not censorship but lack of space. He needed walls. Thus, with the patronage of Siqueiros, Guston and Kadish traveled to Morelia in Mexico to paint a mural in the palace of the former emperor of Mexico, Maximilian. Although this work and the one that followed—a fresco commissioned for the library of a tuberculosis clinic in Duarte, near Los Angeles—incorporated hooded figures and other political symbols, with their otherwise hermetic programs and Mannerist spatial dynamics they were essentially formal tours de force, more Parmigianino or Pontormo than proletarian. What is remarkable about these paintings is that Guston and Kadish, still novices at their craft, had not only thoroughly understood the conventions of architectonic painting but had succeeded in testing their limits.

At the urging of Jackson Pollock, who had been living in New York since 1930, Guston moved there in 1936 and promptly signed up with the mural division of the Federal Art Project of the Works Progress Administration (WPA/FAP), which had recently been established under Roosevelt's New Deal.[4] Having already mastered

7

6. *The Conspirators*, 1932
Oil on canvas, 50 x 36 in.
Location unknown

7. Detail of mural painted with Reuben Kadish,
c. 1931, Morelia, Mexico

8. Guston with *Maintaining America's Skills*
mural for the New York World's Fair, 1937

8

the technical demands of mural painting, Guston was notably successful in gaining commissions. His outdoor wall for the WPA Building at the 1939 New York World's Fair and his indoor mural for the community center at the Queensbridge Housing Project in Queens were popular both with the administrators of the program and with the general public, the World's Fair painting receiving an enthusiastic mention in the *New York Times*.[5]

Working on his WPA commissions during the day, Guston drew from the model at night, but few easel pictures from this period survive. The most complex and frankly political small painting of his first years in New York is *Bombardment*, a graphic indictment of the Fascist air raids against civilians during the Spanish Civil War. With its curious tondo format and the compression and extreme foreshortening of the figures that fill it, *Bombardment*, like Guston's earliest murals, would appear to be an essay in composition and perspective. This time, though, the pictorial devices he chose perfectly accorded with the content of the image, providing a kinetic visual metaphor for the entrapment and radiating concussion of saturation bombing.

Nevertheless, *Bombardment* was a formally conservative painting even for its time. Guston was alert to this fact and was becoming increasingly unsure of his working premises as he became more and more aware of the example set by European modernism and followed by many of his peers. In 1939 he discovered the work of Max Beckmann at the Buchholz Gallery. The same year he saw *Guernica*, whose subject matter was the same as *Bombardment*'s but whose formal syntax could not have been more different, and in 1940 Guston also saw the major Picasso retrospective at the Museum of Modern Art. During this period Guston was also a frequent visitor to the semiprivate A. E. Gallatin collection on Washington Square. There he studied Picasso's *Three Musicians* and Léger's *The City*, in which he identified modern parallels to the structural drama and clarity of Uccello and Piero and so a formal bridge to the present. Meanwhile, Guston engaged in ongoing debates with friends and WPA colleagues such as Pollock (then inspired by Orozco and Thomas Hart Benton), James Brooks (drawn to the Synthetic Cubism of Georges Braque and Picasso), and Burgoyne Diller (the artist-director of the mural division and an articulate interpreter of the Neo-Plasticist theories of Piet Mondrian).

It was not just the Neoclassical ideal that Guston now questioned but also the technical discipline to which he had apprenticed himself. These growing doubts were reinforced by a chance encounter with the abstract painter Stuart Davis, whom he observed at work one day in the studio next to his.

He would mount his scaffold [Guston recalled], lavishly spread paint on in large areas with a large palette knife, step down and look at the result for a while in his suspenders, smoking his cigar. Then he would mount his ladder again and scrape the whole thing off onto the floor. I remember how impressed I was by this lavish use of paint and by his willingness to change the process, while I, in my bay, still under the spell of the Renaissance, was laboriously working on my big cartoon.[6]

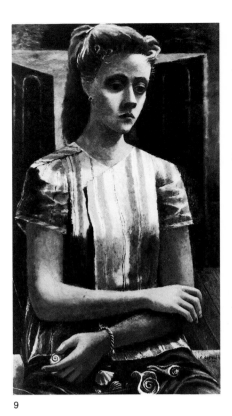

9

Although this experience clearly made a deep impression on him, it was to be another ten years before Guston found his way to a comparable technical freedom and spontaneity.

In 1939 the long-awaited European war broke out, and on both sides of the Atlantic the modernist vanguard was dispersed and demoralized. For Guston, the decade that followed began with retrenchment and reappraisal and culminated in radical change. "In 1941," Guston later remembered, "when I didn't feel strong conviction about the kind of figuration I'd been doing for about eight years, I entered a bad, painful period when I had lost what I'd had and had nowhere to go. I was in a state of dismantling."[7] Ironically, where he went was to the University of Iowa in Iowa City. Located in the American heartland and once the home of Grant Wood, the most famous of the Regionalist painters, Iowa City was at that time insular and conservative and a most unlikely refuge for a cosmopolitan such as Guston. With the gradual phasing out of the WPA, however, Guston needed a means of supporting himself other than public art, whose formal restrictions and social obligations were, in any event, making him increasingly impatient.[8]

In addition, in 1937 Guston had married the painter and poet Musa McKim, whom he had met when both were students at the Otis Art Institute, and in 1943 they had a daughter. The teaching position offered him at the university enabled him to support his family and allowed him, for the first time in almost ten years, to concentrate on his own easel work.

9

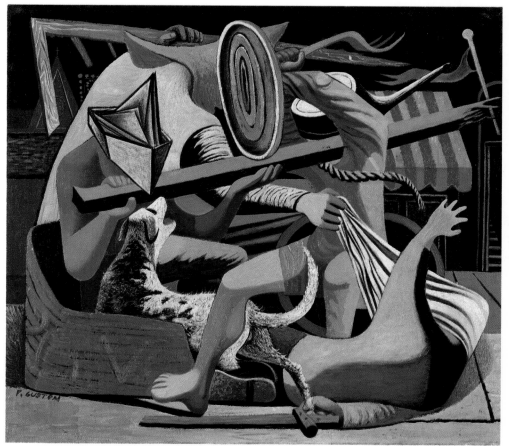

9. *Musa McKim*, 1941
Oil on canvas, dimensions unknown
Location unknown

10. *The Gladiators*, 1938
Oil on canvas, 24½ x 28 in.
The Edward R. Broida Trust, Los Angeles

10

Though welcomed by his students as the embodiment of the artistic vocation and an emissary of modernism, Guston was nonetheless experiencing deep anxieties about his own work, and once again he immersed himself in the traditions of the Renaissance. Moreover, though he had never been tempted by the invitation of Pollock and his teacher Thomas Hart Benton to go out and paint the American scene, Guston discovered in the static ambience of small-town life and Iowa City's vernacular architecture the perfect equivalent for the timeless atmosphere and geometric settings he had admired in the work of Piero and in the still, crepuscular cityscapes of de Chirico. Later he would say, "In the solitude of the Mid-West for the first time I was able to develop a personal imagery."[9] However, the drama that was to serve as the focus of the most important painting of his early days in Iowa—an image of Dead End Kids battling with makeshift weapons in an alleyway—was a carryover from his mural at the Queensbridge Housing Project and a small oil painting of 1938, *The Gladiators*.[10] In *Martial Memory* (1941), which Guston acknowledged as his first mature easel work, the artist transformed the urban genre scene into an allegory of war. More than anything, though, the[11]

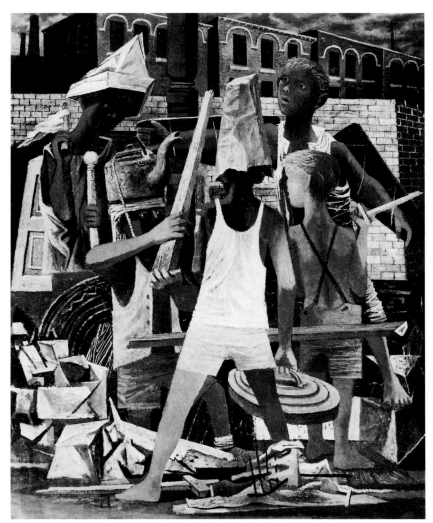

11. *Martial Memory*, 1941
Oil on canvas, 40⅛ x 42¼ in.
Saint Louis Art Museum

12. *If This Be Not I*, 1945
Oil on canvas, 41¾ x 55½ in.
Washington University Gallery of Art,
Saint Louis

11

bold volumetric forms and complex spatial dynamics of *Martial Memory* are inventive paraphrases of Uccello's *Battle of San Romano* and Piero's *The Victory of Heraclius over Chosroes*. Along with *The Gladiators* and his last murals, *Martial Memory* constitutes Guston's final attempt to capture in his own work the monumentality he admired in the paintings of his favorite Renaissance masters.

In his next major painting, *If This Be Not I* (1945), Guston again used a cast of boys and again posed them in the manner of Piero and Uccello; but where *Martial Memory* is anecdotal, *If This Be Not I* is self-consciously theatrical; where the former is mock-heroic, the latter is subdued and melancholy. Taking its title from a nursery rhyme that his wife, Musa, recited to him about an old woman who loses her identity, *If This Be Not I* demonstrates Guston's impressive command of oil technique and his ability to create intricate and convincing spatial illusions, but at the same time it bespeaks his profound misgivings about the uses to which to put that skill. It is an exquisitely artificial meditation on the artificiality of painting, a bittersweet and poetic "machine."

Despite his isolation and uncertainty, by the end of the war

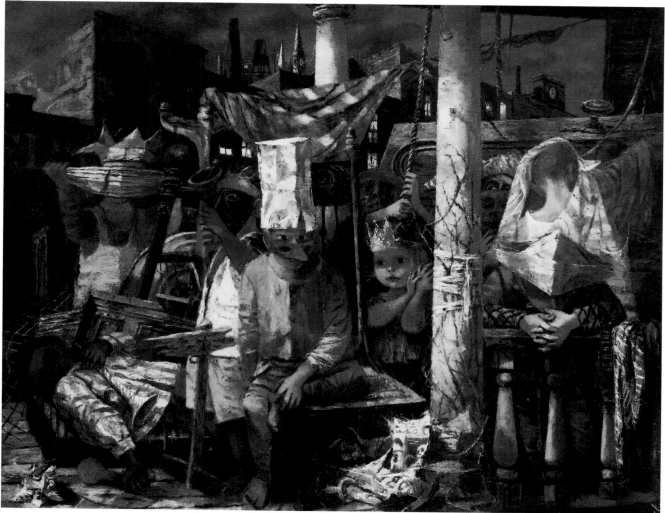

12

Guston had become a nationally recognized painter. As recipient of the First Prize for Painting at the Carnegie Institute's survey of American Art, Guston was the subject of a major article in *Life* magazine in May 1946, the first such coverage given any member of Guston's circle, coming three years before the *Life* article headlined "Pollock: Is He the Greatest Living Painter?" which signaled the beginning of the press blitz that was to make Guston's friend the most famous and infamous painter of the 1950s.

Guston's first one-man show in New York, which took place at the Midtown Galleries in 1945, was warmly received by critics. However, the occasion was marred when Pollock showed up drunk at the dinner party after the opening and lashed out at his old friend for "betraying" their common commitment to modernism with his new and unquestionably traditional paintings. This was neither their first such confrontation nor their last. The tension between Pollock and Guston, which was based on deep mutual respect, reflected a growing division within the ranks of those artists who had shared the social and aesthetic ideals of the WPA. If, in the mid-1940s, Guston admired and still lacked Pollock's vehement painterly attack, Pollock in turn marveled at and envied Guston's gift as a draftsman and his virtuosity as an architect of evocative pictorial spaces.[10]

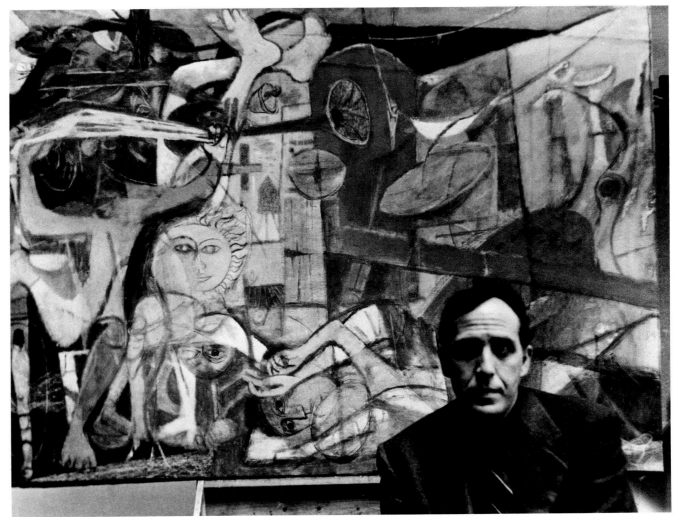

Even before Pollock's challenge, Guston had begun distancing himself from the work for which he was being honored, and he eventually did so publicly, criticizing *Sentimental Moment*—a softly focused but basically naturalistic study of a woman that was reproduced in color in *Life*—as "too literal."[11] Meanwhile, the photograph of Guston in his studio that also accompanied the article contained clues as to the direction he was taking. Though they are difficult to make out in any detail in the grainy image, he was pictured surrounded by paintings quite unlike the representational works featured in the article's other reproductions: semiabstractions composed of interlocking figures and symbols that owe less to the shadowy dramas of de Chirico than to the cataclysmic quasi-Cubism of *Guernica*. While none of these paintings appear to have survived, they were the precursors of those that would occupy Guston for the next two years.

Eager to escape Iowa City, in 1945 Guston accepted a new teaching appointment at Washington University in St. Louis. Once again at home in a major city, Guston regularly frequented its art museum, which housed a significant number of modern paintings, and had access to several local private collections that included important works by Picasso and Max Beckmann. During this period, Beckmann assumed a particular prominence in Guston's mind.[12] The ways in which Guston both assimilated and departed from his example are most evident in *Porch II* (1947). 14 Structurally similar to the friezelike tableaux that Guston had begun in Iowa, *Porch II* depicts a group of sideshow entertainers seemingly pinioned between thin bars that crisscross and frame the stage on which they are gathered. Sparely delineated, these figures are the vestigial presences of a once-sculptural manner. *Porch II* recalls Beckmann's frequent linkage of frivolity and brutality—the upsidedown acrobat to the right is a probable quotation from his triptych, *Departure*—but while the carnival-carnage images in the German painter's work were rendered in robust strokes and rich, exotic hues, Guston's palette was restricted and the bodies he portrayed brittle and emaciated. The delicate congestion of these figures strongly evokes another real and more horrific source: the piles of doll-like corpses that Guston saw in newsreel footage documenting Nazi war crimes.[13] Though not a depiction of the Holocaust, it is a painting conceived in its shadow. If *The Gladiators* and *Martial Memory* play upon the ironies of innocent aggression, *Porch II* is an allegory of war's aftermath that also hints at the imminent renewal of hostilities.

The dark mood of *Porch II* mirrored the artist's own state of mind. Close to a breakdown, Guston, with the help of a Guggenheim Fellowship, took a leave of absence from Washington University in 1947. He never returned. Moving to Woodstock, New York, he bought land and a small house. From there Guston regularly commuted to Manhattan to see shows and to make contact with old friends such as Pollock, Mark Rothko, Adolph Gottlieb, and Willem de Kooning, who came upstate to visit him as well. During this period he was also close to Bradley Walker Tomlin, a longtime resident of Woodstock whose graceful hybrid of Synthetic Cubism and Neoclassicism had evolved toward a pure

13. Philip Guston in his studio, 1945

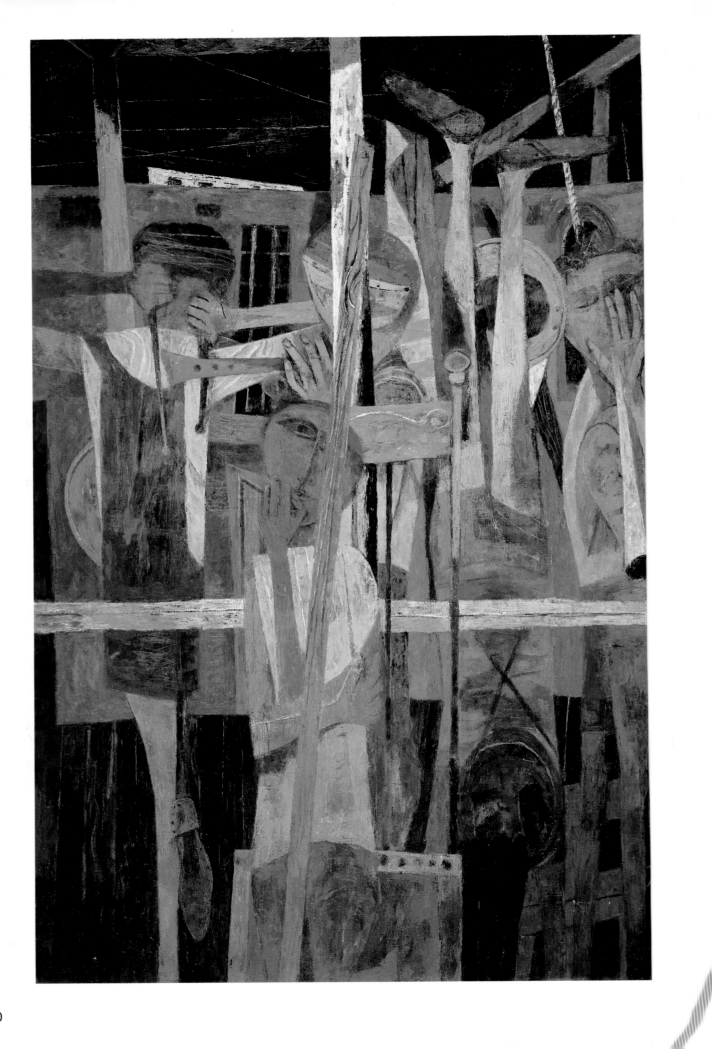

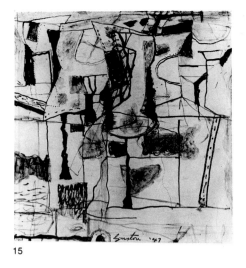

15

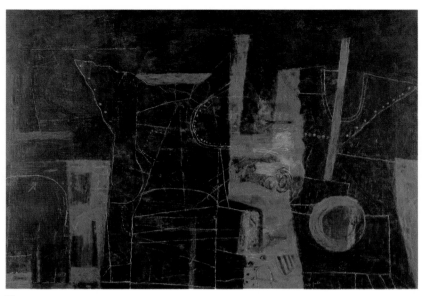

16

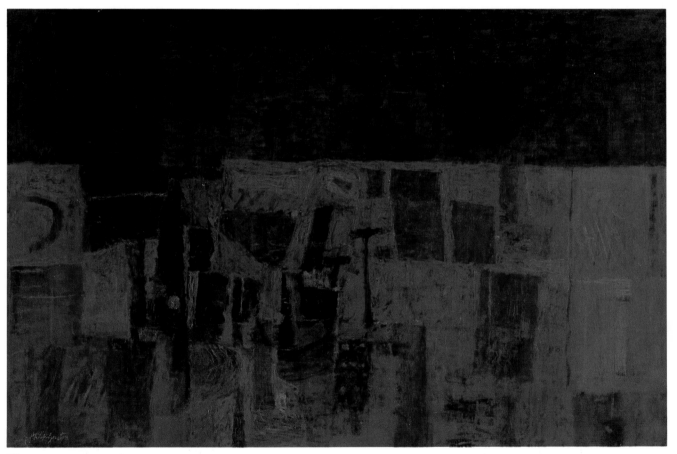

17

14. *Porch II*, 1947
Oil on canvas, 62½ x 43⅛ in.
Munson-Williams-Proctor Institute, Utica,
New York

15. *Study for "The Tormentors,"* 1947
Ink and wash on paper, 10 x 10 in.
The Edward R. Broida Trust, Los Angeles

16. *The Tormentors*, 1947–48
Oil on canvas, 40¾ x 60½ in.
San Francisco Museum of Modern Art

17. *Review*, 1949–50
Oil on canvas, 39⅜ x 59 in.
Estate of Philip Guston;
Courtesy David McKee Gallery, New York

21

calligraphic abstraction in ways that paralleled the changes then taking place in Guston's work.

In 1948 Guston won the Prix de Rome, providing him a year-long stipend and a studio at the American Academy in Rome. In Europe for the first time, Guston was at last able to study the Renaissance masterpieces that he had long revered but had thus far known only from reproductions. On a trip to Spain he studied the work of El Greco and Goya, while in Venice he discovered Titian and Tintoretto, whose more painterly approach had previously been of little interest to him. This belated pilgrimage came during a period when Guston's own work had reached a virtual stalemate, and directly confronting his chosen models seemed to finally liberate him from them, punctuating a whole chapter in his creative and professional life.

During the late 1940s Guston painted little and was satisfied with even less. But, as he did throughout his career whenever faced by a crisis in his work, he drew constantly. Some of these drawings—spare descriptions of landscapes or architectural forms seen during his travels in Europe—anticipate the abraded geometry of his first fully abstract paintings of the 1950s. Others—characterized by figurative forms at first carefully rendered and later more skeletal—are notations for work then in progress.

In a catalog statement made in 1956 Guston said, "What is seen and called a picture is what remains—an evidence."[14] *The Tormentors*, the first of his three major works of the late 1940s, is also the first of Guston's pictures to which this conception of painting as residue applies. Working back through the sketches for it, one can clearly distinguish the images either submerged in the dense black and red pigment of its dominant forms or outlined in the dry white tracery that weaves over them: the raised whip-wielding arm of a Ku Klux Klansman from his work of the early 1930s, the nail-studded sole of a shoe from *Porch II* (a once literal, now faint "repoussoir"), and the brittle slats and cutout shapes that articulate the space of virtually all his paintings of the mid-1940s. Thus, *The Tormentors* is both an inventory and a dissection of the images and devices that had long obsessed Guston, but in its final state the painting has a haunting and aggressive physical presence that he had never before achieved. Elusive symbolism gives way here to the tangible mysteries of paint. Guston's analysis of his work of the 1960s also sheds light on the formal and imaginative dialectic that guided the evolution of *The Tormentors*. "I scrape out all that does not yet belong to me or that belongs too much. . . . Painting becomes a tug of war between what you know and what you don't know . . . between the moment and the pull of memory . . . [it] crosses the narrow passage from diagramming to that other state—a corporeality."[15]

The second of Guston's pivotal pictures of the late 1940s, *Review*, was painted in Woodstock before and after his Italian sojourn, though he had taken it to Rome with the intention of finishing it there. As its title suggests, *Review* is also a reexamination of fundamental images and procedures, but the derivation of its forms is no longer as easily discernible as in *The Tormentors*. Like the eccentric polygons and ciphers in several contemporaneous gouaches—

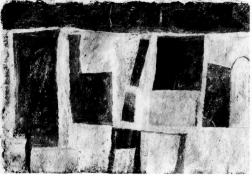

18

small works on rough-edged paper that have no antecedents in Guston's oeuvre—the shapes in *Review* are arranged across the bottom two-thirds of the horizontally divided field of the picture, like the sculptural fragments found embedded in antique Roman walls. In Guston's work of the 1970s a similar division of the canvas is common, and more than once the subject is a wall topped with scattered objects or hung with mirrors or paintings, a wall that blocks one's view while at the same time offering to the eye an array of incomplete or enigmatic images. Once the designer of deep spaces and complex perspective puzzles, in *Review* Guston banished all but the most incidental diagonals, pressing his background forward until it was coexistent with the picture plane. Framed by, laid over, or cut back into this surface are shapes that in their interrupted evolution or progressive revision elide with each other or fuse with the thick veil of pigment that surrounds and supports them.

In *Red Painting*, the last of Guston's transitional abstractions, 19 even this degree of separation between figure and ground disappeared. Chosen by Andrew Carnduff Ritchie for a 1951 survey of American abstract painting and sculpture at the Museum of Modern Art, the first such exhibition to present a major selection of work by members of the New York School, *Red Painting* was similar to *Review* when Ritchie selected it. However, by the time the show opened Guston had completely reworked it. In the interim, the wafer-thin blocks and brittle linear elements of *Review* had melded into fraying clots of oil color or dissolved into attenuated strokes, while the painting's saturated red ground seemed not only to well up around these remnants of form and drawing but to flood over and permeate them. It was Guston's first allover painting. To some unaware of the course of Guston's work since 1947, *Red Painting* came as a rude surprise, and they denounced it as too reductive—a dead end, a point of no return.[16] But for the artist it was a confirmation of the new beginning he had long been seeking. With the completion of *Red Painting* and the reaction it provoked, Guston took his place alongside Pollock, Rothko, and de Kooning in the front line of the Abstract Expressionist vanguard.

18. *Untitled*, 1949
Gouache on paper, 15¼ x 22¼ in.
Estate of Philip Guston;
Courtesy David McKee Gallery, New York

19. *Red Painting*, 1950
Oil on canvas, 34⅛ x 62½ in.
The Museum of Modern Art, New York;
Bequest of the artist

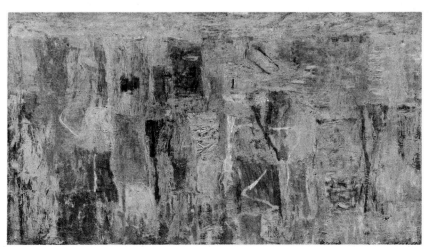

19

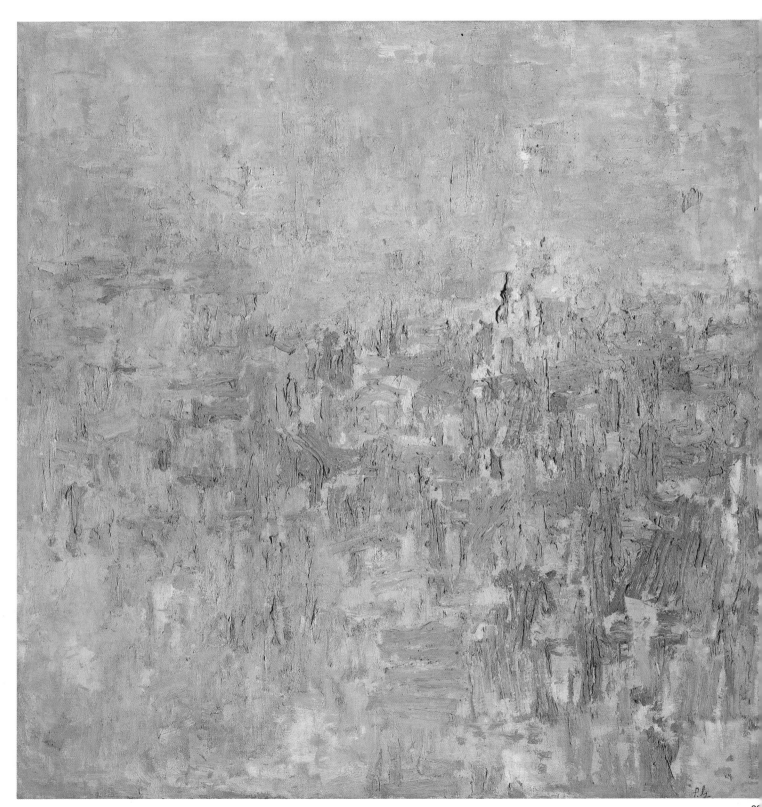

20

# 2  Abstraction

"The desire for direct expression finally became so strong that even the interval necessary to reach back to the palette beside me became too long; so one day I put up a large canvas and placed the palette in front of me. Then I forced myself to paint the entire work without stepping back to look at it. I remember that I painted this in an hour."[17] *White Painting* (1951), whose genesis he thus described, was Guston's first completely organic abstraction. Devoid of any figurative references, it had bypassed the compositional procedures that had determined the pictorial structure of Guston's work since the 1930s, a structure that was still evident in *Red Painting*, though greatly eroded. Before 1950 the final state of Guston's paintings had been dictated to a large extent by formal decisions made in the earliest stages of their development, just as his murals had been fully articulated in preliminary cartoons. Painting itself had been the act of making adjustments in a work's basic design and the means by which Guston breathed life into and took full possession of his preliminary images.[18]

With its scale, improvised forms, and spontaneously unified armature a one-to-one projection of the artist's gesture, *White Painting* established a wholly new method and physical presence in Guston's work. Never again did he diagram his painterly moves in advance. Henceforth a painting was a legible record of all the decisions, whether tentative or assured, that went into its conception and realization. The issue was not one of speed—the rapid execution of *White Painting* was not typical of Guston's abstractions—but rather one of the immediacy and responsiveness of process, the simultaneity of thinking and making. Having painstakingly exhausted an aesthetic of gradual refinement, Guston had at last come to trust his own instincts. The words he used to describe the work and character of his friend Bradley Walker Tomlin apply equally well to his own: "His paintings possessed a tensile and at times precarious balance which covered an anguished sense of alternatives—bound by a gift of proportion his spontaneity was earned."[19]

The paths to abstraction were as various and the pace at which they were traveled as individual as the men and women who made up the New York School. Abstract Expressionism was, in fact, less

21

20. *Attar*, 1953
Oil on canvas, 48½ x 46 in.
Gerald S. Elliot

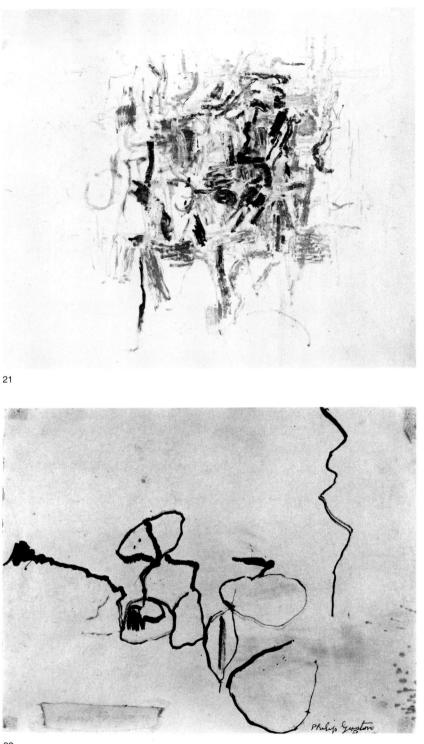

21

22

21. *White Painting*, 1951
Oil on canvas, 57⅞ x 61⅞ in.
San Francisco Museum of Modern Art

22. *Drawing*, 1951
Ink on paper, 9¼ x 11¼ in.
Dore Ashton

23. *Drawing*, 1954
Ink on paper, 17 x 22 in.
Andrew and Denise Saul

a movement in the sense that that term can be applied to Cubism or Surrealism than a loose confederation of artists of the same generation, each following and elaborating upon his own private vision or doctrine. Barnett Newman's heroic notion of geometric abstraction had little in common with Ad Reinhardt's anti-Romantic dogmas, just as de Kooning's almost classical biomorphism was different from the sinewy automatism of Pollock, and Pollock's use of mythic or dream-inspired imagery was distinct from Rothko's transcendentalism. In the most general formal terms, however, one can separate the Abstract Expressionists into two tendencies. The

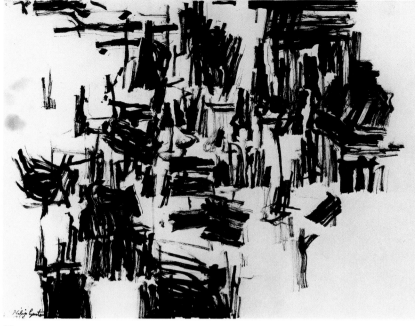

23

first was what Guston called the painters of the "Sublime," by which he meant the inventors of an open and evocative painterly space: Rothko, Newman, Clyfford Still, and, in his own way, Reinhardt.[20] The second was the gestural painters, which included Guston himself along with de Kooning, Pollock, and Franz Kline. But within this group Guston stood apart. In Pollock's work, drawing appeared to enjoy an unlimited freedom of expansion, creating and defining space as it moved outward. In Kline's painting, rough configurations shouldered against the frame that contained them, while de Kooning's arcing forms seemed to flex and explode within their rectangular field. Guston's brush, by contrast, patiently explored the canvas, establishing a network of short, discontinuous strokes that charted the exact dimensions of the painting's format and located its center of gravity. His gesture was not that of the hand that grasps a tool while the arm sweeps but that of an arm that extends a groping hand. It was as if Guston, with eyes half-closed, was feeling his way along a wall, noting all of its changes in surface while waiting for an opening. One is thus reminded of the writings of Henri Focillon, which Guston had read while in Iowa: "It is the action of the hand that defines the hollows of space and the solidity of the things that occupy it. Surface, volume, density are not optical phenomena. Man measures space not with a look but with his hands. . . . Touch fills nature with mysterious forces. Without it, nature remains like those delicious landscapes produced in the darkroom, weightless, flat, and illusory."[21]

Although the irregular geometry of Guston's abstractions of the early 1950s had been anticipated in the architectural and topographic drawings he had made in Europe, his paintings were never landscapes in any literal sense. It was nonetheless to the landscape tradition and to Impressionism, its most purely optical expression, that Guston's work was commonly compared. Conservatives unwilling to accept the notion of a self-sufficient abstract painting had hoped from the beginning to reclaim Abstract Expressionism

27

for the cause of a mimetic art by demonstrating that its organic shapes and sensual atmosphere could be traced to specific natural sources. The confusion over the relation of postwar American abstraction to Impressionism was compounded by often simplistic references to the late work of Claude Monet and by the emergence of second-generation Abstract Expressionists such as Joan Mitchell and Milton Resnick and new painterly realists such as Fairfield Porter, all of whom had an obvious debt to nineteenth-century French painting. Indeed, in reviewing Guston's work in 1953, Porter thought that he detected in it an affinity to the work of Camille Pissarro and Alfred Sisley.[22] Often tagged an "Abstract Impressionist," Guston was included in a 1958 exhibition at the Whitney Museum of American Art, whose intent, in the words of its curator, John I. H. Baur, was to "determine exactly the relation of American Abstract Art and the one traditionally important aspect of observed reality—nature."[23] Its ulterior purpose, vigorously disputed by Abstract Expressionism's most ardent editorial champion, Thomas B. Hess, in an article in *Artnews*, was to prove that the new painting was in danger of succumbing to solipsism, or what Baur called "extreme introspection and private gesture,"[24] and could be redeemed to universality only by the identification or adoption of traditional subject matter. Guston, however, felt no responsibility for what people might think his painting superficially resembled, and he had no great regard for Impressionism. Of the Impressionists, only the most "sculptural" painters, Cézanne and Manet, interested him. Thus, responding to a questionnaire sent by Baur to the exhibiting artists, Guston politely but clearly reaffirmed his commitment to the fundamentally nonreferential aesthetic that Baur, despite his disclaimers, seemed to accuse. "It is not always given to me to know what my pictures 'look like.' I know that I work in a tension provoked by the contradictions I find in painting. I stay on a picture until a time is reached when these paradoxes vanish and conscious choice doesn't exist. I think of painting more in terms of the drama of this process than I do of 'natural forces.'"[25]

The comparison often made between Guston's work and that of Mondrian is, by contrast, both apt and instructive. Though not abstracting from any natural source, Guston did acknowledge that at that time "cities were on my mind and so was Mondrian."[26]
The floating grids of paintings such as *To B.W.T., Painting* (1959), and *Attar* do indeed recall the fragmented spans and rhythms of Mondrian's "plus-minus" pictures. Nonetheless, Guston's work is as different from Mondrian's in its fundamental meaning as it is similar in its underlying structure. Possessed by the vision of a spiritual utopia based on perfect aesthetic harmony, Mondrian and his de Stijl collaborators and American disciples sought to articulate that vision by limiting their pictorial vocabulary to what they considered painting's essential and irreducible elements: straight lines, pure, uninflected surfaces, and a palette of the three primaries, plus black, white, and uniform grays. Guston, on the other hand, was beset by doubts concerning both painting's essence and its relation to the world, and these doubts determined both the look and the substance of his abstract work. Rather than hard and

24
20

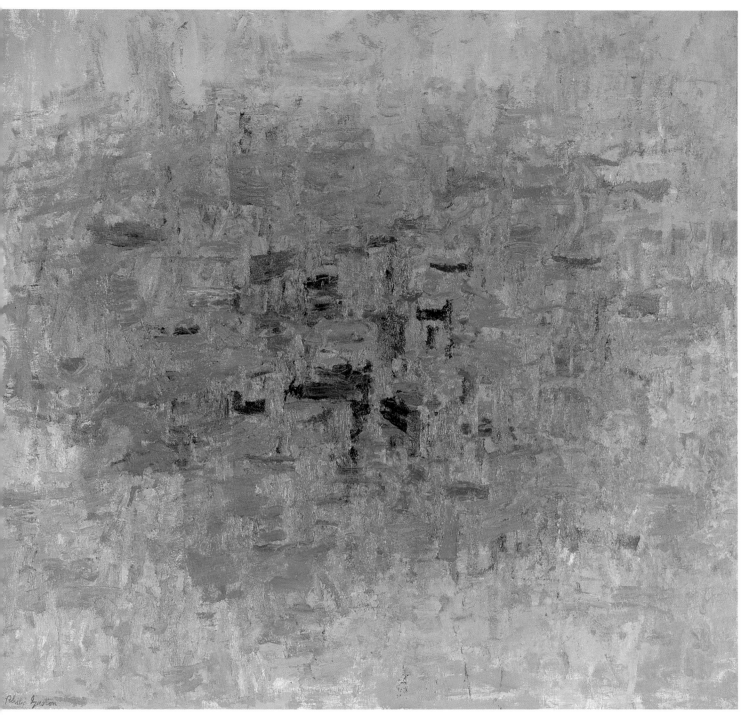

4

24. *To B.W.T.*, 1952
Oil on canvas, 48½ x 51½ in.
Richard E. and Jane M. Lang Collection

impersonal, his surfaces are everywhere imprinted by the changing weight and velocity of his hand; rather than clear, flat, and unequivocal, his color is built up and subtly polluted, while the tonal field over which he worked is a constantly varying fabric of glowing gray tints alternatively oil rich and mineral dry. Everything in Guston's work of the 1950s bespeaks an uneasiness alleviated only in a painting's final stages by a delicate, instinctive, and irreproducible balance and objectivity. For Guston there was no definitive victory over uncertainty—nor any hope of one—only the truce of a brief but brilliant enlightenment.

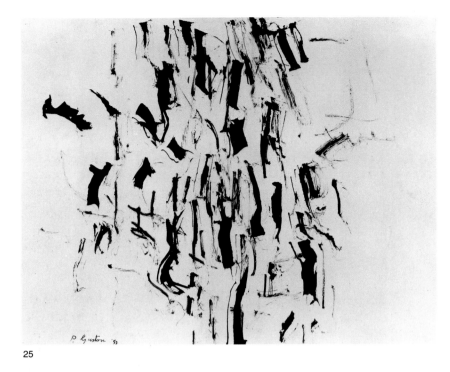

25. *Drawing*, 1953
Ink on paper, 17 x 22 in.
Dore Ashton

26. *Caricature of John Cage*, c. 1955
Ink on paper, dimensions unknown
Location unknown

25

It was this overriding and openly confessed sense of doubt that those conservative critics upset by Guston's abandonment of figuration seized upon to explain and justify their rejection of his abstract work. Writing in the *New York Herald Tribune* in 1962, Emily Genauer summarized this viewpoint: "And then a paradox occurred. His [Guston's] pictures became abstract, but instead of painting tension as an abstract idea tragically applicable to us all, he painted his extremely personal specific tensions, the tensions of a painter who doesn't know where to go, who is frozen by uncertainty into long periods of inactivity and self-doubt—and he lost us."[27] Ignoring the concrete reality and manifest authority of Guston's paintings, Genauer thus reiterated the charge of excessive self-absorption that had been implicitly leveled against Abstract Expressionism by Baur, and like Baur she failed to take into account the social and intellectual context in which Guston and the other painters of his generation were working. For the malaise that he felt was not simply the product of some private confusion. On the contrary, it was the central theme of virtually all avant-garde art and literature of the 1950s. Given the postwar loss of faith in traditional humanist ideals and all supposedly universal systems of value, doubt was not simply an expression of despair but a positive stance, a rejection of the rhetoric of a return to normalcy and a declaration of critical independence. Guston's anxiety about what he described as the "impossibility" of making art in the absence of a vital common language corresponded to the lucid pessimism of Samuel Beckett, whose plays Guston greatly admired, and to the philosophies of Søren Kierkegaard and Jean-Paul Sartre, for whom the meaning of existence could be determined only through the painful process of deciding among several conceivable but mutually exclusive "existences." Guston enacted just such a drama of choice in his own work.

*Hau*
*upwa*
*these t*
*recogni*
*nearby*

26

For Guston the formal and spiritual poles that defined his choices were represented by the physicality and emotional intensity of Rembrandt, whom he revered, as opposed to the classical poise of Piero della Francesca, of whom he wrote, "Without our familiar passions, he is like a visitor on earth, reflecting on distances, gravity and positions of essential forms."[28] In contemporary terms this same polarity is manifested in the affinity between Guston's work and that of Alberto Giacometti at one extreme (although he was not a direct influence) and that of Mondrian at the other. Although Guston had turned to an abstraction similar to Mondrian's rather than to a figurative fundamentalism akin to Giacometti's, his tonal paintings, much like those of the Swiss artist, were informed by a mesmerizing tension between centrally located forms and the loose framing edge of the canvas, between atmosphere and mass, between an elusive perceptual or imagistic reality and a palpable material one.

Closer in temperament to the anxiety-prone Giacometti than to the otherworldly Mondrian, Guston nonetheless hungered for serenity, and the severity of his essentially existentialist outlook was mitigated by his attraction to the ideas of John Cage. Cage and Guston first met in Rome in 1949 and renewed their acquaintance after they had both returned to New York; from that time onward the friendship included as its third and crucial partner the composer and writer Morton Feldman. Cage greatly admired Guston's early and most reductive abstractions, while Guston was intrigued by Cage's benignly negative dialectics, accompanying him to hear the lectures of Cage's teacher, the Zen master D. T. Suzuki. What Zen offered Guston was an alternative to the categorical "either/or" choices of Kierkegaard and Sartre, for in seeking to restore the integrity of experience, Zen refuses to acknowledge the principle of logical contradiction as absolute, affirming instead the essential equality and unity of opposites. Spartan in its discipline, Zen simultaneously strives to embrace the world and remain aloof from it, viewing it not as a void of alienation or conflict but rather as a "meaningless" but rich and varied plenitude. Visiting Guston's studio in the early 1950s, Cage once exclaimed, "My God! Isn't it marvelous that one can paint a picture about nothing!" To which Feldman answered, "But John, it's about *everything*."[29] Both statements were, in fact, true, and it is in the contradictory truth that he was simultaneously painting "nothing" and "everything" that one most directly perceives Guston's affinity for Zen. So, too, it is in the increasing fullness and sensuality of his work from the mid-1950s on that one experiences the pure pleasure in painting that counterpoised the anguish so long manifest in his work.

Just as Guston was simultaneously painting "everything" and "nothing," so, too, his anxiety about the "impossibility" of painting reinforced his faith in its continued possibility, and this paradoxical faith defines his position in the debates that took place among the Abstract Expressionists. For as much as anything, the history of Abstract Expressionism is one of these ongoing arguments over the substance and direction of modernism. Moreover, the terms we have inherited from that debate continue in large measure to define the discussion of the formal syntax, emotional tenor, and philo-

26

27. *Painting*, 1954
Oil on canvas, 63¼ x 60⅛ in.
The Museum of Modern Art, New York;
Gift of Philip Johnson

28. *Zone*, 1953–54
Oil on canvas, 46 x 48 in.
The Edward R. Broida Trust, Los Angeles

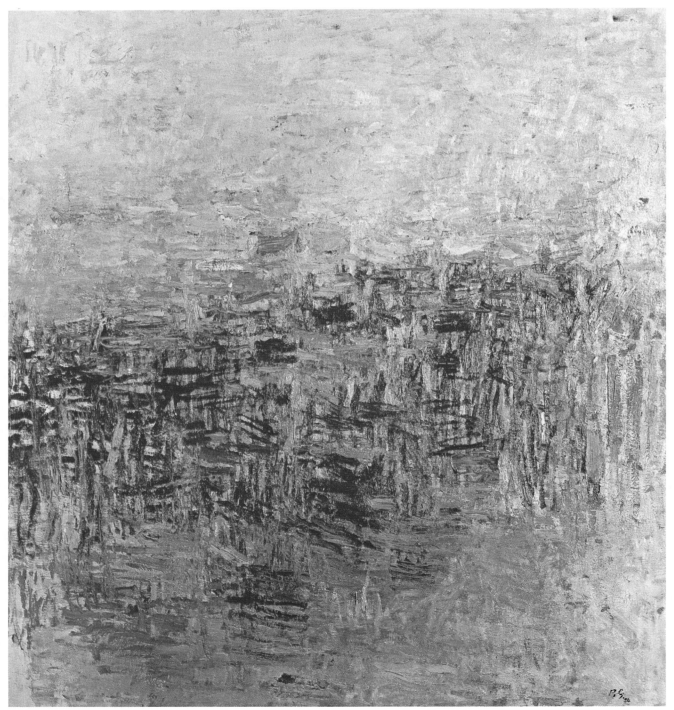

27

28

RITTER LIBRARY
BALDWIN-WALLACE COLLEGE

sophical content of contemporary art. Cageian aesthetics constitute a reaction against the transcendental myths of Abstract Expressionism and are a point of reference for the work of Jasper Johns and Robert Rauschenberg, who are, in turn, primary influences on the appropriative art of David Salle and other painters prominent in recent years; while Reinhardt's extreme austerity is the precursor of much of the Minimal abstraction of the 1960s and '70s. If, in the context of the disputes of the 1950s and '60s, Guston found in Cage a temporary ally, in Reinhardt he met a worthy and notably acerbic adversary.

Reinhardt's position might best be described as the antithetical twin of Cage's acceptance of things as they are—a serial and categorical "no" to Cage's disinterested and universal "yes." Contrary to the Romantic vision of a unity between art and life, and contrary also to Rauschenberg's Cageian dictum that the artist works in the space between the two, Reinhardt insisted that art's purity was predicated upon its absolute autonomy and self-sufficiency. Responding to what he perceived as the intellectual eclecticism and commercial opportunism encroaching upon modernist principles and practice in the 1950s and '60s, Reinhardt objected to any ambiguity of thought or practice, any pretense to making an art beyond intention that might cloak a corruption of these principles. Thus, during a panel discussion in 1960, Reinhardt, with characteristically stinging wit, denounced everything from Surrealism and Expressionism to "wiggly lines."[30] The panel's moderator, Harold Rosenberg, then invited Guston to add his own injunctions to Reinhardt's long list of "Thou Shalt Nots," and Guston answered simply, "The artist should not want to be right."[31] The only possible rejoinder to Reinhardt's invigorating "Art as Art" dogmas, this statement also defines Guston's opposition to the prescriptive and widely influential brand of formalism then being propounded by critic Clement Greenberg. Guston then proceeded to question the motive for such forums. "Well, there is a strange assumption behind panel discussions of art: that it should be understood, . . . that art should be made clear. For whom?"[32] For Guston, painting's power and necessity derived from its essential mysteriousness, and that mystery was a direct consequence of art's lack of purity.

There is something ridiculous and miserly in the myth we inherit from abstract art: That painting is autonomous, pure and for itself, therefore we habitually analyze its ingredients and define its limits. But painting is "impure." It is the adjustment of "impurities" which forces its continuity. We are image-makers and image-ridden. There are no "wiggly or straight lines," or any other elements. You work until they vanish. The picture isn't finished if they are seen.[33]

Thus, impurity and its inevitable companion, uncertainty, were for Guston not the nemesis of painting but its permanent attributes and the only guarantor of its future. The object of painting was not to find a solution to the problem of art's persistent antagonism to or ongoing compromises with reality but rather to find a provisional wholeness within the context of them.

21, 27    From *White Painting* (1951) to *Painting* (1954), Guston's work

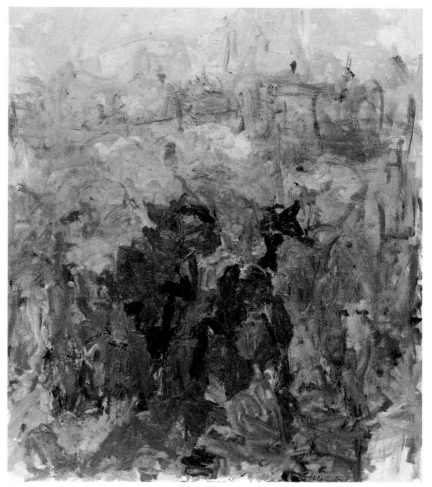

29

was fully nonobjective. The lines that scatter and cluster within their gray fields are spatial markers. The crucial issue was their placement, or what critic Leo Steinberg called their "Whereness."[34] By 1955, however, these dispersed or dispersing fragments had begun to reconverge, as if pulled by a centripetal force into increasingly dense and more variegated masses of color and form. The problem of "Whereness" had become one of "Whatness," as if, acquiring greater bulk and specificity, paint were doubt incarnate emerging as an ever more imperative presence.[35]

By the mid-1950s Guston had abandoned the practice of giving his paintings numerical or generic names, and his new titles reflected the growing "thingness" of his images, suggesting a wide variety of specific subjects, moods, and art historical references. *Voyage* and *Cythera*, for example, are clear allusions to *Voyage to Cythera* 29 by Antoine Watteau, whose cool but radiant reveries interested Guston at the time; while *The Actor*, *The Poet*, and *The Painter* remind one of the themes of Guston's early metaphysical paintings and his long-standing preoccupation with the problem of the artist's nature and identity. One such painting was dedicated to Federico Fellini, one of Guston's favorite film directors, whose fascinated affection for the tawdry artifice of itinerant performers matched his own. With its tightly packed and richly textured forms, luminous color, and intrusive blacks, *To Fellini* recalls in abstract terms 32

29. *Cythera*, 1957
Oil on canvas, 72⅛ x 63¾ in.
Mr. and Mrs. Donald Blinken

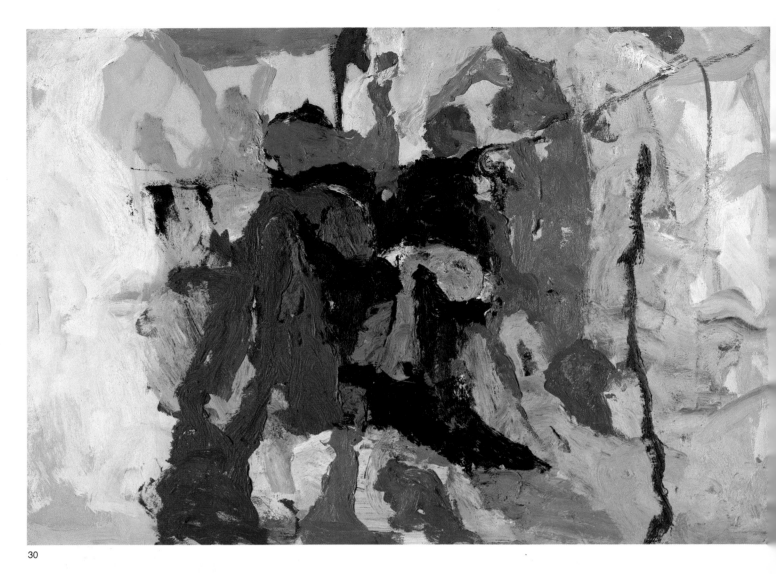

30

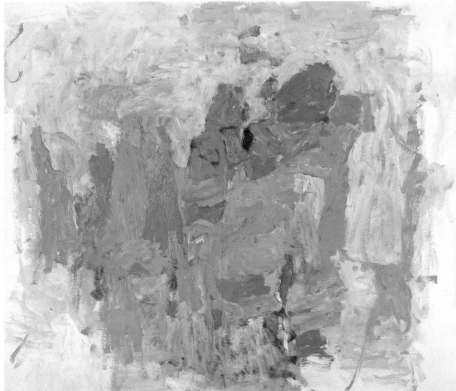

31

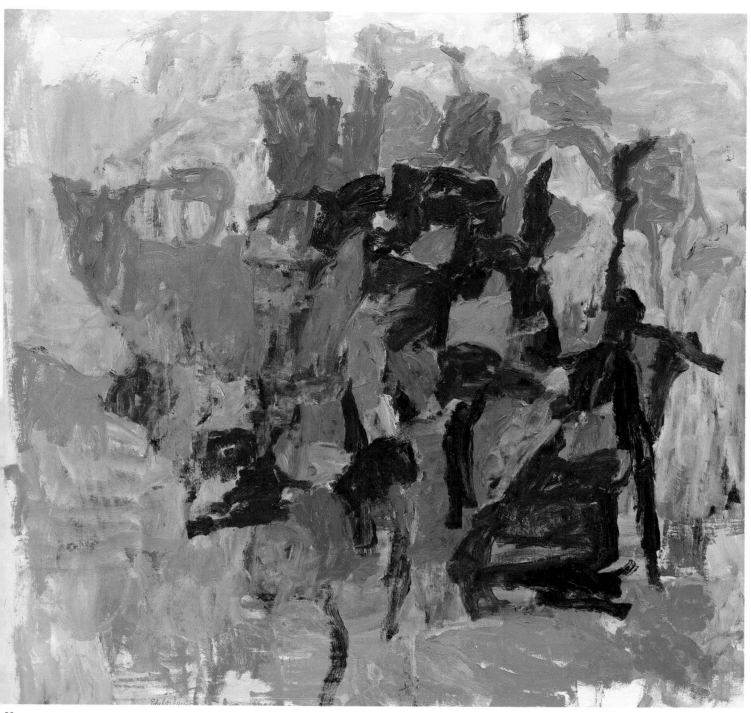

32

30. *Fable II*, 1957
Oil on paper on board, 24⅝ x 35¾ in.
Musa Guston

31. *Passage*, 1957–58
Oil on canvas, 65 x 74 in.
Mrs. Dolly Bright Carter

32. *To Fellini*, 1958
Oil on canvas, 69 x 74 in.
Private collection

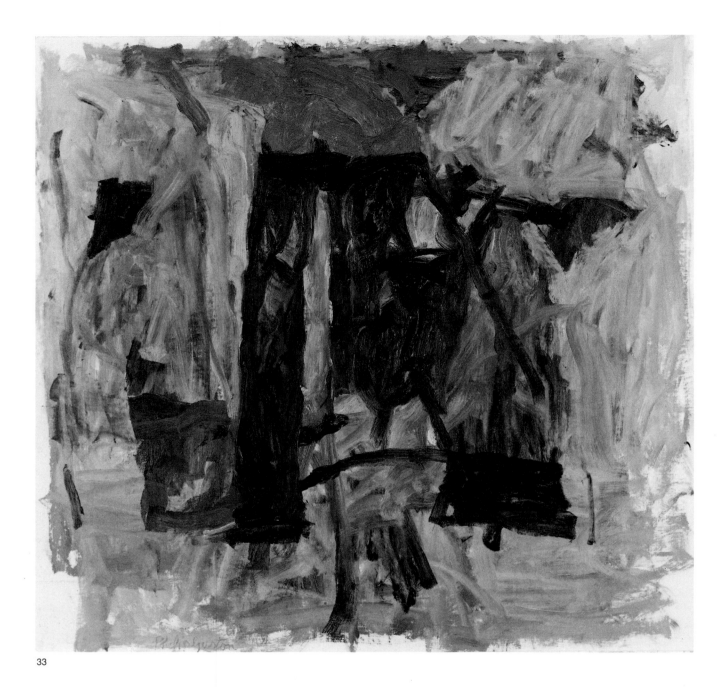

33

the formal congestion and emotional enigmas of *If This Be Not I*, and like Fellini's sensual but often sinister fantasies it is the distillation of an immensely sophisticated and profoundly ambivalent romanticism.

The meaning of these paintings is contained less in the identity of the particular images hinted at in their titles than in the suspended state in which we encounter them and they continue to exist. Neither figurative nor fully abstract, the content of these images is the elusiveness of their being. Emblems of immanence, each image hovers between presence and absence, focus and dissolution. Their ambiguous identity is a function of temporal as well as spatial considerations. Poised between a recognition based on memory and the seductive promise of something completely "new," the shapes in Guston's abstractions define a kind of perpetual present—a self-contained and constantly evolving "here and now." Radiating

33. *Painter I*, 1959
Oil on canvas, 65 x 69 in.
High Museum of Art, Atlanta;
Purchase with funds from the National
Endowment for the Arts, 1974

from and gravitating toward a floating axis, his primary forms describe the circumference of the moment in which an image comes into existence. His paintings express a cyclical rather than a linear conception of time, in which the pull of the past and the future pose an equal threat to the actuality of experience. Or, as Guston would say, "Painting is a clock that sees both ends of the street as the end of the world."[36]

Just as *The Clock* is, in this sense, not so much a picture as the direct imprint of duration, *The Mirror*, and indeed all of Guston's abstract work, constitutes an organic self-portraiture of the kind described by the philosopher Maurice Merleau-Ponty. For Merleau-Ponty, art results from the dialectical encounter between the subjectivity of the artist and the objectivity of the medium in which he works and of the world that surrounds him; it is a process of discovery, not merely a means of exposition. The agency that reveals the unknown that lies hidden in that partially known exterior reality is neither intellectual nor "inspirational" but corporeal. "A technique is a 'technique of the body,'" Merleau-Ponty wrote. "It formulates and amplifies the metaphysical structure of our flesh. The mirror appears because I am at once seer and seen. . . . By virtue of it my outside is rendered complete, all of me that is most secret emerges in this 'face,' a flat and enclosed being which reminds me of my reflection in the water."[37]

Thus, for Merleau-Ponty, as for Guston, art does not reproduce the world, but rather records a kind of phenomenological transubstantiation, embodying as it does the simultaneously responsive and active presence of the artist in the world. The existential content of Guston's work is, in that context, measured not so much by its expressionism as by its immediacy, and what one witnesses in his abstractions of the 1950s is less Guston's search for the specific identity of the forms they seem to suggest than the gradual revelation of the artist's own identity mirrored in the "flat and enclosed" realm of painting.

The decade from 1950 to 1960 saw the confirmation of Abstract Expressionism as the dominant style in contemporary American painting and the recognition of Guston as one of its most important exemplars. In 1952 Guston joined the Charles Egan Gallery, later moving to the Sidney Janis Gallery, where he showed to general critical acclaim in 1956, 1958, 1959, and 1961. For the first time since the Depression, Guston was able to support himself with his work. Despite all the attention he had received, Guston had sold only eleven paintings between 1941 and 1956, and of those done after his turn to abstraction in 1947 he had sold only two, one of which, *Painting* (1954), was purchased for the Museum of Modern Art by the architect Philip Johnson. Indeed, as late as 1955 Guston had been obliged to borrow money to pay for supplies, hence the title of one of his most subtle but sensual abstractions of the period, *Beggar's Joy.*[38]

The same year as his first show at Janis, Guston was chosen by Dorothy Miller for *12 Americans*, the second of her surveys of postwar art at the Museum of Modern Art. In 1958 he was included in a traveling exhibition devoted to Abstract Expressionism organized by the museum's International Council, one of the first such

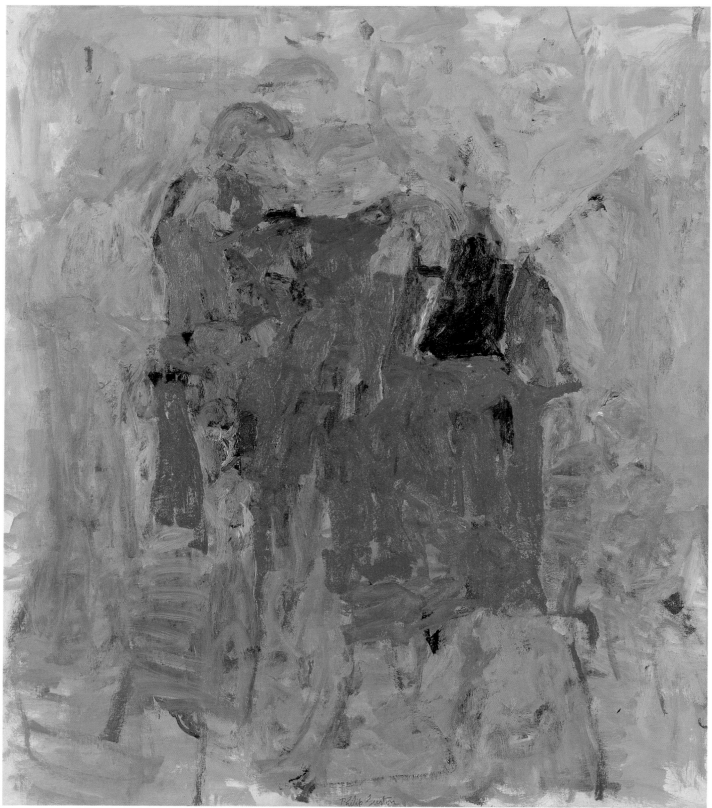

34

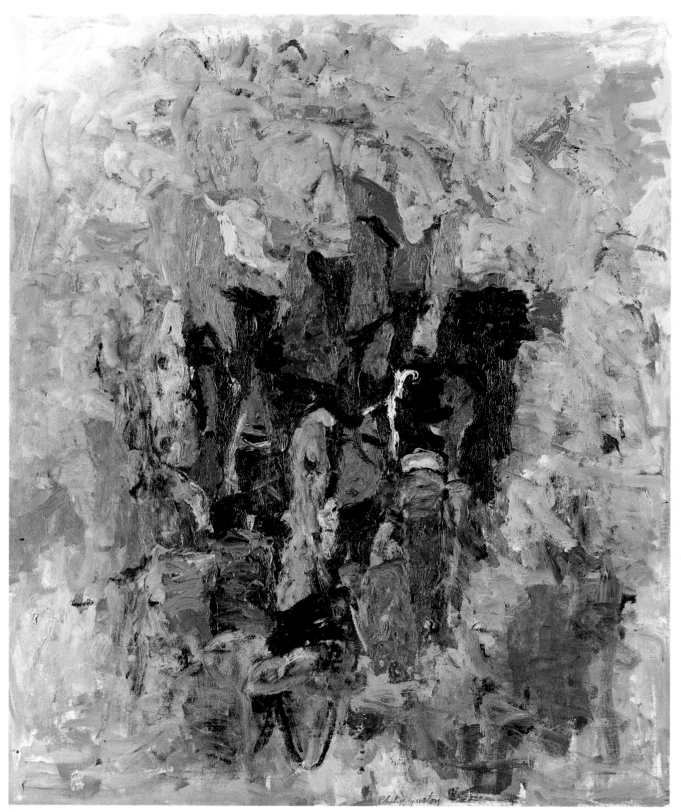

35

34. *The Mirror*, 1957
Oil on canvas, 68⅞ x 61 in.
The Edward R. Broida Trust, Los Angeles

35. *The Clock*, 1956–57
Oil on canvas, 76 x 64⅛ in.
The Museum of Modern Art, New York;
Gift of Mrs. Bliss Parkinson

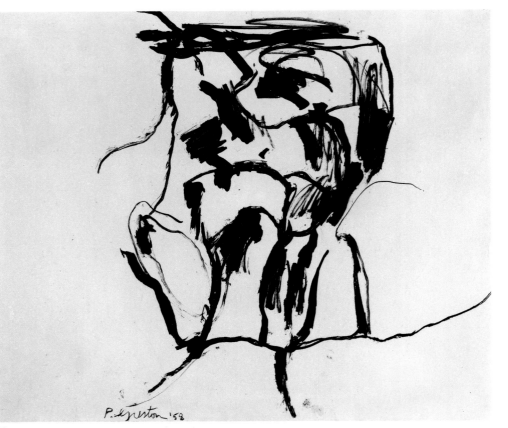

36

efforts to promote modern American art in Europe, and in 1962 the Guggenheim Museum mounted Guston's first retrospective. Combining the theatrical metaphor often applied to Guston's work with Harold Rosenberg's famous definition of Action painting as "an arena within which to act," H. H. Arnason, the exhibition's curator, described *Actor*, and by implication all of Guston's abstractions of the late 1950s, in these terms: "The painting has become a stage on which figure-forms act out comedies and tragedies whose poetic language is paint itself and whose plot is the painter's exploration of the unknown."[39] But by 1959 the congestion on that stage as well as the agitation of Guston's brushwork and the vibrancy of his color had reached a critical point: the delicate balance of his formal syntax was breaking up. At one extreme were small gouaches and oils in which irregular masses of paint clearly disengaged themselves from their tonal backgrounds. At the other were large paintings such as *Close-Up III*, in which the weave of gray strokes and the roseate or pale blue washes that made up their backgrounds seemed to float free of the canvas's restraining edge, while the primary forms within this field appeared to be unraveling. By 1962 this tug-of-war between figure and ground had resolved itself into a pronounced separation of the two. In the work made between the Guggenheim show and his second major exhibition, at the Jewish Museum in 1966, the central issue in Guston's art was the consolidation of the blocky shapes that dominated the center of his paintings and the corresponding homogenization of the now nearly monochrome space that enveloped them. This change in pictorial dynamics was prompted by a radical simplification of method. As Guston explained: "I

37

36. *Head—Double View*, 1958
Ink on paper, 19 x 24 in.
The Museum of Modern Art, New York;
Purchase

42

use white and black pigment; white pigment is used to erase the black I don't want and becomes grey. Working with these restricted means as I do now, other things open up which are unpredictable, such as atmosphere, light, illusion—elements which do seem relevant to the image but have nothing to do with color."[40]

The "image" of these paintings is an impenetrable, at times almost sculptural knot of pigment that attracts, then defies the viewer's gaze like a dark, featureless face. What mattered to Guston more than anything, however, was the process by which a certain image would emerge and detach itself from all the others that had preceded it and then would remain embedded in the surrounding erasures. "A 'thing' is recognized only as it comes into existence," Guston maintained. "To will a new form is inacceptable, because will builds distortion. Desire, too, is incomplete and arbitrary," for the vitality of an image depended not only upon its inevitability but equally upon its unexpectedness.[41] "Sometimes I know what they [the forms] are," he said. "But if I think 'head' while I'm doing it, it becomes a mess. . . . I want to end with something that will baffle me for some time."[42]

By the mid-1960s, art world attention was shifting to new forms of post-painterly abstraction, and the response to the work in Guston's exhibition at the Jewish Museum was mixed. Though Bill Berkson reviewed the show with warmth and understanding in *Artnews*, Hilton Kramer, assuming the role of conservative scold formerly shared by Emily Genauer and John Canaday, declared his preference for the "finer textured abstract impressionist work of a decade ago." Kramer then proceeded to use Guston's "refinement" as the whip with which to flog him for having overstepped the suppposed limits of his talent in the ambitiousness of the paintings and the volume of work shown in the exhibition.[43] Beyond that, the critic was dismayed by what he perceived as the reductiveness and repetition of Guston's work, yet many of the geometric and color-field abstractions to which he compared it were, if anything, sparer and more systematic. The real problem, it would appear, was not so much aesthetic as ideological. Using the exhibition as an occasion to renew his attack on what he considered the rhetorical excesses of Abstract Expressionism's critical partisans, in particular Harold Rosenberg, who had contributed to the catalog, Kramer also seemed to insist that the artist keep his place within the movement's ranks. Despite the fact that Guston was evolving his own painterly or organic version of the minimal or grid picture in ways that paralleled or complemented the work of younger artists, for Kramer those changes appear to have been an annoying inconvenience rather than a development to be explored. In any case, Guston's paintings of the mid-1960s, with their commanding simplicity and tonal and textural subtlety, constitute an important if all too often overlooked contribution to the abstraction of the period.

More reductive still was his work of the next two years. After the Jewish Museum show Guston concentrated exclusively on drawing, and this time he drew more prolifically and with greater economy than ever before. Often consisting of no more than three or four lines, and sometimes only one or two, the shapes and spatial armatures of Guston's "pure" drawings, executed in bold

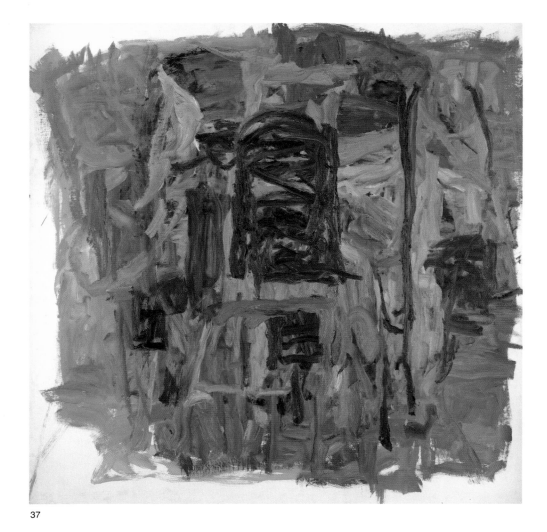

37

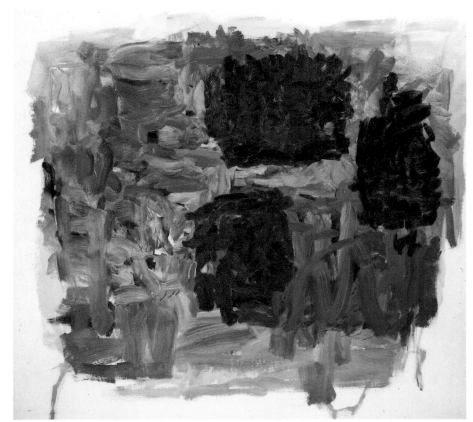

44

38

37. *Close-Up III*, 1961
Oil on canvas, 70 x 72 in.
The Metropolitan Museum of Art, New York;
Gift of Lee V. Eastman, 1972

38. *Meeting*, 1963
Oil on canvas, 69 x 78 in.
Estate of Philip Guston;
Courtesy David McKee Gallery, New York

39. *Air II*, 1965
Oil on canvas, 69 x 78 in.
Estate of Philip Guston;
Courtesy David McKee Gallery, New York

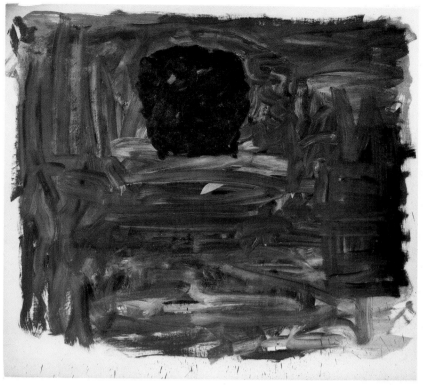

39

black ink or chalk strokes, display none of the revisions long
characteristic of his paintings. Indeed, though the product of a
new period of "dismantling," there is nothing hesitant about these
drawings. Clear, decisive, and idiosyncratic, their elemental struc-
tures seem less the manifestation of a bare-bones Abstract Ex-
pressionism, such as that found in Robert Motherwell's contempo-
raneous Open series, than of a discursive "forming," in some
respects similar to though more muscular than that of Post-
Minimalists of the late 1960s and early '70s such as Richard Tuttle.

Like the head shapes in his last abstractions, the images in
Guston's "pure" drawings represent discoveries of the hand, not
projections of the mind, but once complete they were given titles
such as *Chair* or *Wave* that named their figurative analogues.
*Prague*, however, refers to other, less immediate sources, its title  41
recalling Guston's long-standing interest in Franz Kafka and its
isolated, cagelike image suggesting a prison window and so seem-
ing to foreshadow the return of political content in Guston's work
of the 1970s.

More significant, the strength and clarity of these drawings
were simultaneously the prelude and consequence of fundamental
changes in Guston's approach to his work. Still torn between the
desire to make figurative images and an equally strong commit-
ment to an immediacy he had thus far found only in abstraction,
Guston this time did not attempt to fuse the contrary tendencies of
his sensibility into a new synthetic method or style but instead
permitted them to be expressed fully and freely in two distinct,
competitive, but also complementary bodies of work. In 1970
Guston described the course of this contest between the two halves
of his artistic identity and its outcome:

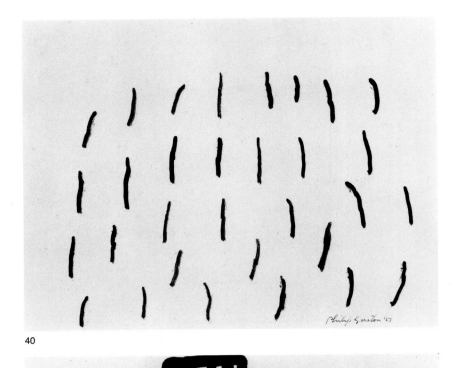

40

43

41

42

40. *Air*, 1967
Ink on paper, 18 x 23 in.
Estate of Philip Guston;
Courtesy David McKee Gallery, New York

41. *Prague*, 1967
Ink on paper, 17½ x 23 in.
Estate of Philip Guston;
Courtesy David McKee Gallery, New York

42. *Magnet*, 1967
Ink on paper, 17¾ x 23 in.
Estate of Philip Guston;
Courtesy David McKee Gallery, New York

43. *Head*, 1968
Ink on paper, 18 x 22½ in.
James Hughes

44. *Ink Bottle and Quill*, 1968
Charcoal on paper, 12½ x 15½ in.
Musa Guston

I remember days of doing "pure" drawings immediately followed by days of doing the other, drawings of objects. It wasn't a transition the way it was in 1948, when one feeling was fading and a new one had not come into existence; or now, where, without conflict, one kind of statement necessarily moves into the next. It was two equally powerful impulses at loggerheads. One day in the house I would tack up a bunch of the pure drawings I had just done, feel good about them, think I could live with this. And that night go out to the studio to do drawings of objects—books, shoes, buildings, hands—feeling *relief* and a strong need to cope with tangible things. I would denounce the pure drawings as too thin and exposed, too much "art," not enough nourishment. The next day, or the day after, back to doing the pure constructions and to attacking the other. And so it went, this tug-of-war, for about two years.

Looking back, it was as if all the conflicts had come together and been compressed in time, with the force distributed equally between the two alternatives. Only when certain doubts cleared in 1968 and I began feeling more positive about the drawings of the tangible world did I begin to paint again. Finally, only total immersion in painting "things" settled the issue.[44]

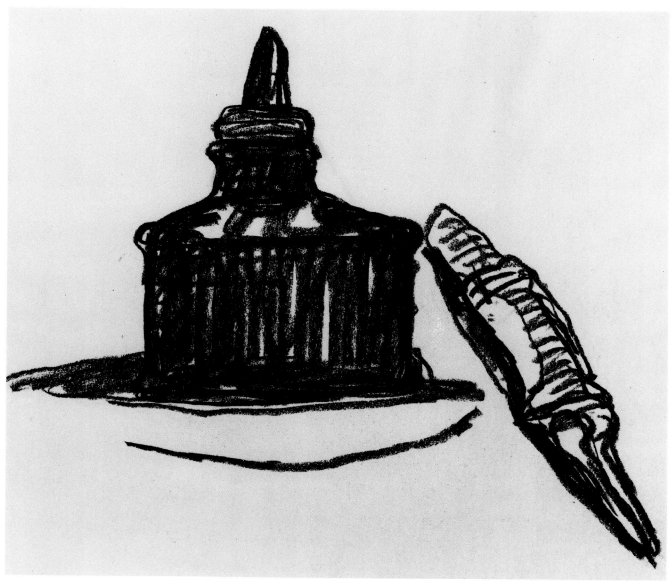

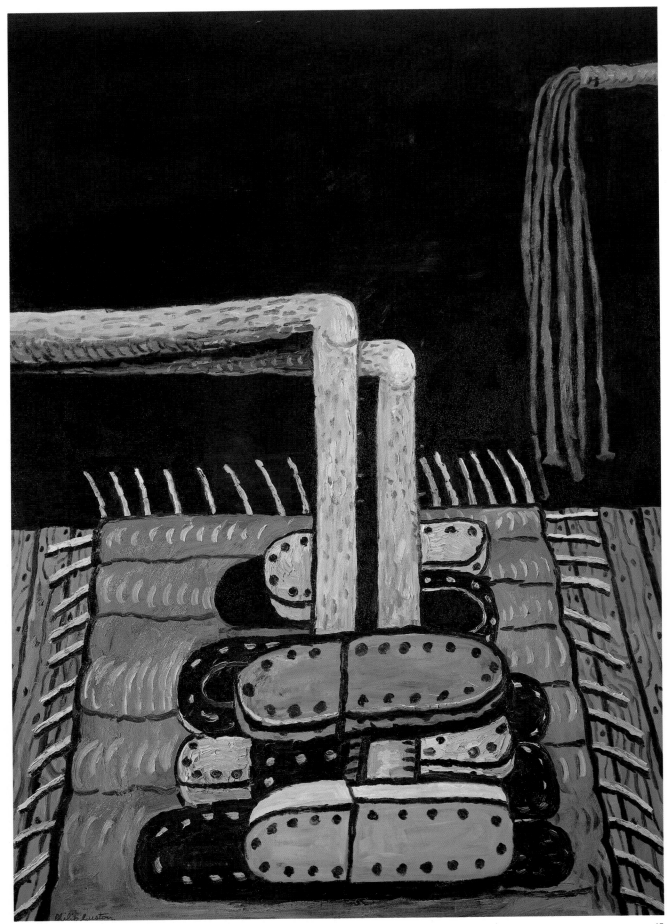

 # A New Figuration

In 1966 Guston joined the Marlborough Gallery, then the dealer for almost all the leading figures of the New York School, and it was generally assumed that he would continue to paint in the Abstract Expressionist manner. But the thirty-three paintings and eight drawings that Guston exhibited at Marlborough in October of 1970 were neither abstract nor, in the then-current meaning of the term, expressionist. Populated by hooded figures who meet in conspiratorial huddles in low-rent rooms or roam deserted city streets in rattletrap cars, crammed full of prostrate, truncated bodies with scraps of urban detritus scattered along the horizon or piled in ominous mounds, this work describes a fantastic but far from remote vision of a world threatened by motiveless violence and littered with the symbols of a no less disconcerting entropy.

The response, immediate and widespread, was one of profound shock. Though the show was sympathetically reviewed by Harold Rosenberg in the *New Yorker* and John Perreault in the *Village Voice*, most critics, having first acknowledged the risk that Guston had taken, then proceeded to chide him for having done so. It was Hilton Kramer, writing in the Sunday *New York Times*, who rendered the most relentlessly negative judgment. In a memorably mean-spirited column entitled "A Mandarin Pretending to Be a Stumblebum,"[45] Kramer once again took out after Guston for having dared to be anything other than the "authentic minor lyricist" that Kramer assumed him to be.[46] Repeating the canard that Guston was merely a "colonizer" of Abstract Expressionism (after having already admitted that his influence on the movement was "second only to Willem de Kooning['s]"), Kramer ridiculed Guston for presuming to play the role of "urban primitive" and for presenting his images as "innocent" or "childlike."[47] The fact of the matter, which Kramer seemed to ignore deliberately, was that Guston had made no such pretense nor was there anything "innocent" or "childlike" about his apocalyptic wastelands.

What triggered Kramer's raging condescension and stymied others less hostile to Guston's work was the cartoonlike style of his new work. Not only did this change in manner seem intended to blur the conventional distinction between high seriousness and low culture, it challenged people's conception of how Guston related

45. *Green Rug*, 1976
Oil on canvas, 94 x 68½ in.
The Edward R. Broida Trust, Los Angeles

to his own generation. Many of Guston's erstwhile admirers were caught off guard by his new paintings, and their inability to respond immediately and positively to his new work was painful to the artist. Such a misunderstanding precipitated a rupture between Guston and Morton Feldman, who, in an image of their mutually 47 regretted estrangement, *Friend—To M.F.*, appears as a gargantuan head half-turned away. Other longtime admirers of Guston simply felt betrayed. To them it seemed as if one of the leading painters of the 1950s had gone over to the forces of the new Pop figuration, whose subversive ironies and commercial success had eclipsed Abstract Expressionism in the 1960s. Some observers, meanwhile, wondered out loud if Guston had been influenced by Robert Crumb's *Zap Comix*, and one might also have proposed a connection to the early work of Peter Saul or the political caricatures of Oyvind Fahlstrom.[48] Guston, however, had been unaware of Crumb's work, while exploring the other parallels reveals more dissimilarities between the artists than shared intentions, for Guston never exploited insult as Saul did, nor was his work ever as textual or polemical as Fahlstrom's.[49]

Guston was not, in fact, following the lead of younger artists but rather returning to his earliest enthusiasms. For if the dominant poles of his thinking were represented by Piero and Rembrandt—seconded by Mondrian, de Chirico, Picasso, and Beckmann—he had nonetheless remained an avid fan of the movies and of comics

46. *City Limits*, 1969
Oil on canvas, 77 x 103¼ in.
Estate of Philip Guston;
Courtesy David McKee Gallery, New York

47. *Friend—to M.F.*, 1978
Oil on canvas, 68 x 88 in.
Saatchi Collection, London

48. *The City*, 1969
Oil on canvas, 72 x 67½ in.
Estate of Philip Guston;
Courtesy David McKee Gallery, New York

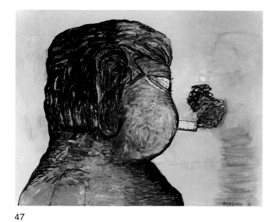

47

48

49

49. *Caricature of Landès Lewitin*, c. 1955
Pencil on paper, 6½ x 10⅜ in.
Estate of Philip Guston

50. *Caricature of Richard Nixon*, 1971
Ink on paper, 10½ x 14½ in.
Philip Roth, London

51. *Meeting*, 1969
Acrylic on board, 30 x 32 in.
Estate of Philip Guston

52. *Wrapped*, 1969
Charcoal on paper, 17½ x 20 in.
The Museum of Modern Art, New York;
Purchase

such as *Mutt and Jeff, Barney Google*, and *Krazy Kat*, which had inspired him as a child.[50] In the 1950s and '60s, moreover, Guston had once again turned to caricature, making sly portraits of what the architect and sculptor Frederick Kiesler called his art world "frenemies," drawings that bear a striking stylistic resemblance to his work of the 1970s.[51]

The real issue, however, was not so much one of influences or precedents or the confrontational connotations of his new style as it was one of the possibilities that cartooning afforded. "I got sick and tired of all that Purity! Wanted to tell Stories," Guston explained to Bill Berkson in 1970. The spontaneous graphic manner he adopted allowed him to do just that and at a pace commensurate with the rush of images through his mind.[52] From the start they came in a flood. "From 1967–69 I painted like mad. The pictures came so fast I had to make memoes to myself, at a table drinking coffee. 'Paint *them*.' I felt like a movie director. Like opening a Pandora's box, and all those images came out."[53] By combining the improvisatory technique that he had used in his abstract paintings with his old habit of setting a stage, choosing props, and directing the action of his players, Guston achieved a stream-of-consciousness procedure that might best be thought of as a kind of narrative Action painting. Thus, although he appeared to have committed aesthetic suicide by killing off the "elegant" Guston, he had in reality brought together the most essential aspects of his older and more fundamental artistic selves.

Given Guston's stated desire to tell stories, it is important to note just how greatly the intent and syntax of his work differed from conventional cartooning or illustration. In 1971, for example, Guston did a series of satirical drawings of Nixon and his cronies, inspired in part by his friend Philip Roth's lampoon, *Our Gang*. Collectively entitled *Alas, Poor Richard*, these drawings are true caricatures, topical and mercilessly unambiguous. It is precisely this topicality and lack of ambiguity that distinguishes them from his paintings. Moreover, Guston did not intend that his paintings be read as progressing from scene to scene as in a comic strip or

50

50

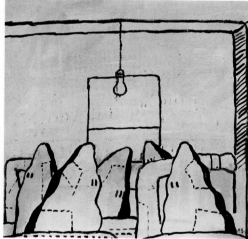

51

52

movie. Rather, he superimposed and obliterated transitional images in order to arrive at a final concentrated picture. Even though a given painting may reinforce or modify the meaning of others done before or after it, each one is essentially self-contained and, like his abstractions, a glimpse of an image in suspended animation and interrupted metamorphosis.

Guston's impatience with "all that Purity" was a reaction to the social as well as aesthetic climate of the late 1960s. By the end of the decade the liberal optimism of the Kennedy era had given way to assassinations, demonstrations, and police violence, to the cynicism of the Nixon administration and the desperation of the Vietnam war. Yet, at a time when the United States was experiencing the most severe civil strife since the Depression, vanguard painting was passing through one of its most rarefied and self-referential phases. Guston was acutely conscious of the irony of that situation.

So when the 1960's came along I was feeling split, schizophrenic. The war, what was happening to America, the brutality of the world. What kind of man am I, sitting at home, reading magazines, going into a frustrated fury about everything—and then going into my studio *to adjust a red to a blue.*

I thought there must be some way I could do something about it. I knew ahead of me a road was laying. A very crude, inchoate road. I wanted to be complete again, as I was when I was a kid. . . . Wanted to be whole between what I thought and what I felt.[54]

Guston's yearning to return to a wholeness he associated with childhood did not, of course, mean a retreat into childlike fantasy. Quite the contrary, for his youth had been profoundly marked by social dislocation. Moreover, his new work had none of the tenderness of his earlier allegorical paintings of boys in conflict. What Guston longed for was not withdrawal but what Harold Rosenberg termed "a liberation from detachment."[55] And, as Rosenberg well understood, the dangers inherent in that desire were greater than those entailed by a simple change in style: "[Guston] has managed to make social comment seem natural to the visual language of postwar painting. Other contemporaries have done political pieces for specific occasions. . . . Guston is the first to have risked a fully developed career on the possibility of engaging art in the political reality. In so doing, he may have given the cue to the art of the nineteen-seventies."[56]

Although Guston clearly meant his new paintings to be interpreted in light of contemporary events, he refrained from the literalness of conventionally partisan art. Whereas the Klansmen in Guston's earliest murals had been real villains, in the work of the 1970s they are a conscious anachronism, a complex symbol of know-nothing terrorism whose antic behavior seems to contradict the menace they embody. Described by the critic Lawrence Alloway as Ubuesque, they are indeed buffoon bullies, cousins of Alfred Jarry's blundering tyrant, Ubu Roi, and, like Jarry's cycle of plays, Guston's paintings are scenes from a surreal and alarming Grand Guignol.[57] Although Guston plainly took pleasure in the vaudevillian misadventures of his flat-footed desperadoes, the humor in

the Klan paintings is less a matter of theatrical stunts than of jarring incongruities. Guston said: "When I show these, people laugh and I always wonder what laughter is. I suppose Baudelaire's definition is still valid, it's the collision of two contrary feelings."[58]

The burlesque brutality of Guston's late paintings reminds one again of Beckmann's work, while also recalling George Grosz's caricatures (which Guston had seen in magazines in the 1930s), Orozco's frescos, and the penny-press engravings of José Guadalupe Posada, whose sardonic Everyman, a grinning skeleton, romps through catastrophe in much the same way that Guston's Klansmen cruise through the no-man's-land of an American city. More than anything, however, Guston's work harks back to the great masters of the grotesque such as Giambattista Tiepolo and Goya.

What critics such as Hilton Kramer missed was not only the fact that Guston's work belonged to this long tradition in which rudeness fortifies erudition and corrosive humor strips humanism of all sentimentality, but the cultural context for such potent admixtures.[59] Like the Baroque, late modernism exists in the shadow of a glorious past. Heir to the great political upheavals and artistic revolutions of the early twentieth century, it is at the same time a manifestation of the compromised wealth of that legacy. At once a dazzling spectacle and a freak show, late modernism simultaneously celebrates and exposes the exaggerated

53. *Flatlands*, 1970
Oil on canvas, 70 x 114½ in.
Byron Meyer

54. *Painter's Table*, 1973
Oil on canvas, 77¼ x 90 in.
Mr. and Mrs. Donald Blinken

55. *Back View*, 1977
Oil on canvas, 69 x 94 in.
San Francisco Museum of Modern Art

54

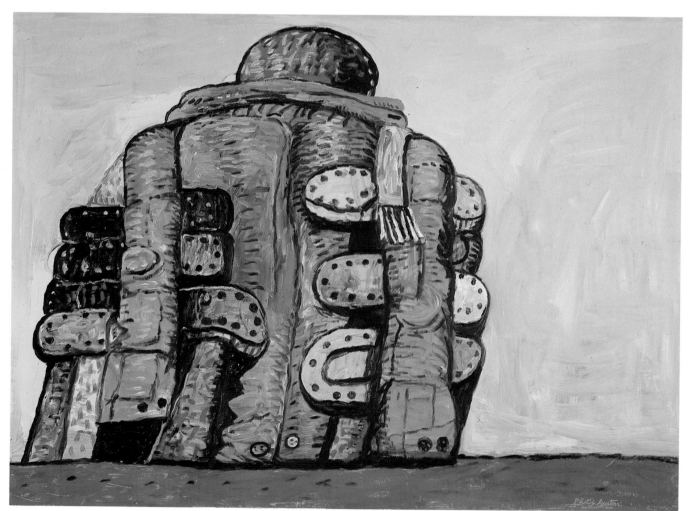

social and aesthetic incongruities upon which contemporary culture is predicated. The fullest expression of those incongruities and of the ambivalence they engender, the grotesque represents the playfulness of the melancholic, the tragic as witnessed by the disabused.

Guston's literary preferences also reflected this affinity for the grotesque. If Beckett's and Kafka's nightmares of alienation were much on his mind during the 1950s, the ironic realism of Nikolai Gogol and Isaac Babel was equally if not more of an inspiration during the 1970s. Guston's paintings *The Coat* and *Back View* (both 1977) recall the central image of Gogol's "The Overcoat," while the alternatively sallow and overripe flesh tones of *Friend—To M.F.* and his other portraits and self-portraits remind one of that story's hero, whose complexion, the author said, "might aptly be described as hemorrhoidal."[60]

In Babel, meanwhile, Guston found someone close to a moral and artistic brother. A Jewish intellectual and radical who during the Russian Revolution rode with the Red Cavalry (an army made up of Cossack horsemen who only a decade earlier had spearheaded the Czarist pogroms), Babel recorded in detail their life of violence as seen by a man at once a part of their community and alone within it—someone who, indeed, might previously have been their victim but who, in a period of upheaval, was caught between their world and the self-contained and antiquated society of the rural Jews. In the fullest and most ambivalent sense, Babel's stories are the chronicle of civil war, the conflict between individual and social identity. Guston, whose mother had described to him the Cossack outrages, saw his own relation to the crude protagonists of his Klan paintings as reflecting a similarly ambivalent and complicitous fascination with violence.

They are self-portraits. I perceive myself as being behind the hood. In the new series of "hoods" my attempt was really not to illustrate, to do pictures of the Ku Klux Klan, as I had done earlier. The idea of evil fascinated me, rather like Isaac Babel who had joined the Cossacks, lived with them and written stories about them. I almost tried to imagine that I was living with the Klan. What would it be like to be evil? To plan, to plot.[61]

Guston also viewed his difficulties with the consensus taste of New York during the late 1960s and early 1970s as analogous to Babel's ambiguous relation to official Soviet culture. Like Babel simultaneously an insider and an outsider, Guston faced ostracism for having challenged an aesthetic orthodoxy that presumed to define what was historically necessary and "right." The problem was that the only promise of creative freedom lay in the willingness to be "wrong." Thus, in 1978 Guston said: "Isaac Babel gave a lovely ironic speech to the Soviet Writers Union. He ended his talk with the following remark. The party and the government have given us everything, but have deprived us of one privilege. A very important privilege, comrades, has been taken away from you. That of writing badly."[62] Though never interested in kitsch or "Bad Painting" as a style, Guston was nonetheless impatient with an academic modernism increasingly protected from risk by *a priori*

56. *Legend*, 1977
Oil on canvas, 69 x 78½ in.
Estate of Philip Guston;
Courtesy David McKee Gallery, New York

56

critical standards, and he fully appreciated the privilege of failure. His gamble, as Peter Schjeldahl noted, was to find "a way to 'fail' hugely."[63]

If these considerations indicate the multiple political connotations of Guston's Klansman, others reveal a more mythic identity. In the 1950s Guston often discussed with Morton Feldman the condition of an artist at the end of a tradition—what it would be like to be "the last painter."[64] This, granted, was an intellectual conceit, but it reflected the feeling of rootlessness and apprehension endemic to the period. By the late 1960s, however, the situation had changed. Modernism as Guston had first known it was exhausted, but the compulsion to paint was as strong as ever. The problem was how to make a painting that was fresh, how to see things as if one had never seen them before. Thus, in conversations with Harold Rosenberg, Guston reversed the terms he had used with Feldman; the issue was no longer what it would be like to be the last painter but what it would be like to be the first. In an interview with Rosenberg, Guston named the inherent contradictions of this inverted version of his original formulation of the problem: "I imagine wanting to paint as a cave man would, when nothing existed before. But at the same time one knows a great deal about the culture of painting. . . . I should like to paint like a man who has never seen a painting, but this man, myself, lives in a world museum. Obviously the painting is not going to be a primitive painting. I hate primitive painting, anyway."[65] The point was, thus, not to pretend to be a naive but to push oneself to an extreme

57

57. *Yellow Light*, 1975
Oil on canvas, 67½ x 96¾ in.
Estate of Philip Guston;
Courtesy David McKee Gallery, New York

58. *Head*, 1975
Oil on canvas, 69¼ x 74¼ in.
Estate of Philip Guston

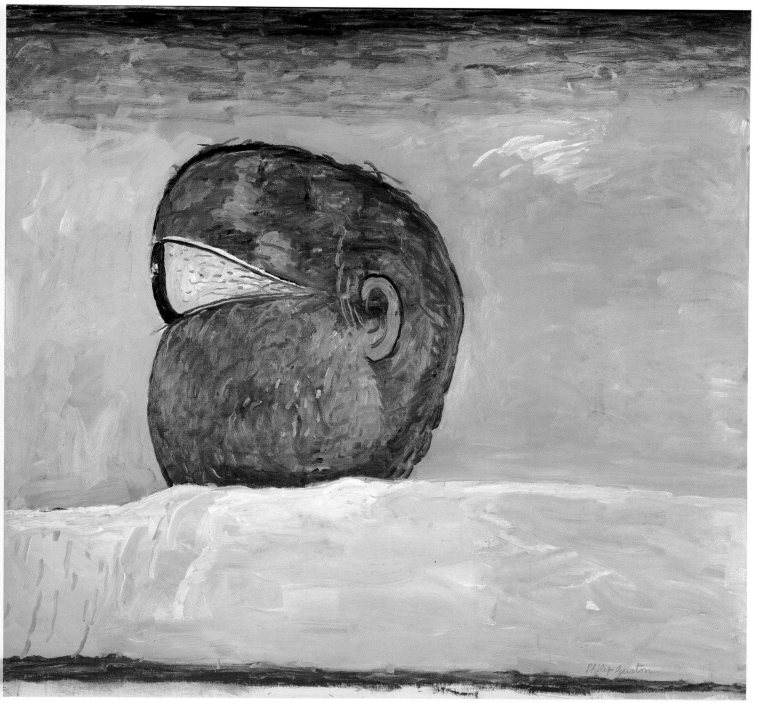

58

where culture could no longer wholly dictate one's response to unanticipated new possibilities. "In this condition of not knowing," Guston explained, "you arrive not at a state of ignorance but at a state of knowing only the thing you know at the time—and that is what is concrete."[66] In that state of "not knowing" the artist became what Rosenberg, citing Stéphane Mallarmé's definition of a poet, called "un civilisé édénique," a civilized first man.[67]

At the time of this exchange Guston was working on his last abstractions, and referring to the quasi-figurative forms that emerge within them, he made allusion to the legend of the Golem. In a sense the diabolical twin of Mallarmé's civilized savage, the Golem is a metaphor for creation that is central to understanding Guston's work of the 1970s. Sculpted out of common red clay, the Golem was a human effigy said to have been made by Cabalistic rabbis at various times from the Middle Ages through the nineteenth century. Considered a reenactment of the creation of Adam, the fabrication of the Golem was the work of pious men, but as a man-made replica of a divine creation, it was necessarily imperfect. In a culture that prohibited graven images as a usurpation of God's power to make living things, the Golem thus represented both an act of faith and an act of hubris.[68]

In symbolic terms, Guston's reintroduction of imagery into his work constituted a similar defiance of the formalist prohibition against figuration. Guston had, of course, consistently sought to demystify the idea of pure painting. In 1954 Morton Feldman wrote: "Philip Guston took away the initial morality of the medium. 'What am I working with?' he said. 'It's only colored dirt.'"[69] But the problem was not so much that of what right he had to depict the human form, but whether it was possible to conjure out of "colored dirt," the mudlike red and gray pigments of his work of the 1950s, an image with a presence and actuality equal to that of abstract painting. For Guston, the challenge was to make a painting that was not only visually compelling but vital. Even before his imagery had become plainly figurative, Guston would say: "The strongest feeling I have, and it's confirmed the next day or the following week, is that when I leave the studio, I have left there a 'person,' or something that is a thing, an organic thing that can lead its own life, that doesn't need me anymore."[70] However, the story of the Golem, like that of Frankenstein or the Sorcerer's Apprentice, is also a parable of the price paid for such presumption. A reflection of man's dual nature, the Golem is at once an objectification of his power and a manifestation of his corruption. Guston's prolonged struggle with figuration was conditioned by an awareness of just this duality, and the release of his late work came only with the revelation that the full realization of his creative freedom required acknowledging the monstrosity of his own imagination. Thus, Guston said in 1978:

I know that I started similar things in the past, 20 to 25 years ago and would scrape them out. . . . Well, then I would subsequently ask myself, "Why did I scrape them out?" Well, I wasn't ready to accept it, that's the only answer. That leads me to another point: it doesn't occur to many viewers that the artist often has difficulty accepting the painting himself.

59. *Above and Below*, 1975
Oil on canvas, 67¼ x 72¾ in.
Estate of Philip Guston

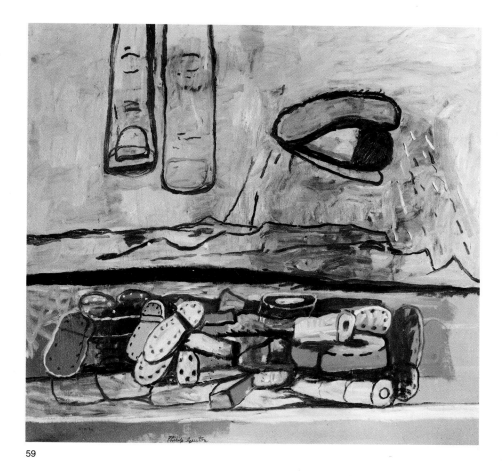

59

You can't assume that I gloried in it, or celebrated it. I didn't. I am a night painter, so when I come into the studio the next morning the delirium is over. I come into the studio very fearfully, I creep in to see what happened the night before. And the feeling is one of, "My God, did I do *that*?" That's the only measure I have. The kind of shaking, trembling of . . . That's me? I did that?"[71]

Cartoon character, brutal clown in an absurd morality play, or Klansman and symbol of an America at war with itself, the hooded figure whose appearance inaugurates the last and most important phase of Guston's work is more than anything the Golem, whose proud, bewildered, and finally horrified progenitor is forced to recognize in his appalling surrogate the image of his own impurity and overwhelming humanity.

Although a major event, by most standards Guston's 1970 exhibition at Marlborough was not a success. Scarcely any work was sold, and once the initial furor had died down the conventional wisdom became that Guston had taken a detour from which he was not likely to return. Sensitive to what he felt was a lack of support from his dealer, Guston quit Marlborough in 1972 and went back to teaching as a professor at Boston University, where he remained from 1973 to 1978. In 1974 he joined the David McKee Gallery, a small out-of-the-way exhibition space newly founded by a former staff member at Marlborough, who made a strong and lasting commitment to Guston's work. Although he

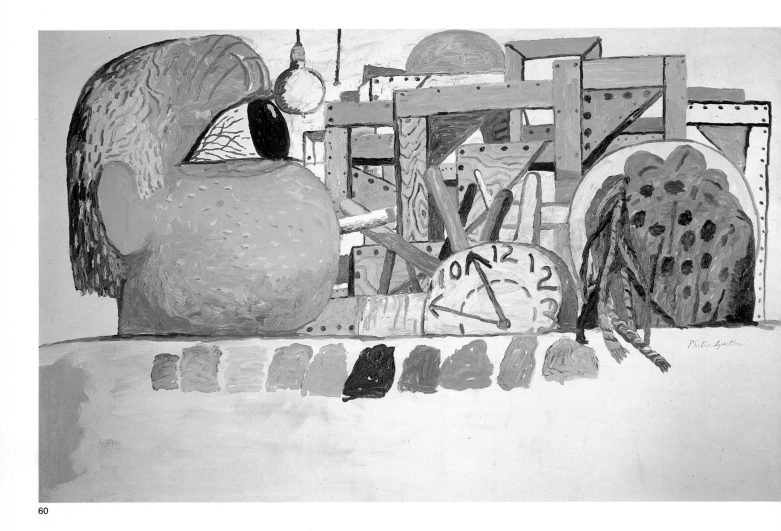

continued to show with McKee, each time with increasing impact, in a basic psychological sense Guston had left behind "the great New York art party," as the critic Edward F. Fry would later write.[72] Commuting to Boston once a month and visiting Manhattan only infrequently to see shows, Guston more than ever made his life in Woodstock and the life he was creating in his studio the center of his world. Henceforth, the circle of friends who came to see him there and with whom he engaged in an active correspondence consisted, for the most part, not of painters but of writers such as novelists Philip Roth and Ross Feld and poets Bill Berkson, Clark Coolidge, William Corbett, and Anne Waldman. Guston maintained only intermittent contact with members of his own generation, though he did write to old colleagues such as Stephen Greene and James Brooks and carried on long telephone conversations with Willem de Kooning, who lived in a similar kind of voluntary isolation on Long Island.

During this last and most productive decade of his life Guston often quoted a remark made to him by John Cage in the 1950s: "When you are working," Cage said, "everybody is in your studio— the past, your friends, the art world, and above all your own ideas—all are there. But as you continue painting, they start leaving, one by one, and you are left completely alone. Then, if you are

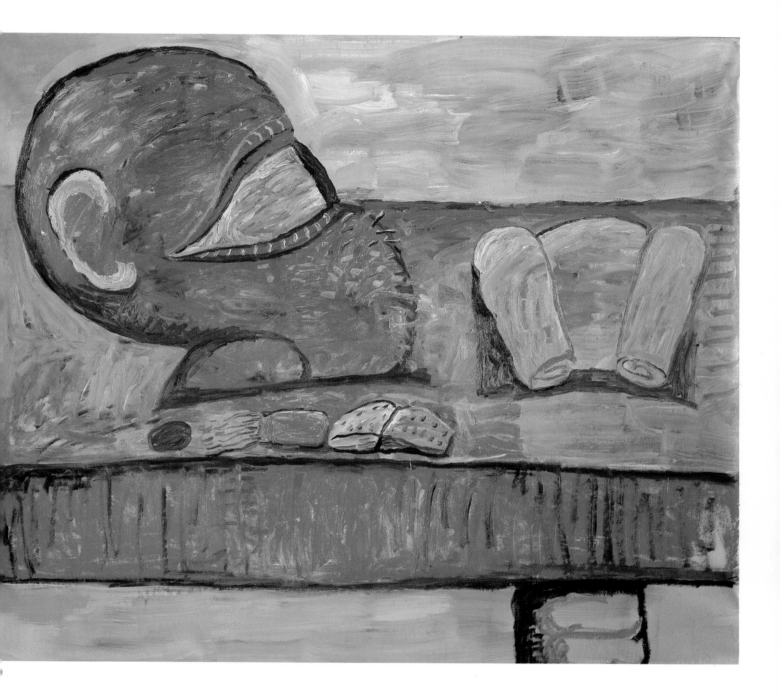

60. *Studio Landscape*, 1975
Oil on canvas, 67 x 104 in.
Estate of Philip Guston;
Courtesy David McKee Gallery, New York

61. *Head and Table*, 1975
Oil on canvas, 67 x 80 in.
Estate of Philip Guston;
Courtesy David McKee Gallery, New York

lucky, even you leave."[73] Though Guston was alone more than ever before after 1970, his work, rather than emptying out, was suddenly crowded with images from his past and with intrusive specters of the world outside his studio. Unable to escape, Guston resolved to confront them. With that confrontation as the subject of his art, his painting became a struggle for freedom within the context of his isolation and of his heritage. De Kooning, one of the few painters to come to his defense in 1970, understood this.

I think I like de Kooning best, he said, "You know, Philip, what your real subject is? It is freedom."

The other important thing that de Kooning said to me, which I think is wonderful, was this: he said, "Well now you are on your own! You've paid off all your debts!"... I think I am.... I don't look at my pantheon of the masters of the last 500 years of European painting as I used to. Or when I do I see them differently.[74]

To be sure, Guston's late paintings are replete with art historical emblems, but they are indeed seen differently. The pointing hand sheathed in a Mickey Mouse glove, which appears often in his work, is a sly variation on the Renaissance device of including in each painting a figure whose gesture directs attention to the central drama—except, of course, that in Guston's case the hand points toward chaos rather than to any scripted order. Indeed, knowing the origins of Guston's imagery is in some measure central to understanding his work, and no major artist of recent memory has raised the issue of the role of iconography in contemporary painting in as significant and problematic a fashion. Certainly, Pop art and the new figurative painting of the 1980s incorporate myriad iconographic references, but the strategies of appropriation employed by the Pop painters or the Neo-Expressionists tend to emphasize the disjunction between the images they borrow as well as the distance of the artist and the viewer from the traditional sources from which they quote. Meanwhile, Guston was concerned lest his paintings be read simply as iconographic mystery stories. Quoting Paul Valéry, he said of his new paintings as he had of his earlier work that he did not want them to "disappear into meaning."[75] But rather than dissociate himself from the imagery to which he laid claim, Guston sought to digest it wholly in such a way that it would reemerge organically integrated into his own sensibility and organically changed in its import. What he sought was not an ironic detachment from but an even greater intimacy with the ideas and forms that haunted him. Thus, by the end of the 1960s, having fully assimilated both the art historical past and his own, Guston no longer had to turn to outside sources to confirm his creative impulses. Rather, images both old and new seemed to flow from and through him in an ever-accelerating torrent.

62, 63 The two versions of *Painter's Forms* (1972 and 1978) depict this phenomenon. In the first, an almost naturalistic head spews from its open mouth a stream of objects: shoes, a bottle, and other rudimentary forms. Unlike Magritte or Johns, whose elegant linguistic puzzles confound the distinction between verbal and pictorial naming, Guston was not toying with codes of representa-

62. *Painter's Forms*, 1972
Oil on Masonite, 48 x 60 in.
Estate of Philip Guston;
Courtesy David McKee Gallery, New York

63. *Painter's Forms II*, 1978
Oil on canvas, 75 x 108 in.
Estate of Philip Guston;
Courtesy David McKee Gallery, New York

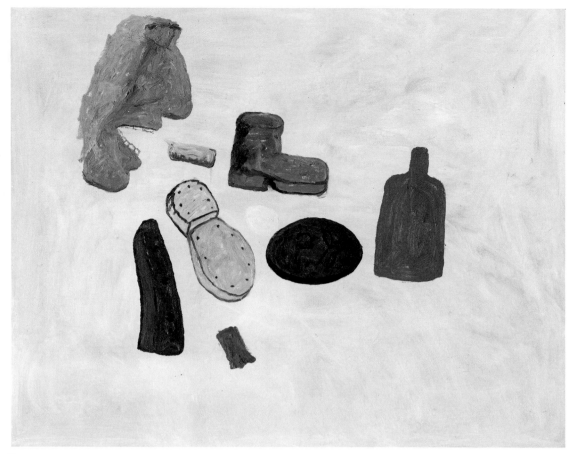

62

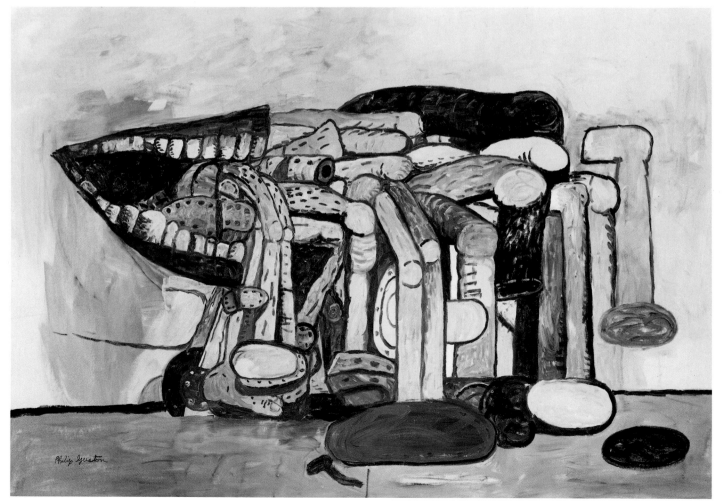

63

tion. On the contrary, he painted as if speaking directly in the language of "things." Here again, Guston felt a fellowship with Babel: "I like Babel too because he deals totally with fact. There can be nothing more startling than a simple statement of fact, in a certain form. As Babel says, there's no iron that can enter the heart like a period in the right place."[76] Chosen from the everyday objects that surrounded him, the things that filled Guston's work were painted on small panels as "statements of fact" before being incorporated into larger works, where they became the nouns, verbs, and punctuation of his stories.

63    In the reprise of *Painter's Forms* a chaotic tangle of legs issues forth from a huge human maw, and the easy utterance of the first version gives way to a gagging, involuntary purging of images. Once abstract and almost classical, Guston's work was now compulsively visceral. Though he had often said that art was a product of the mind, Guston had, in fact, become a painter of the body, a body at the mercy of the other alien bodies that seemed to inhabit it. Thus, despite his concern for facts and the apparent realism of his new imagery, Guston's imaginative world was subject to constant, urgent metamorphosis, and the state of any image represented but one possible incarnation of its basic form. For example, the short downward stroke frequently used in his "pure" drawings as a spatial inflection became in his new paintings the sign for windows in the blocky buildings of a city skyline. Two such blocks paired together became the symbol of an open book, with the same rank of short marks used to indicate the letters or words of an archetypal language. Bent back upon its spine, this book might in turn be transformed into a mass of hair framing a face or into two inverted feet in nail-studded shoes, a symbol of the 1940s thus reemerging organically in the work of the 1970s. Not only did Guston's initially limited inventory of objects engender new images, revealing the essential mutability of a seemingly stable world, but paint itself might also dictate the introduction or transformation of forms. As Thomas B. Hess noted: ". . . wanting a complex passage of grays and blacks in one area, [Guston] put in some frayed ropes bundled into a scourge. In other words, where Guston's clue images used to be masked by paint, now his equally important pictorial intentions—his delight in virtuoso handling, in translucencies and viscosities—are masked by narrative."[77]

Meanwhile, the spatial dynamics of Guston's paintings are similarly elemental and organic in their permutations. Usually the scene is set by a simple horizontal division of the canvas, each half dominated by a single hue—most often blue or black opposite red or roseate grays—and the resulting space is almost closed off by the density of pigment and color. Although Guston's paintings, like Rothko's late work, are frontal and expansive in design, their atmosphere is, by contrast, heavy and airless. Emphatically earthbound, they instill claustrophobia rather than intimate transcendence. Their topography consists of barren embankments that press forward like landslides against the picture plane, encroaching upon the viewer's space while seeming to forbid any escape for the figures that languish half-embedded in them. Thus, Guston's work recalls the somber, denuded landscapes of Goya's Black Paintings.[78]

64. *Book*, 1968
Acrylic on board, 16 x 19 in.
Estate of Philip Guston;
Courtesy David McKee Gallery, New York

65. *Future*, 1978
Oil on canvas, 80 x 107 in.
Estate of Philip Guston

64

66

65

As in Goya's work, the primary dramatic tension in Guston's paintings is this overwhelming metaphorical weight against which struggle the restless creatures of the artist's imagination, while the primary formal tension is between the physical weight of paint and the anxious activity of the artist's brushwork. In no work are these tensions clearer than in *Moon* (1979), in which a painter works furiously, sunk in a gap between a huge mud wall crawling with bugs and a gigantic still life of artist's materials. Though autobiographical in detail—behind his Woodstock studio was a ravine where Guston jettisoned his failed paintings—*Moon* has a larger meaning hinted at by the artist's remark that paint was "only colored dirt." Trapped between the mounds of pigment on the palette in front of him and the earthen mound at his back, Guston had translated into his own terms the equation of mortality—from dust to dust. In *Ravine* (1979), however, all that remains is the embankment and the bugs. If *Moon* is an allegory of the vanity of human effort, *Ravine* is a bleak premonition of the obliteration of all living things, save the insects that will inherit the planet.

66

67

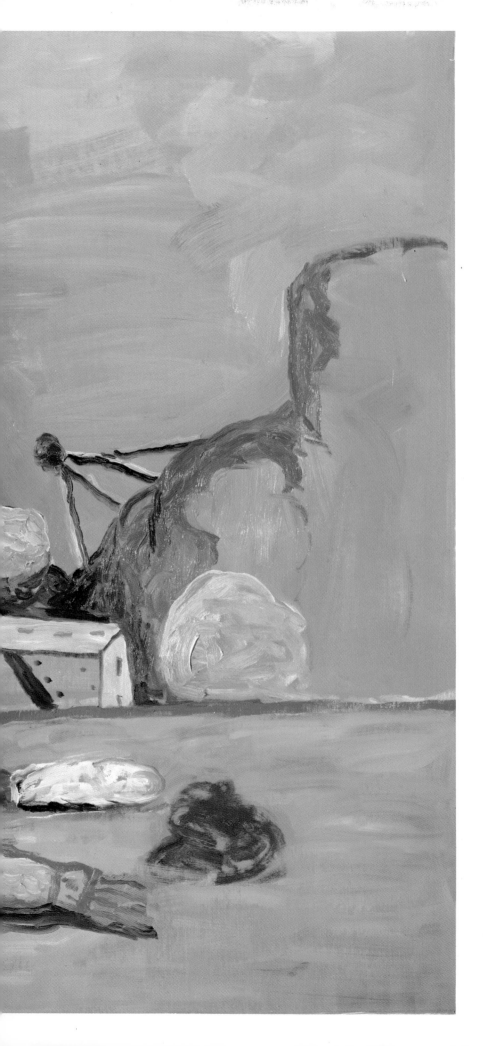

66. *Moon*, 1979
Oil on canvas, 69 x 80 in.
Philip Johnson

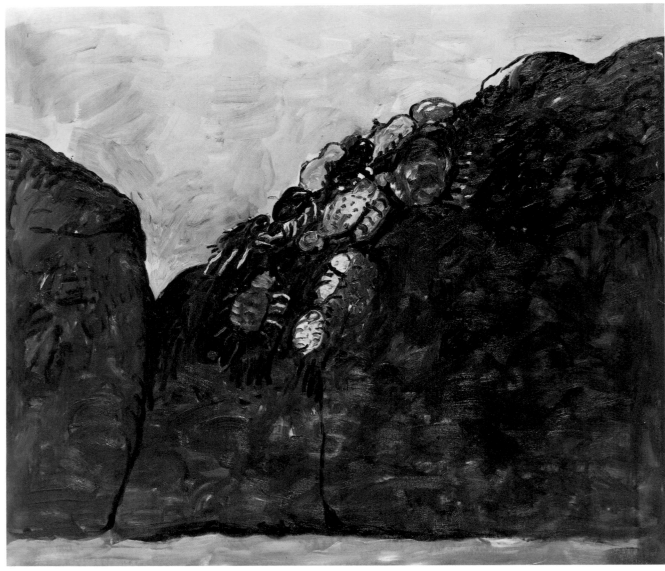

67

More than nuclear holocaust, however, the landscape in *Ravine* suggests the aftermath of a flood. As early as 1943 Guston had 68 done drawings of survival-at-sea exercises for *Fortune* magazine that, for all their documentary realism, clearly prefigure such works of the late 1970s as the triptych composed of *Red Sea*, *The Swell*, 70 and *Blue Light*; the three versions of *Deluge*; and numerous paintings in which the flood has become the archetypal symbol of the apocalypse.[79] In some of these late paintings water wells up undramatically but inexorably, in others it is a riptide of beautiful coiling waves that carry off a host of helplessly bobbing heads amidst the flotsam and jetsam of the studio. For all the alarm apparent in their open, staring eyes, however, the victims of this catastrophe seem more than anything trapped by their own passivity. Surprised by a force if not beyond their comprehension then beyond their powers of resistance, they constitute a community accidentally united by a shared fate—a fate determined as much by their perplexed resignation as by the physical dangers that threaten them.

67. *Ravine*, 1979
Oil on canvas, 68 x 80 in.
Estate of Philip Guston;
Courtesy David McKee Gallery, New York

68. *Flotation Exercise* (from series done for
*Fortune* magazine), c. 1943
Pencil and charcoal on paper, 23⅞ x 29¼ in.
Estate of Philip Guston;
Courtesy David McKee Gallery, New York

69. *Rain*, 1975
Ink on paper, 19 x 24 in.
The Edward R. Broida Trust, Los Angeles

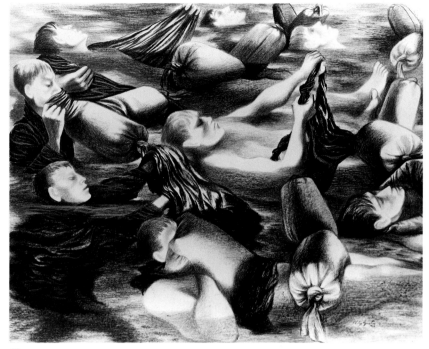

68

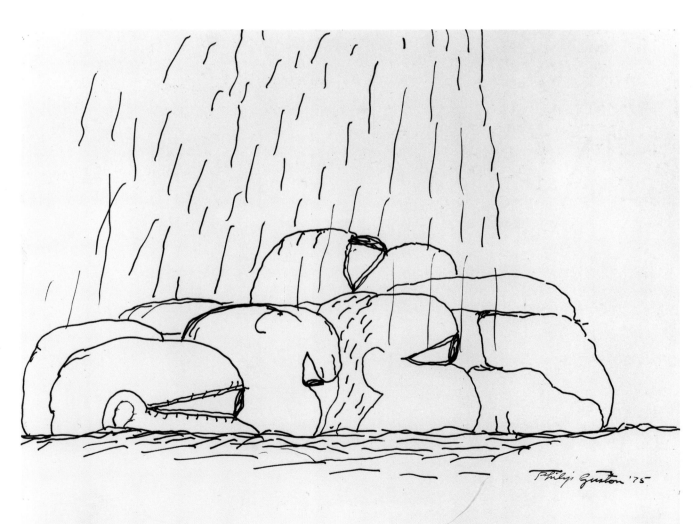

69

70. *Deluge III*, 1979
Oil on canvas, 68 x 81½ in.
Estate of Philip Guston;
Courtesy David McKee Gallery, New York

71. *Group in Sea*, 1979
Oil on canvas, 68 x 88½ in.
Estate of Philip Guston;
Courtesy David McKee Gallery, New York

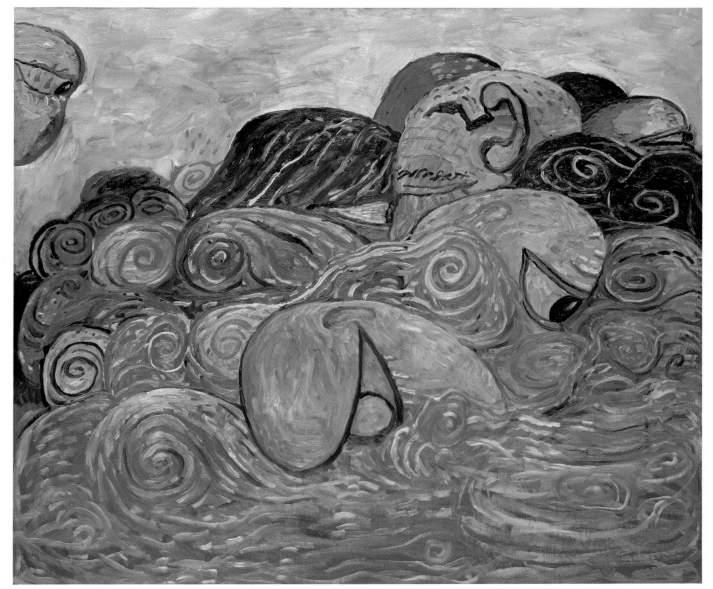

70

If these paintings portray a dank, sometimes turbulent purgatory,
73 *Pit* (1976) is a hallucinatory descent into hell. In a related earlier
72 painting, *Cellar* (1970), a heap of legs and other objects has been
discarded down an ominous hatch, as if it were evidence of a crime
hastily but unsuccessfully concealed. In *Pit* a single down-turned
head and an even more morbid jumble of legs have been cast into a
huge chasm, which widens beneath the crust of a rock-strewn
plain. Above this chasm burn two fires, and between them is
propped a ghostly painting of a blood red rain. Combining these

72

72. *Cellar*, 1970
Oil on canvas, 78 x 110 in.
Mr. and Mrs. Graham Gund

73. *Pit*, 1976
Oil on canvas, 75 x 116 in.
Australian National Gallery, Canberra

74. *Ancient Wall*, 1976
Oil on canvas, 80 x 93½ in.
Estate of Philip Guston;
Courtesy David McKee Gallery, New York

symbols of desolation with the fractured arc of the landscape, *Pit* recalls images of the Last Judgment by Italian masters such as Giotto and Nardo di Cione, where the hierarchic levels of the universe are arranged in balconylike tiers, the lowest being Inferno, a vast crack opening into the earth. Like these Renaissance paintings, *Pit* is at once visionary and graphic, fantastic and all too real.

Max Beckmann once wrote: "Oh, this infinite space! We must constantly fill up the foreground with junk so that we do not have to look at its frightening depth. What would we poor people do, if we could not always come up with some idea, like country, love, art and religion, with which we can again and again cover up that dark hole."[80] Although Guston sometimes painted the "dark hole" that threatened to engulf him, the foreground of many of his pictures, like that of Beckmann's, was occupied by a barrier of "junk" partially obscuring that emptiness. Nonetheless, Guston's enigmatic still lifes seem closer to those of de Chirico than to the impacted accumulations of Beckmann, and like de Chirico he used them to deliberately blur the boundary between intimate and open space—between the small monuments on the table top and the monoliths on the horizon. But where de Chirico's cryptic juxta-

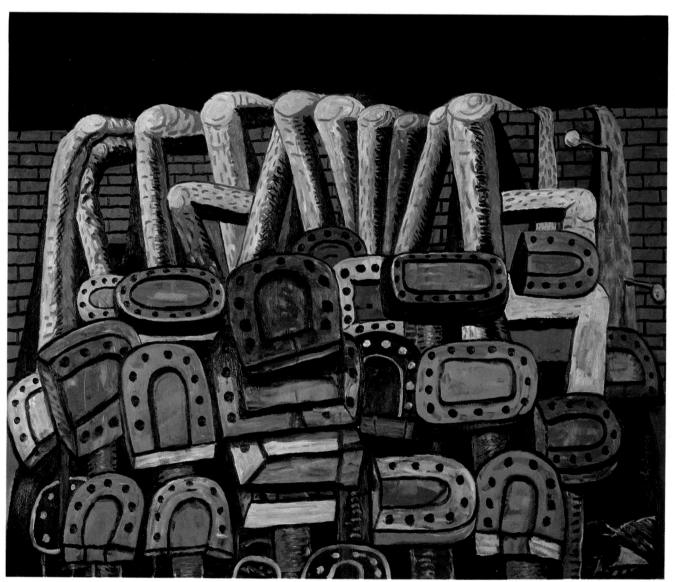

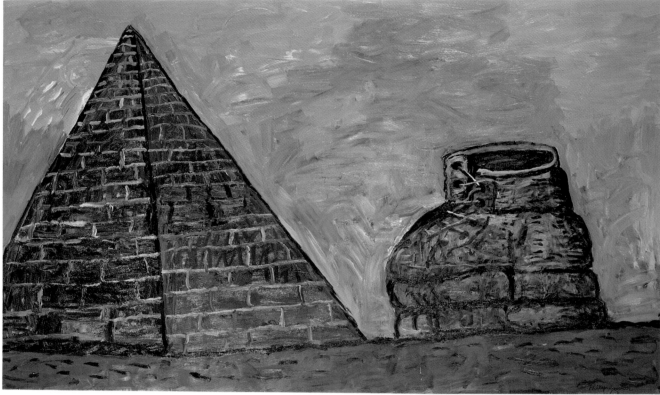

75

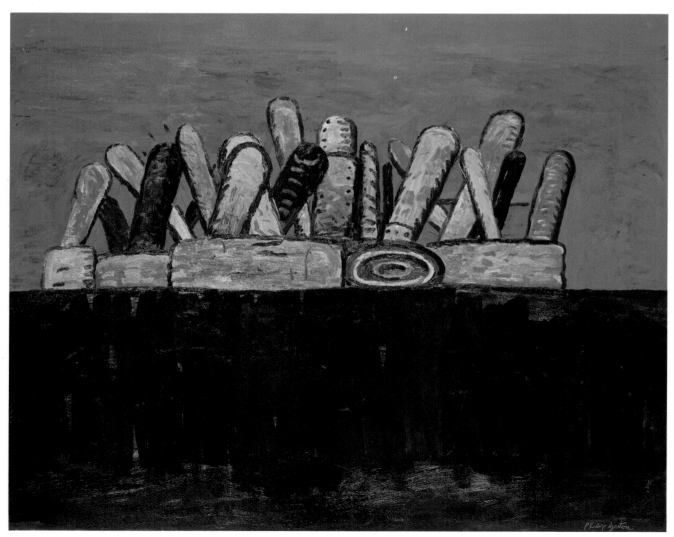

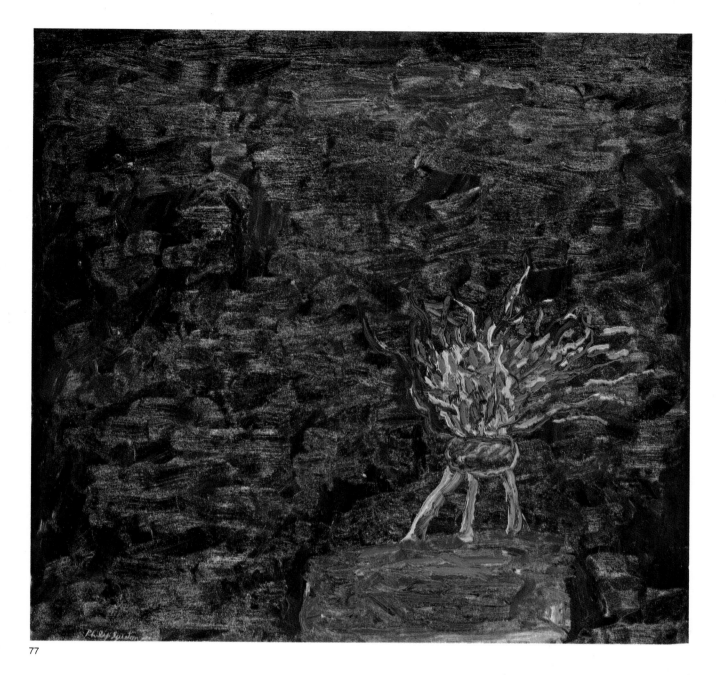

77

75. *Pyramid and Shoe*, 1977
Oil on canvas, 68 x 116 in.
Renee and David McKee, New York

76. *Red Sky*, 1978
Oil on canvas, 82 x 105½ in.
Paula and Gerald Lennard

77. *Flame*, 1979
Oil on canvas, 69 x 74 in.
Estate of Philip Guston;
Courtesy David McKee Gallery, New York

positions of objects are bathed in the brilliant, dematerializing dusk of childhood dreams, Guston's forms, starkly lit, are the ponderous phantasms of an adult insomniac. Moreover, to a greater degree than de Chirico, Guston confused not only location but scale. In *Pyramid and Shoe* (1977) the two objects named meet literally on an equal footing. The latter being no less rooted in place than the former, it represents the individual and the ephemeral confronting the anonymous, the collective, and the eternal. By 1978 all relative indications of scale and all remaining distinctions between interior and exterior space had disappeared. In *Red Sky* huge cans of paint stuffed with brushes sit on a rich bed of black against a dark red sky—compressed into massive wholes, the forms lose their identity. Things no longer occupy landscape, they have become landscape. An equal sense of mystery was achieved by isolating images and enlarging the space around them. In *Kettle* a bulbous teapot steams out into the void, while in *Flame* a brazier

75

76

77

78. *The Magnet*, 1975
Oil on canvas, 67½ x 80½ in.
Saatchi Collection, London

79. *Frame*, 1976
Oil on canvas, 74 x 116 in.
Saatchi Collection, London

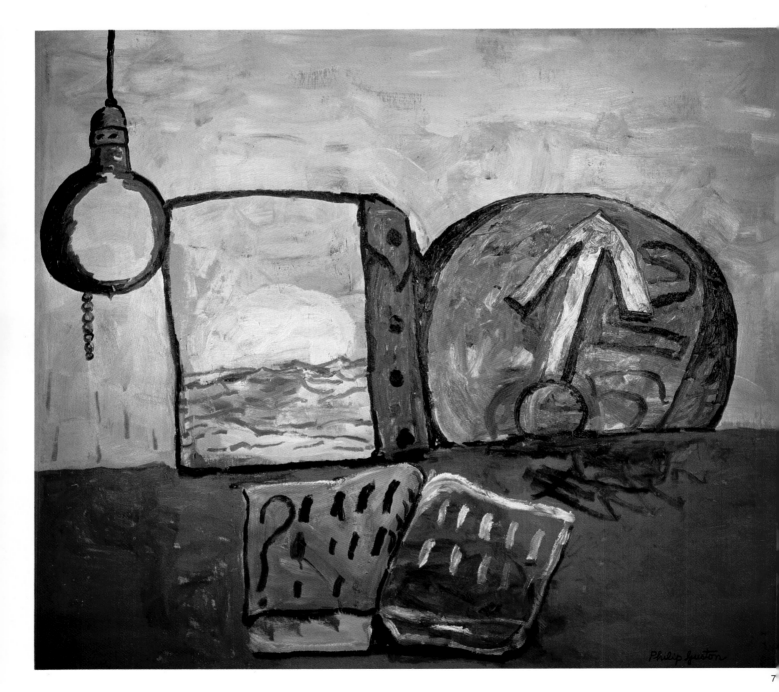

78

burns against the darkness. These pictures, and others such as *The* 78
*Magnet* and *Frame*, have a simplicity and grandeur unique in con- 79
temporary still-life painting. In them traditional genres are conflated,
and commonplace objects, assuming an almost animate presence,
enjoy the same status as the figure in a heroic Baroque composition.

At the center of this alternatively dense and fragmented universe
is the artist himself. In some paintings, such as *Moon*, he is pitted

against the intractability of matter, but more often he is at the
mercy of his own inertia. In *Painting, Smoking, Eating*, the artist, a
huge staring eye encased in fleshy, ill-shaven cheeks, lies on his bed
like an alert but still unraised Lazarus. In *Legend* he dreams
on his bed, his room filled with images from his work, recalling the
caption of one of Goya's *Caprichos*: "The sleep of reason produces
monsters." Influenced by his own bouts of depression, Guston thus
portrayed the lethargy and melancholia that constitute the dark
side of the painter's saturnine but protean nature.[81] The whips,
bottles, and cigarette butts that litter his studio in *Bad Habits*,

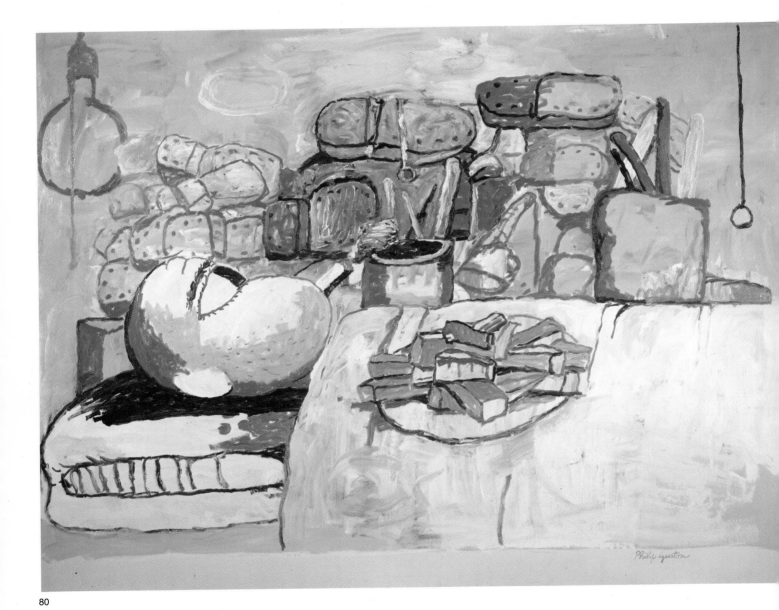

80

80. *Painting, Smoking, Eating*, 1973
Oil on canvas, 77½ x 103½ in.
Stedelijk Museum, Amsterdam

81. *Bad Habits*, 1970
Oil on canvas, 73 x 78 in.
Australian National Gallery, Canberra

*Febrile*, and other paintings are the stimulants upon which the artist depends for release from this catatonic distress and the emblems of his often masochistic vocation. Painting itself is both a gesture of hope and another "bad habit," a routine of heightened sensation and self-punishment that promises escape from anxiety yet all too frequently only exacerbates it.

The reality that Guston described, however, was not one of total self-absorption. Though the Klansman disappears after 1973—that hooded figure having been both a form of self-portraiture and an image of the brutal legions that threaten the peace—the two halves

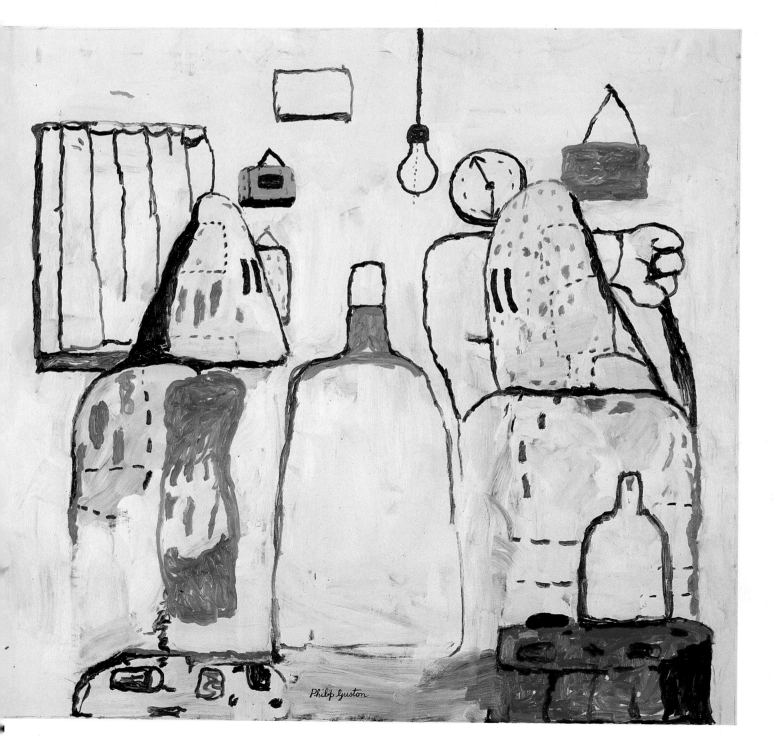

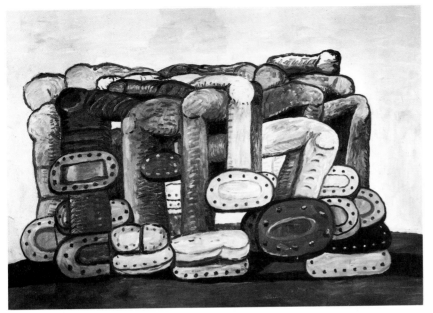

82

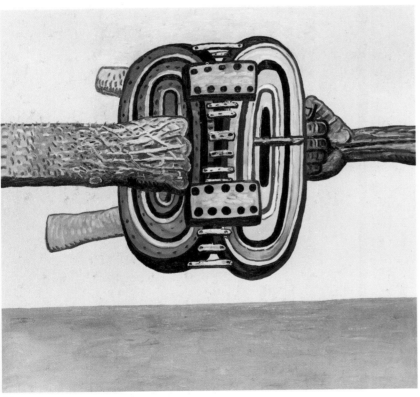

83

of his originally composite identity remain and confront each other as separate entities. On the one hand is the lima-bean–shaped head of the painter, on the other the spindly legs and hobnailed boots that silt up around the edge of his island-bed in *Painting,* 45 *Smoking, Eating,* invade the studio like a mob in *Green Rug,* 82 or dominate the room like a hecatomb in *Monument.* A related image of the late 1970s is that of thick, hairy arms brandishing 11, 10 the garbage-top shields first seen in *Martial Memory* and *The* 84 *Gladiators.* In *The Street* menace becomes warfare and a cluster of

these arms clashes with a phalanx of stampeding legs, while in *Hinged* their shields are quite literally locked in the hopeless embrace of combat. 83

Clement Greenberg once remarked that, with the exception of Arshile Gorky, Guston more than any painter of his generation personified the romantic idea of the artist.[82] Yet if Guston's late paintings continue to reflect that vision, they also demystify the artist's alienation and root it in the social realm. The truncated figures that overrun his paintings affirm the implacable nature of the public realities that impinge upon even the most private of existences, while his queasy but unflinching self-portraits remove the cosmetic veil that obscures our view of the painter's world. Together they belie the hope of all but the most conditional transcendence of life through art.

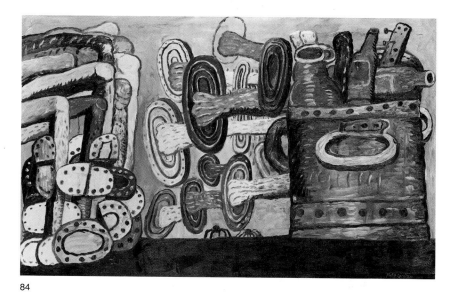

84

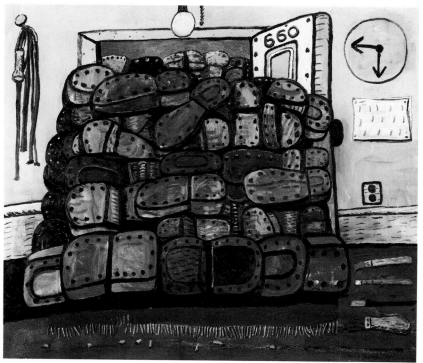

85

82. *Monument*, 1976
Oil on canvas, 80 x 110 in.
Estate of Philip Guston;
Courtesy David McKee Gallery, New York

83. *Hinged*, 1978
Oil on canvas, 68½ x 73½ in.
Estate of Philip Guston;
Courtesy David McKee Gallery, New York

84. *The Street*, 1977
Oil on canvas, 69 x 110¾ in.
The Metropolitan Museum of Art, New York;
Lila Acheson Wallace and Mr. and Mrs.
Andrew Sane Gifts; Gifts of George A. Hearn,
on exchange, and Arthur Hoppock Hearn
Fund, 1983

85. *The Door*, 1976
Oil on canvas, 81 x 96 in.
Martin Z. Margulies, Miami

86

86. *Southern*, 1976
Ink on paper, 19 x 24 in.
Estate of Philip Guston;
Courtesy David McKee Gallery, New York

87. *Head*, 1977
Oil on canvas, 69½ x 85 in.
Estate of Philip Guston;
Courtesy David McKee Gallery, New York

88. *Tears*, 1977
Oil on canvas, 68 x 114½ in.
Estate of Philip Guston;
Courtesy David McKee Gallery, New York

89. *Source*, 1976
Oil on canvas, 76 x 117 in.
The Edward R. Broida Trust, Los Angeles

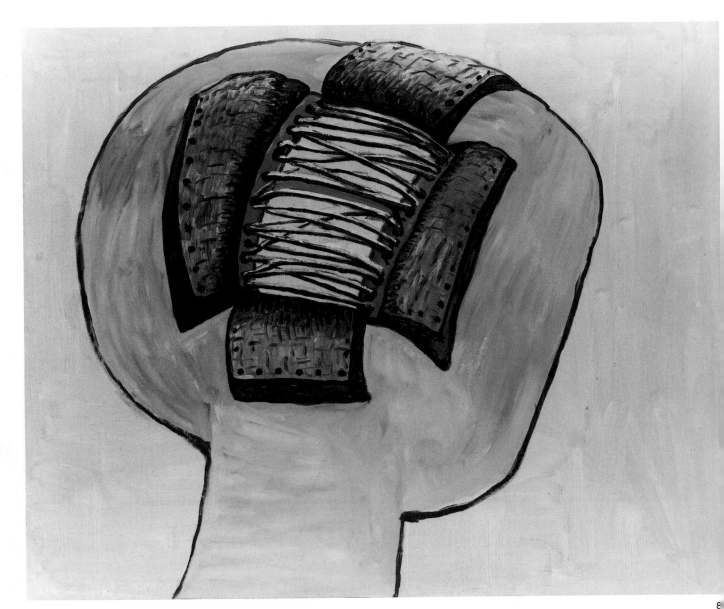

84

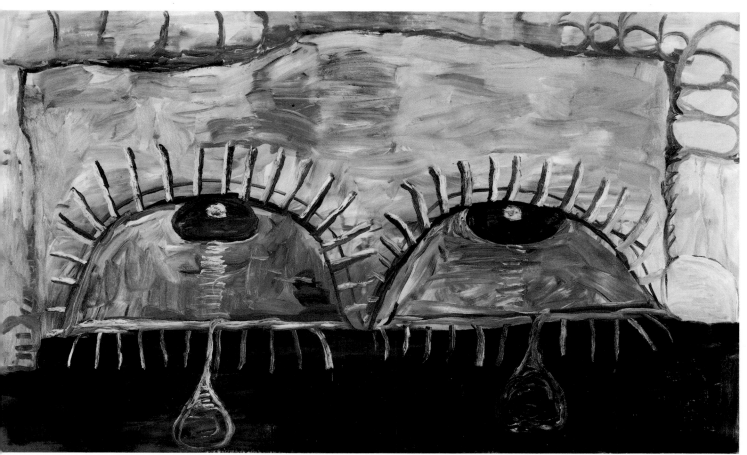

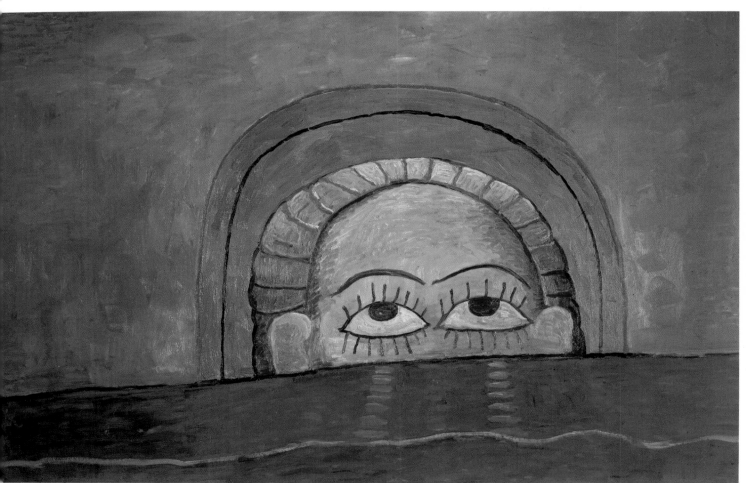

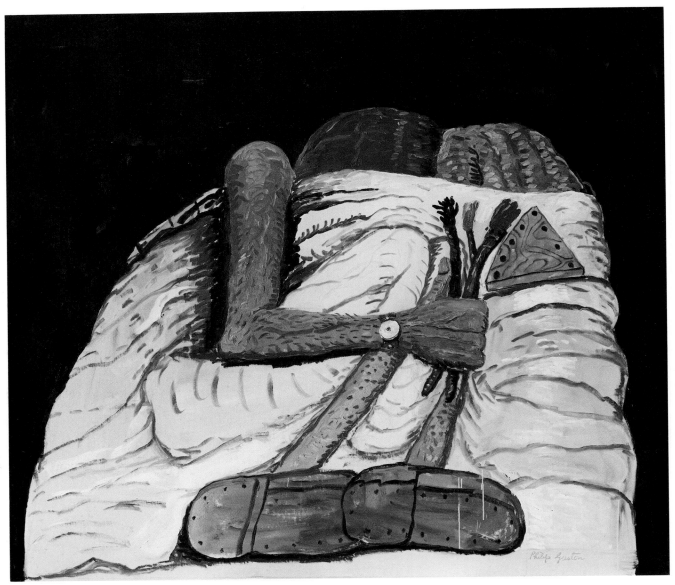

90

90. *Couple in Bed*, 1977
Oil on canvas, 81 x 94½ in.
Estate of Philip Guston;
Courtesy David McKee Gallery, New York

91. *Web*, 1975
Ink on paper, 19 x 24 in.
Mr. and Mrs. Harry W. Anderson

92. *Melancholy Studio*, 1977
Oil on canvas, 68 x 108 in.
Estate of Philip Guston;
Courtesy David McKee Gallery, New York

91

92

By 1976, when Guston painted *The Door*, the calendar, clock, 85 cigarettes, and crowd of feet that fill the picture had taken on a more personal and urgent meaning as symbols of time. That year Guston was hospitalized for exhaustion, and in 1977 his wife, Musa, suffered a stroke. But, as he wrote to Bill Berkson, painting was his only salvation, and despite the strain he continued to work at an ever-accelerating pace.[83] Taking as their subject the very precariousness of his situation, Guston's last paintings are informed by an increasing coincidence of the autobiographical and the archetypal. Often painful to look at, many of these paintings were not shown until after his death.

From 1975 on, portraits of Musa or the emblematic image of a woman are frequent. In *Source* she appears as a serene and un- 89 blinking presence rising above a deep but calm sea. In *Tears* (1977) 88 a woman's head is framed by a prosceniumlike curtain of hair, eyes wide as in *Source* but this time weeping. The starkest of these images, *Head*, shows the back of a shaven skull painted in delicate 87 washes, in the middle of which heavy impasto lines describe a harsh, sutured wound. Other paintings such as *Ladder* and *Melan-* 93, 92 *choly Studio* focus on the uneasy intimacy of a couple; in the spare but luminous *Night* a man and a woman huddle together, riding 94 the waves of an utterly black sea. One must look to Rembrandt to find a comparably moving or candid portrait of a marriage lived in the shadow of age and loss.

93

93. *Ladder*, 1978
Oil on canvas, 70 x 108 in.
The Edward R. Broida Trust, Los Angeles

94. *Night*, 1977
Oil on canvas, 68 x 120¼ in.
Estate of Philip Guston;
Courtesy David McKee Gallery, New York

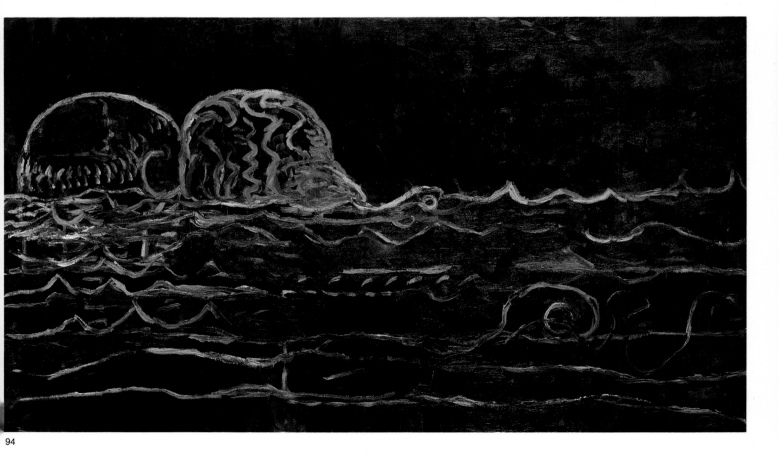

94

95. *Untitled*, 1980
Ink on paper, 18¾ x 26¼ in.
Estate of Philip Guston;
Courtesy David McKee Gallery, New York

96. *Untitled*, 1980
Acrylic on board, 20 x 30 in.
Estate of Philip Guston;
Courtesy David McKee Gallery, New York

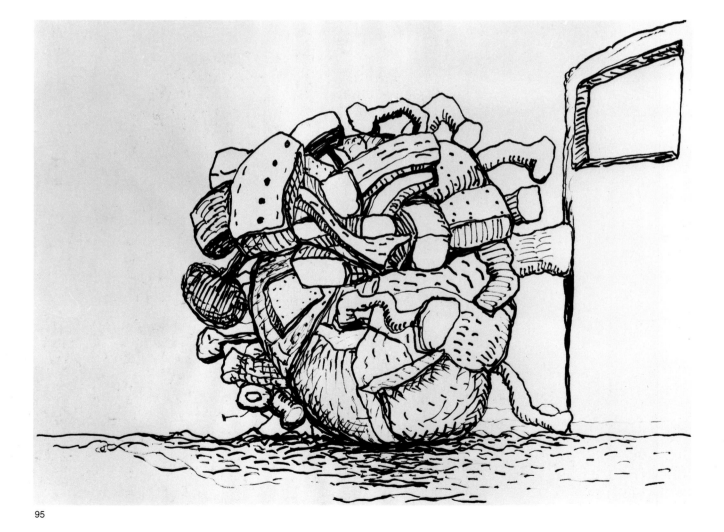

95

In 1979 Guston suffered a near-fatal heart attack. Prevented from working on large-scale pictures during the last year of his life, he nonetheless produced numerous drawings and small paintings, many of which contain allusions to his own mortality. Some feature his signature on tombstonelike blocks; others depict ruins and fragments of imagery scattered over desolate hillsides. Yet Guston's final works are neither lugubrious nor resigned. On the contrary, they evidence an undiminished artistic confidence and determination. Among his last works two in particular seem to express the complex nature of Guston's awareness of his own impending death. In one a massive ball lies motionless and riddled 95 with broken forms as if, having come to rest, it incorporated all that had once stood in its path. It is a symbol of both wholeness and finality. In the second, a similar ball patched together by 96 makeshift plates reveals itself to be the head of a man with one vast eye staring straight out at the incline ahead of it. When Guston died on June 7, 1980, it was this rough persona that confronted the absolute certainty of the end, a Sisyphean presence undaunted by the impossibility of going farther.

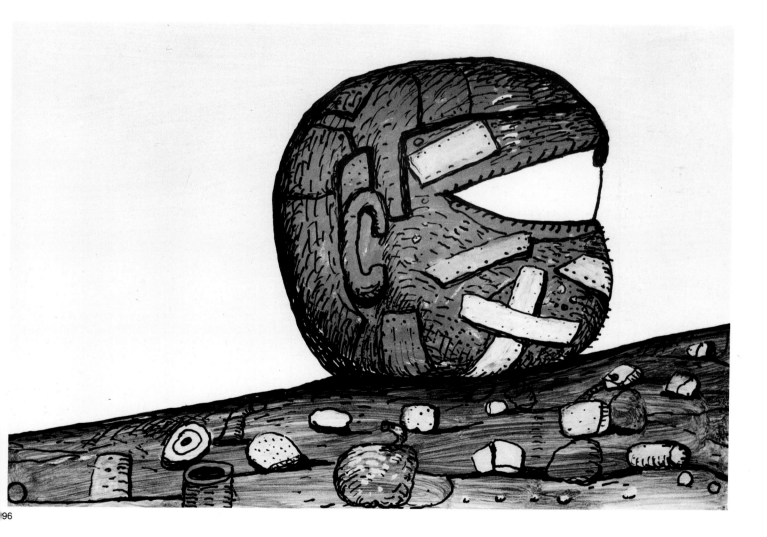

96

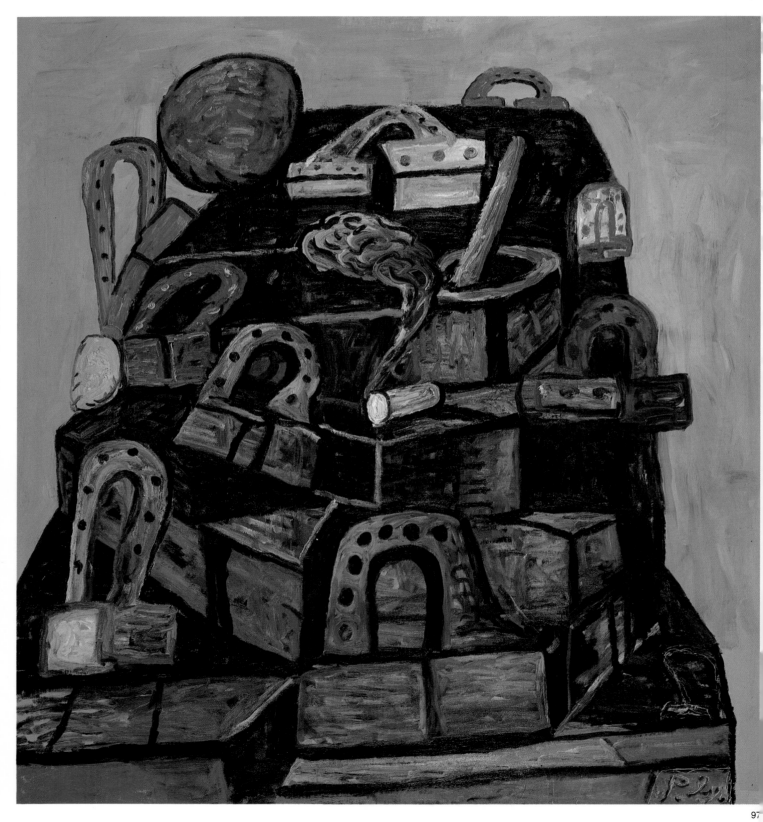

 **Closure and Continuity**

97. *Tomb*, 1978
Oil on canvas, 78⅛ x 73¾ in.
The Museum of Modern Art, New York;
Acquired through the A. Conger Goodyear,
Elizabeth Bliss Parkinson Funds and
Purchase

"In Philip Guston's growth, the whole evolution of modern art seemed to be recapitulated. And it was still a personal compulsion that moved him, in the fifties, to cross the threshold of abstraction. He had reached it on foot, pacing out every inch of the way."[84] Writing in 1956 in response to the 12 *Americans* exhibition at the Museum of Modern Art, *Arts Magazine* reviewer Leo Steinberg first sounded what was to become a recurrent theme in the criticism of Guston's work. For in hailing Guston's entry into the company of the Abstract Expressionists, Steinberg also took note of the special position that Guston held within that group and what seemed his slow, even reluctant acceptance of pure abstraction. That reluctance was real. Just two years after Steinberg's article was published, Guston wrote: "I do not see why the loss of faith in the known image or symbol should be celebrated as a freedom. It is this loss we suffer, this pathos that motivates modern painting and poetry at its heart."[85] When Guston made this statement he was still painting abstractions and continued to do so for almost another ten years. Yet for many observers Guston remained the perpetual outsider among abstract painters. He was not, however, alone in his ambivalence: at precisely the moment in the early 1950s when Guston began to paint his most radically nonobjective work, de Kooning started his Woman series and Pollock began to incorporate recognizable figurative forms in his black and white abstractions. These paintings by de Kooning and Pollock stirred up a tempest of criticism among formalist critics, but that controversy only reminds one of the distance that separated working artists, for whom abstraction was an individually arrived at and intuitively felt necessity, from others, especially nonartists, for whom it represented an ideological cause as much as or more than an expression of creative freedom.

Guston's ambivalence and the significance of his eventual return to figuration can be fully appreciated only if one first takes into account his intense and lasting involvement with art history and his idiosyncratic conception of its aesthetic rhythms. In 1966 Morton Feldman wrote: "Guston is of the Renaissance. Instead of being allowed to study with Giorgione, he observed it all from the Ghetto—in the Marshes outside Venice where the old iron works

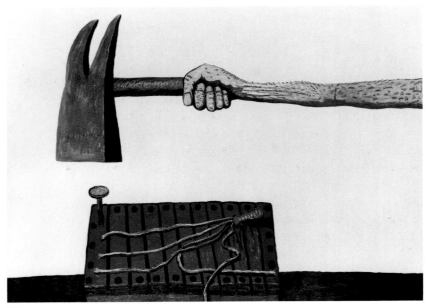

98

98. *Red Box*, 1977
Oil on canvas, 69 x 96¼ in.
Estate of Philip Guston;
Courtesy David McKee Gallery, New York

99. *Box and Shadow*, 1978
Oil on canvas, 69 x 98½ in.
Estate of Philip Guston;
Courtesy David McKee Gallery, New York

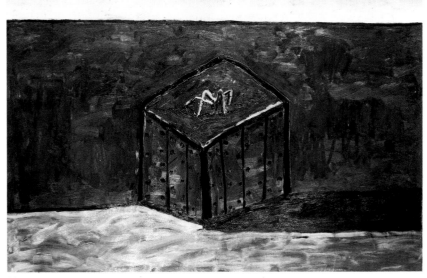

99

were. I know he was there. Due to circumstances, he brought that art into the diaspora with him. That is why Guston's paintings are the most peculiar history lesson we have ever had."[86] The issue was not, of course, literally one of Guston's Jewish origins, but rather that of the metaphorical ghetto into which he and nearly all his peers were born, for if the United States represented the raw incarnation of the Modern Age, it was at the same time the "iron works" outside the cultural capitals of Europe. The problem for Guston and his contemporaries was to catch up to the artistic revolution emanating from Europe while at the same time coming to terms with the artistic heritage that had prompted that rebellion and still permeated it, a heritage that Europeans took for granted. For American painters, acquaintance with those European traditions, both the old and the new, was synchronic. Torn between a distant and seemingly inexhaustible past and the multiplicity of rapidly evolving new styles, they were forced to commute from one

formal, ideological, and temporal extreme to another, while in the process synthesizing a version of art history suited to their individual needs. Gorky, for example, devoted himself to a succession of remote mentors, beginning with Cézanne, moving backward to Ingres through the Neoclassicism of Picasso, and then forward to the Surrealism of Joan Miró and Matta. Guston reached back even farther, emulating the old masters while at the same time grappling with the issues raised by modern tendencies from muralism and Metaphysical painting to Cubism and pure abstraction. In this context, as Steinberg understood, Guston's long struggle with Modernism was not the exception to that fought by other artists, but rather the fullest expression of it.

To explore Guston's relation to art history, therefore, is not simply a matter of tracing influences or explaining his reservations about abstraction. In fact, that relationship is a primary motive in his work. Unwilling to choose between the exclusive claims of individual movements and not content to treat what he knew as so much "art information" to be appropriated and collaged into learned pastiches, Guston sought to integrate and make his own the disparate traditions in which he saw his complex sensibility reflected. The historical component of his work is ultimately the measure of his true ambition. Responsive to the new, he also claimed the whole of the past as his domain and set out to make paintings that could answer to both. Thus, even though he sometimes was temporarily the outsider in relation to current fashion, Guston wanted to be, and in the end succeeded in being, the consummate insider.

It is this ambition that accounts for Guston's unique position among the leading figures of the last decade. Considered one of the two or three most important of the Abstract Expressionists at the end of the 1950s, by 1970 Guston had been banished by many critics to an honorable but secondary status. By the end of the 1970s, however, Guston was once again one of the most influential and widely exhibited of American painters. Throughout the last decade of his life Guston showed regularly at his New York gallery, and his work was featured in countless surveys of contemporary art, such as *The New Spirit of Painting* in London in 1980, shortly after the artist's death. In 1979 Guston was given a second major retrospective, at the San Francisco Museum of Modern Art, which then traveled to Washington, D.C., Chicago, Denver, and the Whitney Museum of American Art in New York. This return to prominence seemed almost a resurrection, and it is perhaps tempting to romanticize Guston's comeback as another example of the myth of the genius belatedly, if not posthumously, discovered. But Guston was neither unknown nor forgotten; rather, he had been placed under a kind of critical "house arrest." Fully aware of the challenge that this situation presented and the freedoms that it afforded, he proceeded to alter and enlarge the scope of his art in ways that negated the established assessment of his place and importance. In so doing, he helped to change the course of American painting in the 1970s and '80s.

For if, as Steinberg said, Guston had reached the frontier of abstraction on foot, he had also traversed its territory "pacing out

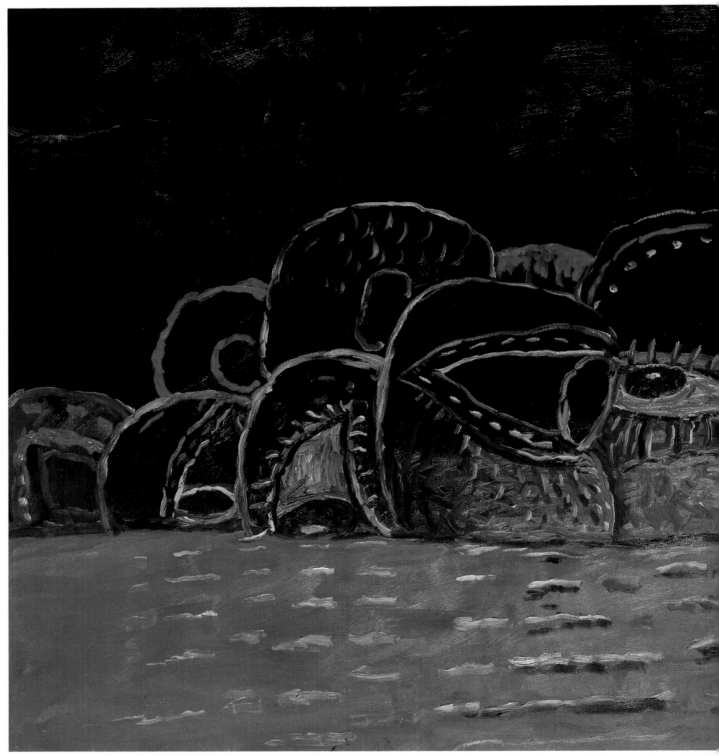

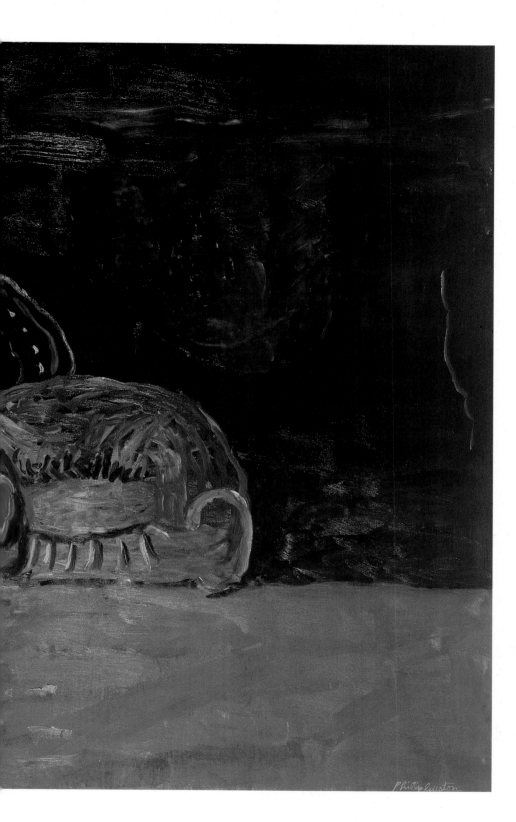

100. *Cabal*, 1977
Oil on canvas, 68 x 70 in.
Whitney Museum of American Art, New York;
50th Anniversary Gift of Mr. and Mrs.
Raymond J. Learsy

every inch of the way." Then in the early 1970s, alone among Abstract Expressionist painters, Guston crossed its outer boundary and established himself in new territory with a body of work that, in its full-blown and emotionally charged figuration, set him definitively apart from his peers while captivating a younger generation of New Image or Neo-Expressionist painters. Yet, as much as Guston's late paintings may now seem to embody the characteristics of what has become known as Neo-Expressionism, one must be careful not to ascribe to them meanings that, while intended to demonstrate their affinity with the work of these younger artists, fail to take account of the abiding complexities of his art. Despite the autobiographical content of much of Guston's work and the bold manner in which it is painted, Guston was not indulging in headlong "self-expression," much less was he simply reacting against the increasingly programmatic forms of abstraction that dominated the 1960s and '70s. As impatient as he was with academic modernism, Guston remained convinced of the importance of Mondrian and other abstract artists in whose work he identified "an anxious fix" corresponding to the tension that infused his own paintings.[87] Many of his late paintings are, in fact, more abstract than representational. *Red Sky*, for example, is an almost pneumatic variation on his cluster grids of the early 1950s, while *Arena* is less a picture within a picture than a tug-of-war between floating planes and primary forms.

Nor should Guston's work be judged by the direct stylistic influence that it *has* had on younger artists. In the 1950s, when Guston was being much copied, de Kooning remarked, "Well Phil, they're imitating you now instead of me, putting all the paint in the middle. They always imitate the part you most hate about your own

76

101

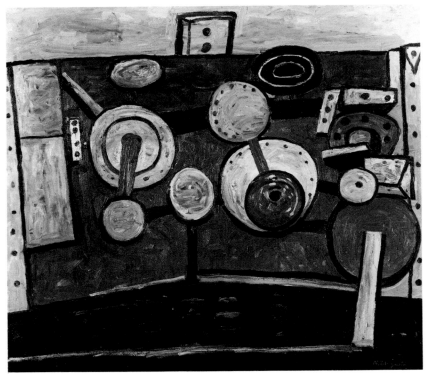

101. *Arena*, 1978
Oil on canvas, 73 x 78 in.
Estate of Philip Guston;
Courtesy David McKee Gallery, New York

101

work."[88] Indeed, it is the imitators, not the creators, of an original art who give it its characteristic look. The graphic style and imagery of Guston's late paintings were, in fact, no less conditioned by doubt than the fragile textures and structures of his abstractions had been—and are no more readily available to casual or even earnest disciples. Instead, the value of Guston's example resides in the substance of his work and the ways it embodies his fundamental attitudes toward art making and his concern for art's continuity. That concern was informed and reinforced by the daily experience of painting: "To paint is always to start at the beginning again, yet being unable to avoid familiar arguments about what you see yourself painting. The canvas you are working on modifies all previous ones in an unending baffling chain which never seems to finish. For me the most relevant question and perhaps the only one is, 'When are you finished?' When do you stop? Or rather why stop at all?"[89]

The key issue was not that of painterly manner or the choice between abstraction and figuration but of how to sustain one's identity and the momentum of painting against the tendency to lapse into formula and a fixed persona. "For if, as I believe," Guston affirmed, "one is changed by what one does—what one paints—continuous creation can only be furthered in *time*. That is, to *maintain* the condition of continuity—or as we might put it, the subversion of finality."[90] To subvert finality in one's own work is to forestall closure in historical terms as well, and Guston's work constituted an unyielding revolt against the visions of millennial modernists, who foresaw an "end to history"—a new age in which all of painting's problems had been "solved."

Motivated by this resistance to finality, Guston's career was a cycle of expansions and contractions, departures and returns. In each phase he moved beyond the assumptions that had previously guided him, only to double back and reexamine the untested possibilities they still contained. As he did so, the burden of the past increased, but so did the richness of experience his work encompassed. The marvel is that he not only bore the weight of that burden but in the end freed himself from it, creating paintings that for all their affinities with his earlier work remain unaccountably strange and mysterious. We confront them now with the same puzzlement that Guston himself felt each morning looking at his accomplishment of the night before, seeing both an image of the familiar and a vision of the unknown.

Certain artists do something [Guston wrote] and a new emotion is brought into the world; its real meaning lies outside of history and chains of causality.

Human consciousness moves, but it is not a leap: it is one inch. One inch is a small jump, but that jump is everything. You can go way out, and then you have to come back—to see if you can move that inch.[91]

No painter of Guston's generation better understood the rigors of that process, and as time passes it becomes clear that the leap Guston took at the end of his life was anything but small. As a whole, Guston's career does indeed represent one of the most

peculiar (and useful) history lessons we have ever had, while his individual paintings count among the great works of the second half of this century.

102. *Talking*, 1979
Oil on canvas, 68½ x 78 in.
The Edward R. Broida Trust, Los Angeles

103. *Feet on Rug*, 1978
Oil on canvas, 80 x 104 in.
Estate of Philip Guston;
Courtesy David McKee Gallery, New York

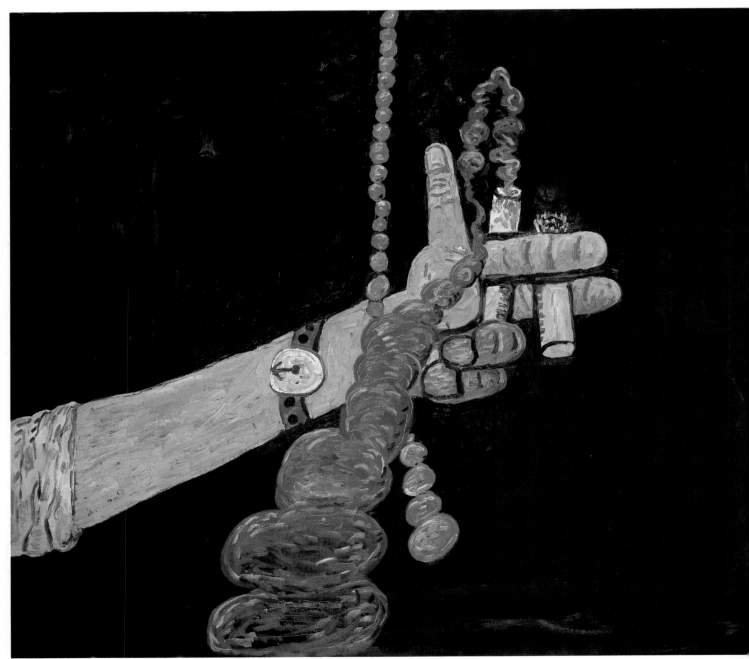

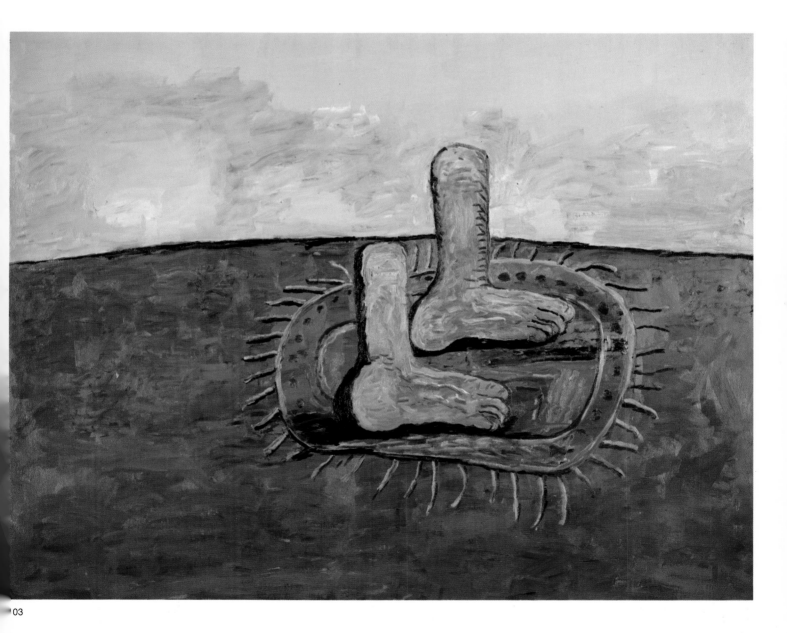

# NOTES

1. Maurice Merleau-Ponty, *L'Oeil et l'esprit* (*The Eye and the Mind*) (Paris: Gallimard, 1964), p. 9; translation by the author.

2. Dore Ashton, *Yes, But . . . : A Critical Study of Philip Guston* (New York: Viking Press, 1976), p. 15. The description of this incident and much of the biographical detail on Guston's early life in my first two chapters were gleaned from this book, which contains the most comprehensive account of Guston's youth to date. Many of the facts reported by Dore Ashton were confirmed and expanded in interviews with Stephen Greene, James Brooks, and Herman Cherry.

3. Herman Cherry, interview with author, New York City, January 9, 1985.

4. In 1933 Guston joined the PWAP (Public Works of Art Project) in Los Angeles. This program was a precursor of the WPA/FAP, which he joined in 1935 while still in California and under whose auspices he and Reuben Kadish were commissioned to paint the mural in Duarte. That work was signed *Philip Goldstein*, his family's name, but in a letter of December 13, 1937, he notified WPA/FAP officials that he had changed his name and thereafter all his work was signed *Philip Guston*.

5. "Mural on WPA Building Judged Best Outdoor Art," *New York Times*, August 7, 1939, p. 3.

6. Ashton, *Yes, But*, p. 40.

7. Ibid., p. 62.

8. Guston resigned from the WPA/FAP in 1940, but in 1941 he executed three decorative murals for the S.S. *Monroe*, the S.S. *Van Buren*, and the S.S. *Jackson* of the President Steamship Lines. That same year he completed a mural for the United States Forestry Building in Laconia, New Hampshire, working in collaboration with his wife, Musa McKim, and in 1942 he painted his last public work, *Reconstruction and Well-Being of the Family* for the Social Security Building in Washington, D.C. That mural was not installed until 1943. Also in 1943, in addition to the drawings of military training and the defense industry that he did for *Fortune* magazine, Guston did a series of drawings explaining celestial navigation for the U.S. Navy. Thus, though Guston concentrated primarily on his own easel work during this period, he continued to support himself in part from illustration and public commissions.

9. Quoted in Thomas Albright, "A Survey of One Man's Life," *San Francisco Chronicle*, May 15, 1980.

10. Guston's arguments with Pollock were reported to me by both Stephen Greene and James Brooks. The interview with Stephen Greene took place in New York City, July 3, 1984; the interview with James Brooks took place at his house on Long Island, October 28, 1984.

11. Quoted in "Philip Guston: Carnegie Winner's Art Is Abstract and Symbolic," *Life* 20 (May 27, 1946): 90.

12. Greene, interview with author.

13. References to the influence of the Holocaust on *Porch II* were made by Guston in Albright, "A Survey of One Man's Life," and confirmed in my interview with Greene.

14. Artist's statement, *12 Americans*, exhibition catalog (New York: Museum of Modern Art, 1956), p. 36.

15. Quoted in Irving Sandler, "Guston: A Long Voyage Home," *Artnews* 58 (December 1959): 36.

16. H. H. Arnason, *Philip Guston*, exhibition catalog (New York: Solomon R. Guggenheim Museum, 1962), p. 20.

17. Ibid., p. 21.

18. Irving Sandler, in his use of cropped photographs to illustrate his article "Guston: A Long Voyage Home," was the first critic to show how the abstract forms in *The Tormentors* derive from the quasi-abstract shapes of the legs of the performers cut off and isolated in the bottom section of *Porch II*. But, whereas in *Porch II* these shapes and the intervals between them were drawn in and then gradually adjusted, as was Guston's habit, in *The Tormentors* similar forms were arrived at by a more discursive technique. The change in method between these two paintings marks the first step in Guston's turn to improvisatory abstraction. *Review* and *Red Painting* constitute an assimilation of the lessons learned from that change, while *White Painting* represents the definitive shift to consistently gestural abstraction.

19. Philip Guston, "Notes on the Artist," in *Bradley Walker Tomlin*, exhibition catalog (New York: Whitney Museum of American Art, 1957), p. 9.

20. Jan Butterfield, "A Very Anxious Fix: Philip Guston," *Images and Issues* I (Summer 1980): 31.

21. Henri Focillon, *Vie des formes* (Paris: Quadrige/Presses Universitaires de France, 1981), p. 108; translation by the author.

22. Fairfield Porter, "Reviews and Previews," *Artnews* 51 (February 1953): 55.

23. John I. H. Baur, *Nature in Abstraction: The Relation of Abstract Painting and Sculpture to Nature in Twentieth-Century American Art*, exhibition catalog (New York: Whitney Museum of American Art, 1958), p. 5.

24. Ibid., p. 11. Baur's catalog essay is a curious and evasive document. He repeatedly claims not to be forcing "nature" upon abstraction nor to have any desire to attack Abstract Expressionism, and yet his arguments are full of asides and loaded phrases that seem to serve both of these ends. Thomas B. Hess in his article on the exhibition, cited below, correctly understood the tactic being used and lifted and highlighted those sentences that carry what seems to be the ulterior message of Baur's exhibition and essay. I have done the same. Hess's article, entitled "Inside Nature," appeared in *Artnews* in February 1958, pages 41, 60, and 64.

25. Quoted from a letter to John I. H. Baur, excerpted as part of Guston's statement in *The New American Painting*, exhibition catalog (New York: Museum of Modern Art, 1959), p. 40. This letter was partially quoted in the catalog essay for Baur's exhibition *Nature in Abstraction*, but this section was excluded.

26. Quoted in Albright, "A Survey of One Man's Life."

27. Emily Genauer, "Guston's Switch from Meaning," *New York Herald Tribune*, May 6, 1962.

28. Philip Guston, "Piero della Francesca: The Impossibility of Painting," *Artnews* 64 (May 1965): 39.

29. Quoted in Butterfield, "A Very Anxious Fix," p. 33.

30. Philip Pavia and Irving Sandler, eds., "The Philadelphia Panel," *It Is* 5 (Spring 1960): 37. In addition to Guston, Reinhardt, and its moderator, Harold Rosenberg, the panel consisted of Jack Tworkov and Robert Motherwell.

31. Ibid.

32. Ibid., p. 38.

33. Ibid.

34. Leo Steinberg, "Fritz Glarner and Philip Guston at the Modern," in *Other Criteria: Confrontations with Twentieth-Century Art* (New York: Oxford University Press, 1972), p. 283.

35. Ibid.

36. Philip Guston, "Statement," *It Is* 1 (Spring 1958): 44.

37. Merleau-Ponty, *L'Oeil et l'esprit*, p. 33.

38. Arnason, *Philip Guston*, p. 27.

39. Ibid., p. 32.

40. Quoted in William Berkson, "Dialogue with Philip Guston, November 1, 1964," *Art and Literature: An International Review* 7 (Winter 1965, p. 56).

41. Philip Guston, "Faith, Hope and Impossibility," *XXXI Artnews Annual 1966*, October 1965, p. 103.

42. Quoted in Berkson, "Dialogue with Philip Guston," p. 66.

43. Hilton Kramer, "Art: Abstractions of Guston Still Further Refined," *New York Times*, January 15, 1966.

44. Artist's statement, *Philip Guston: Drawings 1947–1977*, exhibition catalog (New York: David McKee Gallery, 1978), n.p.

45. Hilton Kramer, "A Mandarin Pretending to Be a Stumblebum," *New York Times*, October 25, 1970, sec. B, p. 27.

46. Kramer, "Abstractions of Guston Still Further Refined."

47. Kramer, "A Mandarin Pretending to Be a Stumblebum."

48. Bill Berkson, "The New Gustons," *Artnews* 69 (October 1970): 44.

49. Between 1963 and 1965 Fahlstrom did two paintings that reproduce full-page strips from *Krazy Kat*, but in these paintings (as in those of Lichtenstein, Warhol, and others) the emphasis is upon the recontextualization of comic-book emblems, whereas Guston drew on the syntax of the comics to create a wholly new imagery.

50. "Borrowings" from *Krazy Kat* include the butte-like forms of Guston's skylines, the lima-bean shape of his archetypal heads, and the bricks that fly through his late work. His use of these images and forms, however, is utterly different from that of George Herriman, for if, for example, the flying brick in the strip is a symbol of amorous aggression, in Guston it is an emblem of social violence. As always, when making such iconographic links, it is difference, not similarity, that is the important issue.

51. Paul Brach, "Looking at Guston," *Art in America* 68 (November 1980): 100.

52. Berkson, "The New Gustons," p. 44.

53. Quoted in Jerry Talmer, "'Creation' Is for Beauty Parlors," *New York Post*, April 9, 1977.

54. Ibid.

55. Harold Rosenberg, "Liberation from Detachment," in *De-definition of Art* (New York: Macmillan, 1972), pp. 130–40.

56. Ibid., p. 140.

57. Lawrence Alloway, "Art," *Nation*, November 30, 1974, p. 574.

58. Quoted in Renee McKee, ed., "Philip Guston Talking," transcript of a lecture given at the University of Minnesota in March 1978, in *Philip Guston Paintings 1969–1980*, exhibition catalog (London: Whitechapel Art Gallery, 1982), p. 54.

59. In 1969 the Whitney Museum mounted an omnibus exhibition entitled *Human Concern/Personal Torment: The Grotesque in American Art*. In many ways poorly chosen, this exhibition nonetheless drew interesting connections between Imagists such as Ed Paschke, Jim Nutt, and H. C. Westermann; West Coast artists such as Peter Saul and Robert Crumb; and the Depression-era sculptural cartoons of David Smith's *Medals for Dishonor*. While Guston may or may not have seen this show, Kramer almost certainly must have, and his avoidance of the social and contextual issues raised by Guston's work thus seems particularly odd.

60. Nikolai Gogol, "The Overcoat," *The Diary of a Mad Man and Other Stories*, trans. Andrew R. MacAndrew (New York: New American Library, 1960).

61. Quoted in "Philip Guston Talking," p. 52.

62. Ibid., p. 53.

63. Peter Schjeldahl, "Self-Abuse on Parade," *Village Voice*, July 15–21, 1981.

64. Morton Feldman, "Philip Guston: The Last Painter," *XXXI Artnews Annual 1966*, October 1965, pp. 97–100.

65. Quoted in "Philip Guston's Object: A Dialogue with Harold Rosenberg," in *Philip Guston: Recent Paintings and Drawings*, exhibition catalog (New York: Jewish Museum, 1966), n.p.

66. Ibid.

67. Ibid.

68. Gerschom G. Scholem, *The Kabbalah and Its Symbolism* (New York: Schocken Books, 1969), pp. 158–204, and Jorge Luis Borges, *Seven Nights* (New York: New Directions Books, 1980), pp. 95–106.

69. Quoted by Morton Feldman in notes contained in the file on Guston in the library of the Museum of Modern Art.

70. Quoted in "Philip Guston's Object: A Dialogue," n.p.

71. Quoted in "Philip Guston Talking," p. 55.

72. Edward F. Fry, "Freedom, Modernity, Humanism: The Late Works of Philip Guston," in *Philip Guston: The Late Work*, p. 17.

73. Quoted in Pavia and Sandler, "The Philadelphia Panel," p. 37.

74. Quoted in Butterfield, "A Very Anxious Fix," p. 31.

75. Quoted in "Philip Guston's Object: A Dialogue," n.p.

76. Quoted in Mark Stevens, "A Talk with Philip Guston," *New Republic* 182 (March 15, 1980): 26.

77. Thomas B. Hess, "The Abstractionist Who Came in from the Cold," *New York 7* (December 9, 1974): 102.

78. Though Guston rarely mentioned Goya, in a letter to Bill Berkson in May 1974 he included a small sketch of one of Goya's Black Paintings, which depicts a dog either buried in the mud with only his head showing or, as Guston captioned it, climbing a hill. This sketch does more than confirm a historical link between Guston's use of landscape and Goya's, for Guston's sketch of the Goya seems to prefigure the head and objects struggling against gravity on steep inclines that frequent Guston's last works.

79. Also worth noting in this connection is a painting by Uccello, one of Guston's favorite painters, entitled *The Flood and the Recession of the Waters*, although Guston's "Deluge" paintings in no way base themselves directly on the structure or the biblical imagery of this work.

80. Quoted in Peter Selz, *Max Beckmann*, exhibition catalog (New York: Museum of Modern Art, 1964), p. 23.

81. From the Renaissance on, artistic or poetic melancholy has been a common subject in painting and literature, and a reproduction of Albrecht Dürer's engraving *Melancholia*, one of the most important treatments of the subject, hung in Guston's house for many years. For an exhaustive and entertaining study of the artist's "saturnine" temperament as presented in Western art and art history, see Rudolf and Margot Wittkower, *Born under Saturn: The Character and Conduct of Artists: A Documented History from Antiquity to the French Revolution* (New York: W. W. Norton & Co., 1963).

82. Greene, interview with author.

83. Philip Guston to Bill Berkson, April 10, 1975, from a collection of letters donated by Berkson to the library of the University of Connecticut at Storrs.

84. Steinberg, "Fritz Glarner and Philip Guston at the Modern," p. 282.

85. Quoted in Baur, *Nature in Abstraction*, p. 10.

86. Feldman, "Philip Guston: The Last Painter," p. 100.

87. Quoted in Butterfield, "A Very Anxious Fix," p. 35.

88. Quoted in April Kingsley, "Philip Guston's Endgame," *Horizon* 23 (June 1980): 37.

89. Guston, "Faith, Hope and Impossibility," p. 101.

90. "Philip Guston Talking," p. 51.

91. Philip Guston, "Faith, Hope and Impossibility," p. 153.

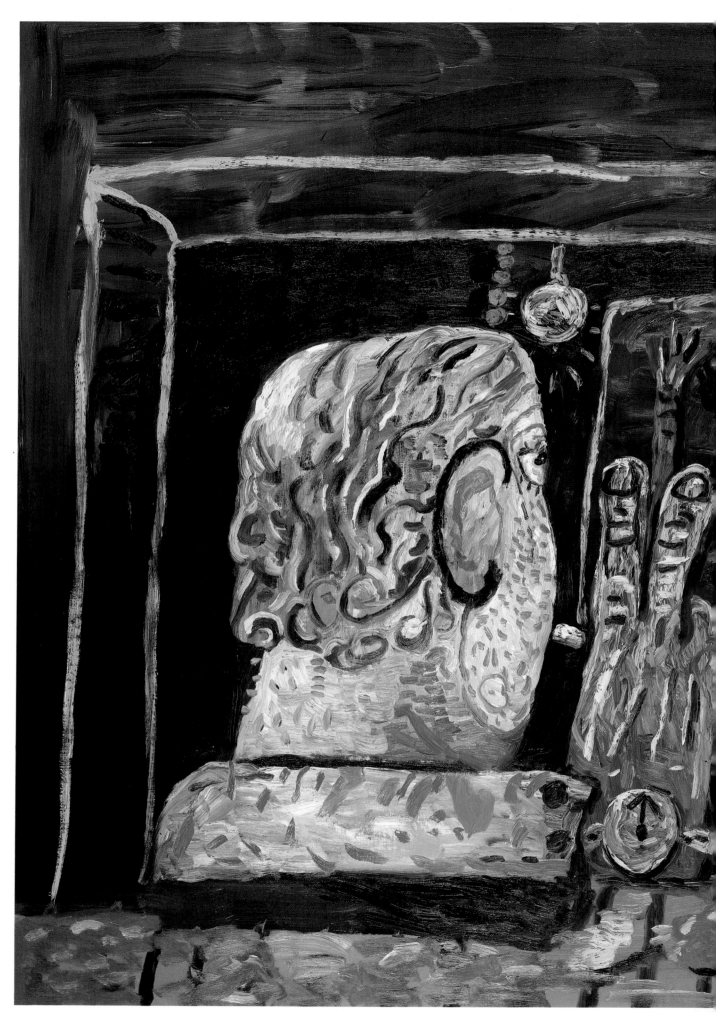

104. *Painter at Night*, 1979
Oil on canvas, 68½ x 80½ in.
Emily and Jerry Spiegel

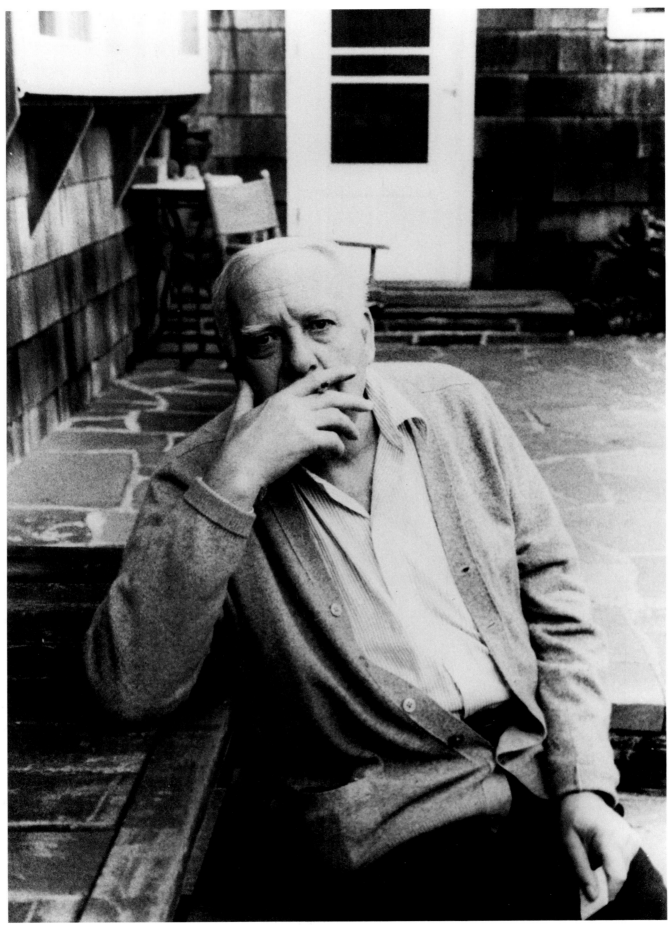

# Artist's Statements

What is seen and called a picture is what remains—an evidence.

Even as one travels in painting towards a state of "unfreedom" where only certain things can happen, unaccountably the unknown must appear.

Usually I am on a work for a long stretch, until a moment arrives when the air of the arbitrary vanishes, and the paint falls into positions that feel destined.

The very matter of painting—its pigment and spaces—is so resistant to will, so disinclined to assert its plane and remain still.

Painting seems like an impossibility, with only a sign now and then of its own light. Which must be because of the narrow passage from diagramming to that other state—a corporeality.

In this sense, to paint is a possessing rather than a picturing.

> Statement in *12 Americans*, exhibition catalog (New York: Museum of Modern Art, 1956), p. 36.

To will a new form is inacceptable, because will builds distortions. Desire, too, is incomplete and arbitrary. These strategies, however intimate they become, must especially be removed to clear the way for something else—a situation somewhat unclear, but which in retrospect becomes a very precise act. . . .

There are twenty crucial minutes in the evolution of each of my paintings. The closer I get to that time—those twenty minutes—the more intensely subjective I become—but the more objective too. Your eye gets sharper; you become continuously more and more critical.

There is no measure I can hold on to except this scant half-hour of making.

> From "Faith, Hope and Impossibility," *XXXI Artnews Annual 1966*, October 1965, pp. 103, 138.

Is the painting a vast precaution to avoid immobility, a wisdom which can include the partial doubt of the final destiny of forms? It may be this doubt which moves and locates everything.

> From "Piero della Francesca: The Impossibility of Painting," *Artnews* 64 (May 1965): 39.

105. Philip Guston, 1979

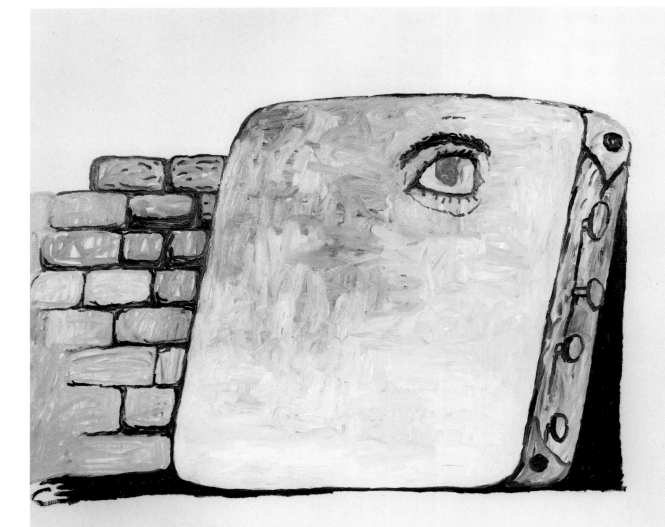

I expect other people to look at painting the way I look at painting, just as painting. My work must be demanding for a spectator, but what can I do? I think there's some law at work—an invisible law—that means you can only accept certain things at a certain time—so that if you're working to please yourself or catering to yourself, why should you cater to a looker or art critic? Why should you meet their expectations? If I destroy my own expectations, why should I worry about others' expectations?

From an interview with Gladys Shafran Kashdin, 1965.

Yes—I too puzzle over "meanings"—I mean the linkage of images when they are together in a certain way and then how all changes, when in another combination on the wall. Last month, trying to

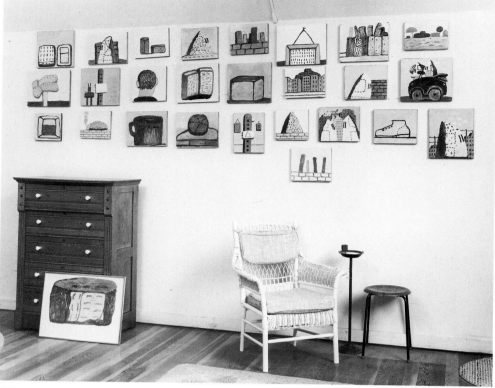

107

select 9 or 10 paintings from about 40 for [the] McKee show, I shifted pictures around for days and nights, *reeling* from the diverse possible *meanings* the pictures possess when in different image relationships. But that is the potency of image making—it's as if we are dense—swamped—image-ridden—we teem with meanings "constantly." So the "WHAT" is never settled. Of course never can be. There are days when in a kind of half-awake state, the images of one painting move into another. I don't myself know what is where—nothing to do with separate pictures anymore but a sort of confused *swarm* where everything can become everything else—in a split second. I "panic" and hate it and desire it to stop fully as much as I love and need it and want to continue endlessly. The "curse" of image making—as if one wants to gorge and eat up the world—a hunger—but then also deep down is another hunger —for some "peace"—detachment—for a single form which might "contain" so much multiplicity. Is that possible? I comfort myself, at times, with the thought that *perhaps* one's whole work—I mean all the images and structures I have made—is all one image anyway. Is this too much of a metaphysical "idea" only? But what if it is "true"? . . . When I am in the work I give myself over to the compulsion (no easy matter as you know) and the "puzzle" subsides a little—but it is always there. Perhaps *never* to know.

> From a letter to Bill Berkson, January 19, 1976, on deposit in the library at the University of Connecticut at Storrs.

It's a long, long preparation for a few moments of innocence.

> From a lecture at the University of Minnesota, 1978.

106. *The Canvas*, 1973
Oil on canvas, 67 x 79 in.
Estate of Philip Guston;
Courtesy David McKee Gallery, New York

107. Guston's Woodstock studio

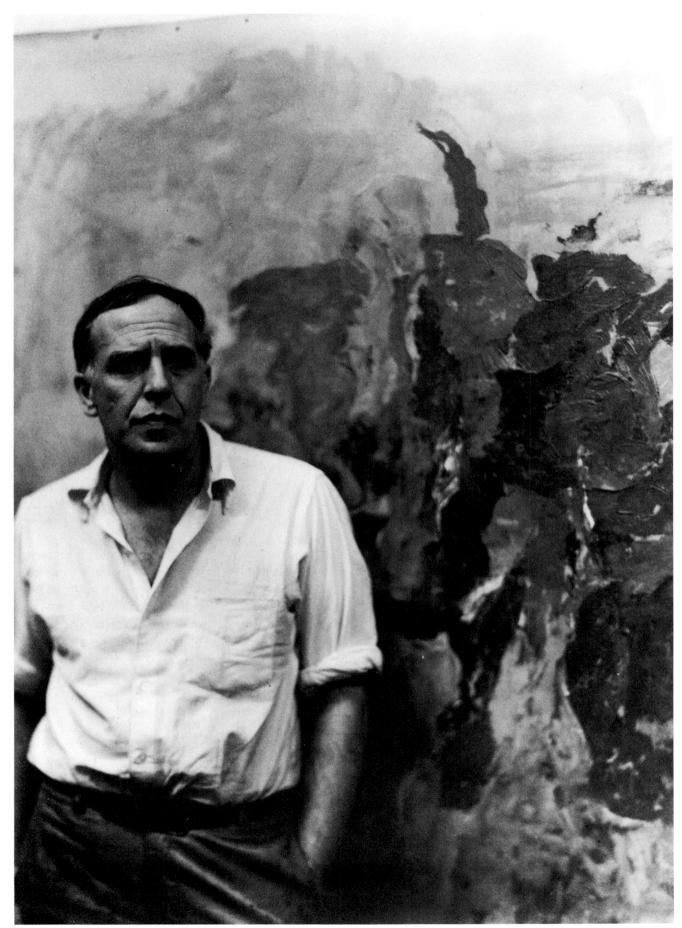

# Notes on Technique

Philip Guston was a precocious master of the traditional craft of painting. Largely self-taught, he modeled his earliest work on that of Renaissance artists such as Uccello, Piero della Francesca, Masaccio, and Signorelli, developing the clearly delineated forms of his compositions in thin, smooth layers of oil paint. His drawings and studies for paintings, often classical in their flowing contour line and tonal nuances, are remarkable for their virtuosity and dramatic luminosity. Guston was also proficient in fresco technique, which he used for many of his murals, and for his exterior wall for the WPA Building at the New York World's Fair he experimented with synthetic industrial paints, deriving from them a remarkable chromatic subtlety. In response to his discovery of Titian and Tintoretto, Guston's paint handling changed during the 1940s, and the once hard surfaces of his work gave way to increasing variations in texture and opacity.

Modern painting, however, is a product of its limitations, and from the 1940s on, Guston radically simplified his technique. Where he had once used a full palette, henceforth he restricted his range of colors to a short list of personal primaries: alizarin crimson, cadmium reds, oranges, and yellows, cobalt blue, permanent green, black, and white. He mixed his colors to achieve tonal modulations rather than to create full-strength secondary hues such as purple or additional greens or oranges. Often these tints were the result of accidental combinations that occurred when one wet color was dragged over another or scraped off, exposing an altered color beneath. During the 1960s Guston limited his palette still further, using only black and white and washes of red or blue in the underpainting. In his late work, Guston's palette included all of his original primaries, but in many works it was limited to a pair or a triad of basic colors, most often chosen from blue, red, green, black, and white.

Starting in the 1950s Guston painted directly on an oversized piece of unstretched canvas tacked to the wall. While the dimensions of a picture would be inscribed in pencil before work began, he still had the option of making adjustments in that rectangle once the internal structures of a painting had emerged. The process by which this occurred involved the constant addition and subtrac-

108. Philip Guston, mid-1950s

tion of paint of widely varying degrees of density and viscosity, resulting in surfaces at times extraordinarily thick and at others exceedingly thin, alternatively unctuous and turpentine dry. Often Guston would leave large areas of primed but untouched canvas exposed. One measure of Guston's technical virtuosity is that despite these extremes in texture and thickness, his paintings remain remarkably free from the cracking that is normally the consequence of testing the limits of oil paint in this way. Generally, Guston would work on only one painting at a time, staying with it for weeks and sometimes months. Toward the end of his life, however, he would complete a painting in a single prolonged session and emerge from the studio only when the work was finished.

From 1966 to 1968 Guston briefly used acrylics for the small panel paintings in which he did his first studies of objects and Klansmen, restricting himself at that time to red, black, and white. Toward the end of his life, when he was no longer able to work on large-scale paintings in oils, he switched to gouache, water-based paints that he had used frequently in the 1950s, and produced a considerable number of richly hued small works in that medium. In 1979, in collaboration with Gemini G.E.L., Guston also did a series of lithographs, a technique he had used only once before for a series of prints in the mid-1960s.

After 1950 Guston ceased making studies in preparation for specific paintings, but drawing was always a major aspect of his work. Throughout his life he did reams of finished drawings, caricatures, sketches, and carefully lettered and embellished versions of poems by his wife, Musa, and his friends Bill Berkson, Clark Coolidge, William Corbett, and others. His favorite media were charcoal and ink and quill or reed pen. The last was particularly important to his graphic work because he was able to treat it much like a brush, deriving from the idiosyncratic cut of each quill's tip a new and unpredictable range of marks and, as the

109

109. *Summer*, 1980
Lithograph, 20 x 30 in.
© Gemini G.E.L., Los Angeles, 1980

110. Philip Guston at Gemini G.E.L., 1979

ink dried, an equally varied and surprising diversity of tonal values and textures.

In the late 1960s Guston wrote: "It is the bareness of drawing I like. The act of drawing is what locates, what suggests, discovers. At times it seems enough to draw, without having the distraction of color and mass. Yet it is an old ambition to make drawing and painting one."[1] That ambition to a large extent determined Guston's artistic course, and it led to his progressive simplification of means in both media. The apparent crudeness of his late work was, in fact, a highly sophisticated synthesis of a lifetime's experience of both painting and drawing, and the fusion between the two permitted him to articulate his vision unhampered by technical restrictions. It was, thus, a fusion of painting, drawing, and thinking.

1. Artist's statement, *Philip Guston: Drawings, 1947–1977*, exhibition catalog (New York: David McKee Gallery, 1978), n.p.

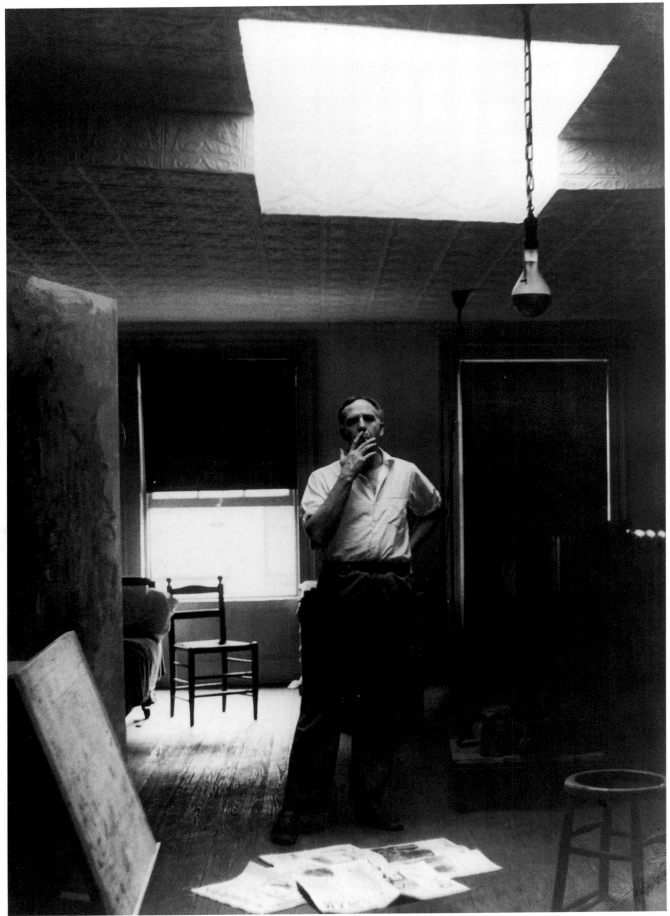

# Chronology By Janis Ekdahl

**1913** June 27—Philip Goldstein born in Montreal, Canada, to Louis Goldstein and Rachel Ehrenlieb Goldstein, Russian emigrés from Odessa; he is the youngest of seven children.

**1919** Family moves to Los Angeles.

**1920** Father commits suicide.

**1925** Philip begins drawing, encouraged by mother's gift of a correspondence course with the Cleveland School of Cartooning.

**1927** Enrolls in Manual Arts High School, Los Angeles, where he becomes friends with Jackson Pollock. Their art teacher, Frederick John de St. Vrain Schwankovsky, introduces them to Oriental philosophy and the teachings of mystics Ouspensky and Krishnamurti as well as to contemporary European art, particularly Cubism.

**1928** Guston and Pollock are expelled for distributing a broadside satirizing the English department. Pollock is readmitted but Guston stays out of school to study on his own; supports himself with odd jobs, including working as an extra in the movies.

**1930** Awarded a year's scholarship to Otis Art Institute, Los Angeles. Guston leaves Otis after three months, preferring to independently study reproductions of Picasso and Italian Renaissance masters, especially Piero della Francesca. Becomes friends with Reuben Kadish, who introduces him to Lorser Feitelson, an influential Los Angeles painter. Feitelson shows him the collection of Walter and Louise Arensberg, which includes several modern European paintings acquired at the Armory show in 1913.

**1931** First solo exhibition held at Stanley Rose's bookshop and gallery in Los Angeles. Becomes involved with social and political issues and attends meetings of the John Reed Club, a Marxist group that encourages artists to abandon "art for art's sake." Fresco panels based on the trial of the Scottsboro Boys, which Guston and others in the club had begun, are destroyed in a raid by the police "Red Squad."

**1932** Becomes aware of the Mexican mural movement through the local activity of David Alfaro Siqueiros and José Clemente Orozco.

**1934** Travels to Morelia, Mexico, with Kadish and the poet and critic Jules Langsner. With Siqueiros's support they are given a commission to execute a mural in the palace of the former emperor Maximilian, depicting the struggle against war and fascism. Guston returns to Los Angeles and joins the Public Works of Art Project. Begins a mural commission, with Kadish, for the International Ladies Garment Workers Union Tuberculosis Sanitorium in Duarte, near Los Angeles.

**1935** Joins the mural division of the Works Progress Administration Federal Art Project (WPA/FAP).

**1935–36** Winter—moves to New York City at the urging of Pollock, who had moved there shortly before; initially stays with Pollock and his brother, Sandy McCoy. Meets James Brooks, Burgoyne Diller, Arshile Gorky, Willem de Kooning, and Stuart Davis through his work for the WPA/FAP. Visits New York's museums and galleries and is especially influenced by the modern European art in the A. E. Gallatin collection in the Museum of Living Art at New York University and the 1935 de Chirico exhibition at the Pierre Matisse Gallery.

**1937** February 4—marries Musa McKim, an artist and poet. December 13—notifies WPA/FAP officials that he has changed his name to Philip Guston.

**1938** Executes a mural commission for United States Post Office, Commerce, Georgia.

**1939** Executes major mural commission, *Maintaining America's Skills*, for the façade of the WPA Building at the New York World's Fair; it wins first prize in the outdoor mural category, based on a public opinion poll. Commissioned by WPA/FAP to create a mural for the lobby of the community center of the Queensbridge Housing Project, Queens, New York. Discovers the work of Max Beckmann in a show at Buchholz Gallery.

111. Philip Guston, mid-1950s

**1940** Visits the Picasso retrospective exhibition at the Museum of Modern Art, New York. Resigns from the WPA/FAP and begins to concentrate on easel painting.

**1941** Executes decorative murals for three ships of the President Steamship Lines: S.S. *Monroe*, S.S. *Van Buren*, S.S. *Jackson*. Executes mural, in collaboration with his wife, for the United States Forestry Building in Laconia, New Hampshire. Moves to Iowa City to be instructor of art at the State University of Iowa (until 1945), where he begins to paint a series of nostalgic portraits and cityscapes; completes *Martial Memory*, an allegory of war that Guston considers his first mature easel work.

**1942** Completes his last mural, for the Social Security Building in Washington, D.C., *Reconstruction and Well-Being of the Family* (installed 1943).

**1943** January 18—daughter, Musa Jane, born. Guston is commissioned by *Fortune* magazine to depict the defense industry and army air-training programs of the Central Training Command; for this assignment makes several visits to Texas. Also does a series of drawings exploring celestial navigation for the U.S. Navy.

**1944** Solo exhibition of paintings and drawings held at the State University of Iowa.

**1945** Wins First Prize for Painting at *Painting in the United States*, Carnegie Institute, Pittsburgh. First solo exhibition in New York held at Midtown Galleries. Becomes instructor at St. Louis School of Fine Arts, Washington University (until 1947); appointed head of painting department. Paints *Performers* and begins *Porch II*, his last two figurative paintings before his shift to abstraction.

**1947** Receives Guggenheim Fellowship and takes leave of absence from Washington University. Moves to Woodstock, New York; becomes good friends with Bradley Walker Tomlin. Completes *Porch II*.

**1948** Awarded Prix de Rome from the American Academy in Rome. Awarded $1,000 grant from the American Academy of Arts and Letters in New York. Completes *The Tormentors* and begins *Review*, the first two of three transitional abstractions that occupy Guston from 1947 to 1950.

**1948–49** Spends a year traveling in Italy, studying old masters and drawing; visits Spain and France. Completes *Review* after returning to Woodstock.

**1950** Spring semester—is visiting artist at University of Minnesota, Minneapolis. Returns to New York City; becomes an active member of the Eighth Street Club. Develops friendships with critics Harold Rosenberg and Thomas B. Hess and composers John Cage and Morton Feldman. Paints *Red Painting*, the last of his transitional abstractions, which creates a stir when included in *Abstract Painting and Sculpture in America* at the Museum of Modern Art.

**1951** Becomes adjunct professor of painting, New York University (until 1958). Paints *White Painting*, his first completely abstract and gestural painting.

**1952** First solo exhibition of abstract paintings held at the Peridot Gallery, New York. Joins the Charles Egan Gallery, New York.

**1953** Becomes instructor at Pratt Institute, Brooklyn (until 1958).

**1955** Joins the Sidney Janis Gallery, New York, as do other Abstract Expressionists such as de Kooning, Kline, Pollock, and Rothko.

**1956** *Painting* (1954) purchased for the Museum of Modern Art by Philip Johnson.

**1957** Included in *IV Bienal de São Paulo*.

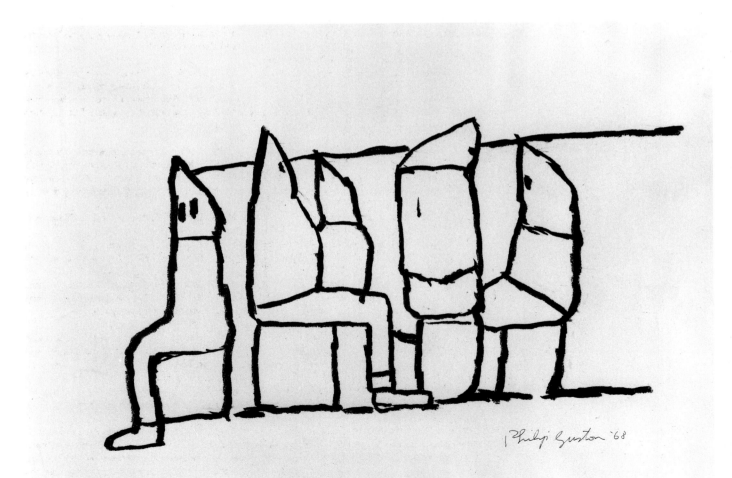

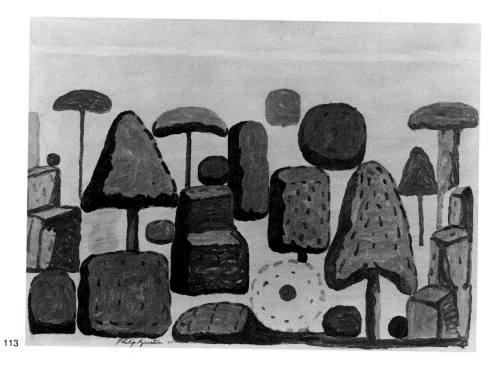

113

112. *Group I*, 1968
Charcoal on paper, 18 x 24 in.
Private collection, New York

113. *Farnesina Gardens, Rome*, 1971
Oil on paper on panel, 29 x 40½ in.
Peter Knudsen, Black Hills, Michigan

**1959**  Receives $10,000 Ford Foundation grant and gives up teaching formally until 1973. Included in *V Bienal de São Paulo* and *Documenta II*, Kassel, West Germany.

**1960**  Summer—travels in Europe for three months, visiting the *XXX Venice Biennale*, where a major selection of his work is on view, and touring Umbria to study Italian painting.

**1961**  Serves as guest critic at Yale Summer School, Norfolk, Connecticut (returns in 1963, 1971, 1973, 1974).

**1962**  Major retrospective held at the Solomon R. Guggenheim Museum, New York.

**1966**  Major solo exhibition of abstract paintings held at the Jewish Museum, New York. Is artist-in-residence at Brandeis University, Waltham, Massachusetts; a concurrent retrospective is held at the Rose Art Museum. Joins Marlborough Gallery, New York.

**1967**  Teaches seminars at New York Studio School, New York (until 1973). Moves permanently to Woodstock, New York.

**1967–68**  Stops painting and concentrates exclusively on drawing, shifting gradually from minimal gestural abstractions to cartoonlike still lifes and figure studies that feature the image of Ku Klux Klansmen.

**1968**  Awarded second Guggenheim Fellowship. Summer—is artist-in-residence at Skidmore College, Saratoga Springs, New York.

**1969–70**  Is guest critic, Graduate School of Fine Arts, Columbia University, New York (returns in 1972–73).

**1970**  Exhibits new figurative work at Marlborough Gallery, which attracts widespread attention and considerable hostile criticism. Awarded honorary doctorate of fine arts by Boston University. Elected trustee of the American Academy in Rome.

**1970–71**  Is artist-in-residence at American Academy in Rome. Travels throughout Italy, Sicily, and Greece; executes a series of oils on paper focusing on formal gardens and Etruscan and Roman excavations.

**1972**  October—withdraws from contract with Marlborough Gallery and moves all unsold paintings to Woodstock. Elected member of the National Institute of Arts and Letters, New York.

**1973**  Begins teaching at Boston University (until 1978); commutes to Boston once a month. Klan figures are replaced by lima-bean–shaped heads as principal protagonists in his paintings.

**1974**  Joins David McKee Gallery, New York.

**1975**  Receives Distinguished Teaching of Art Award from the College Art Association.

**1976**  Briefly hospitalized for exhaustion. Paints *Monument, Source, Pit, Wharf, Green Rug, Frame*, and other major works.

**1978**  Elected member of American Academy of Arts and Sciences, Boston. Elected professor emeritus, Boston University. Paints *Friend—To M.F.* and *The Ladder*.

**1979**  Suffers a near-fatal heart attack.

**1980**  Receives Creative Arts Award, Brandei University. May 16—major retrospective open at the San Francisco Museum of Modern Art Guston concentrates on making drawings ano gouache-on-paper paintings. June 7—dies in Woodstock, New York.

# Exhibitions

## Solo Exhibitions

### 1931
*Philip Guston*, Stanley Rose Gallery, Los Angeles.

### 1944
*Paintings and Drawings by Philip Guston*, State University of Iowa, Iowa City, March 5–19.

### 1945
*Philip Guston*, Midtown Galleries, New York, January 15–February 3.

### 1947
*Philip Guston*, Munson-Williams-Proctor Institute, Utica, New York, November 2–December 1.
*Philip Guston*, School of the Museum of Fine Arts, Boston.

### 1950
*Philip Guston*, University Gallery, University of Minnesota, Minneapolis, April 10–May 12.

### 1952
*Paintings 1948–1951 by Philip Guston*, Peridot Gallery, New York, January 2–26.

### 1953
*Philip Guston*, Charles Egan Gallery, New York, January 12–February 7.

### 1956
*Recent Paintings by Philip Guston*, Sidney Janis Gallery, New York, February 6–March 4.

### 1958
*Philip Guston*, Sidney Janis Gallery, New York, February 24–March 22.

### 1959
*29 Recent Paintings by Philip Guston*, Sidney Janis Gallery, New York, December 28–January 23, 1960.

### 1961
*New Paintings by Philip Guston*, Sidney Janis Gallery, New York, February 13–March 11.

### 1962
*Philip Guston*, Solomon R. Guggenheim Museum, New York, May 2–July 1, and tour to the Stedelijk Museum, Amsterdam; Palais des Beaux-Arts, Brussels; Whitechapel Art Gallery, London; Los Angeles County Museum.

### 1966
*Philip Guston: Recent Paintings and Drawings*, Jewish Museum, New York, January 12–February 13.
*Philip Guston: A Selective Retrospective Exhibition: 1945–1965*, Rose Art Museum, Brandeis University, Waltham, Massachusetts, February 27–March 27.

### 1967
*Philip Guston*, Santa Barbara Museum of Art, Santa Barbara, California, February 15–March 26.

### 1969
*Philip Guston*, Jefferson Gallery, Los Angeles, opened January 20.
*Philip Guston: Paintings and Drawings*, Gertrude Kasle Gallery, Detroit, October 4–30.

### 1970
*Philip Guston: Recent Paintings*, Marlborough Gallery, New York, October 17–November 7.
*New Paintings: Philip Guston*, School of Fine and Applied Arts Gallery, Boston University, November 14–December 13.

### 1971
*Philip Guston: Recent Work*, La Jolla Museum of Contemporary Art, La Jolla, California, August 1–October 3.

### 1973
*Philip Guston: Major Paintings of the Sixties*, Gertrude Kasle Gallery, Detroit, March 10–April 7.
*Philip Guston Drawings, 1938–1972*, Metropolitan Museum of Art, New York, July 11–September 4.

### 1974
*Philip Guston: New Paintings*, School of Fine and Applied Arts Gallery, Boston University, March 15–April 14.
*Philip Guston*, Gertrude Kasle Gallery, Detroit, November 9–December 12.
*Philip Guston*, David McKee Gallery, New York, November 15–December 18.

### 1975
*Philip Guston*, Makler Gallery, Philadelphia, February 17–March 29.
*Philip Guston: Drawings for Bill Berkson's "Enigma Variations,"* Gallery Paule Anglim, San Francisco, December 16–January 26, 1976.

### 1976
*Philip Guston: Paintings 1975*, David McKee Gallery, New York, March 6–April 10.

### 1977
*Philip Guston: Paintings 1976*, David McKee Gallery, New York. Shown in two parts: March 18–April 8 and April 9–30.
*A Selection of Recent Works by Philip Guston*, Achim Moeller Gallery, London, summer.

### 1978
*Philip Guston: Major Paintings 1975–76*, Allan Frumkin Gallery, New York, September 29–November 2.

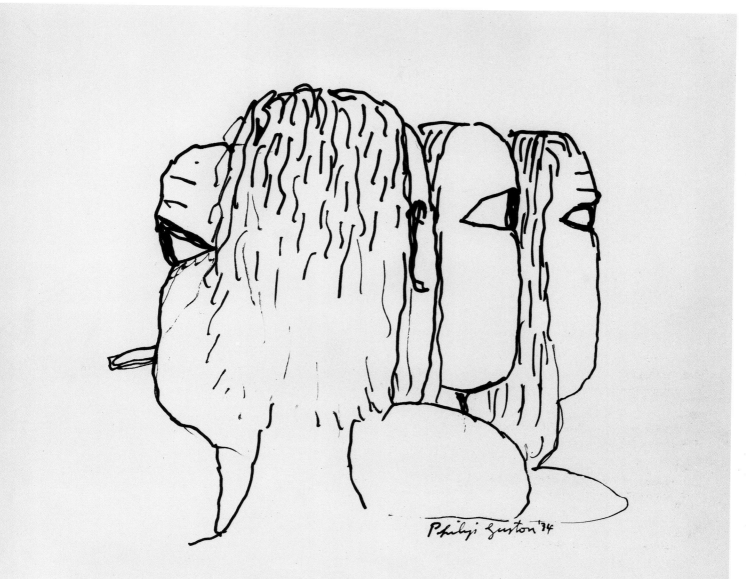

14

114. *Four Heads*, 1974
Ink on paper, 18 x 24 in.
The Edward R. Broida Trust, Los Angeles

*Philip Guston: Drawings 1947–1977*, David McKee Gallery, New York, October 3–November 4.

*Philip Guston: New Works in San Francisco*, San Francisco Museum of Modern Art, December 21–January 21, 1979.

**1979**

*Philip Guston: Paintings 1978–1979*, David McKee Gallery, New York, October 6–November 10.

**1980**

*Philip Guston*, Akron Art Institute, Akron, Ohio, March 8–May 4.

*Philip Guston*, San Francisco Museum of Modern Art, May 16–June 29, and tour to Corcoran Gallery of Art, Washington, D.C.; Museum of Contemporary Art, Chicago; Denver Art Museum; Whitney Museum of American Art, New York.

*Philip Guston: Recent Paintings*, John Berggruen Gallery, San Francisco, May 21–June 21.

*A Tribute to Philip Guston: Paintings and Drawings from 1950 to 1980*, David McKee Gallery, New York, October 11–November 12.

**1981**

*Philip Guston: The Last Works*, Phillips Collection, Washington D.C., March 21–May 24, and tour to Cleveland Museum of Art; Museum of Art, Carnegie Institute, Pittsburgh.

*Philip Guston: Sens Ultimos Anos*, United States participation at the *XVI Bienal de São Paulo*, October 16–December 20, and 1983 tour to Museo de Arte Moderno, Mexico City; Centro de Arte Moderno, Guadalajara, Mexico; Museo de Arte Moderno, Bogotá, Colombia.

**1982**

*Philip Guston: The Last Works, 1980,* David McKee Gallery, New York, January 12–February 10.

*Paintings by Philip Guston,* Asher/Faure Gallery, Los Angeles, May 22–June 19.

*Philip Guston,* Montgomery Museum of Fine Arts, Montgomery, Alabama, June 10–August 22.

*Philip Guston: Lithographs,* Yellowstone Art Center, Billings, Montana, September 9–October 24.

*Philip Guston: Paintings, 1969–80,* Whitechapel Art Gallery, London, October 13–December 12, and tour to Stedelijk Museum, Amsterdam; Kunsthalle, Basel.

**1983**

*Philip Guston: Selected Paintings,* Yares Gallery, Scottsdale, Arizona, January 23–February 16.

*Philip Guston,* Gemini G.E.L., Los Angeles, February.

*Philip Guston Paintings,* David McKee Gallery, New York, October 8–November 5.

**1984**

*Philip Guston: The Late Works,* National Gallery of Victoria, Melbourne, August 17–September 16, and tour to Art Gallery of Western Australia, Perth; Art Gallery of New South Wales, Sydney.

*Philip Guston: The Last Works, Paintings and Drawings, 1979–1980,* Hayden Gallery, Massachusetts Institute of Technology, Cambridge, October 13–November 25.

**1985**

*Philip Guston: Small Works, 1968–69,* David McKee Gallery, New York, April 4–May 4.

---

**Selected Group Exhibitions**

---

**1933**

*14th Annual Exhibition of Painters and Sculptors,* Los Angeles Museum, April 7–June 12. Also included in 1934.

**1934**

*Progressive Painters of Southern California,* Los Angeles Museum, January.

**1937**

*An Exhibition in Defense of World Democracy . . . Dedicated to the Peoples of Spain and China,* American Artists Congress, New York, December 15–30.

**1938**

*Annual Exhibition of Contemporary American Painting,* Whitney Museum of American Art, New York, November 2–December 11. Also included in 1940, 1942–43, 1943–44, 1944, 1945, 1946, 1947, 1948, 1950, 1953, 1956, 1957, 1958, 1961, 1963.

**1939**

*3rd Annual Membership Exhibition: Art in a Skyscraper,* American Artists Congress, New York, February 5–26.

*American Art Today,* New York World's Fair, April 30–October.

**1941**

*Directions in American Painting,* Carnegie Institute, Department of Fine Arts, Pittsburgh, October 23–December 14.

**1942**

*Biennial Exhibition of Contemporary American Paintings,* Virginia Museum of Fine Arts, Richmond, March 4–April 14. Also included in 1946 and 1948; won the Payne Purchase Prize for *The Sculptor* in 1946.

*Annual Exhibition of American Paintings and Sculpture,* Art Institute of Chicago, October 29–December 10. Also included in 1943, 1944, 1945, 1946, 1951, 1959; won the Flora Mayer Witkowsky Prize for *The Street* in 1959.

**1943**

*Biennial Exhibition of Contemporary American Oil Paintings,* Corcoran Gallery of Art, Washington, D.C. March 21–May 2. Also included in 1945, 1949, 1955.

*Painting in the United States,* Carnegie Institute, Pittsburgh, October 14–December 12. Also included in 1944, 1945, 1947, 1948, 1949; won First Prize ($1,000) for *Sentimental Moment* in 1945.

**1944**

*One Hundred Thirty-ninth Annual Exhibition of Painting and Sculpture,* Pennsylvania Academy of the Fine Arts, Philadelphia, January 23–February 27.

*110 American Painters Today: The Second Annual Purchase Exhibition,* Walker Art Center, Minneapolis, August 18–September 11. Also included in 1950.

**1945**

*Critics' Choice of Contemporary Arts and Antiques Show,* 17th Armory, New York.

**1946**

*Annual Exhibition of Contemporary American Sculpture, Watercolors and Drawings,* Whitney Museum of American Art, New York, February 5–March 13. Also included in 1950, 1951, 1952, 1953, 1955, 1962.

*Twelve Americans,* Institute of Modern Art, Boston, March 8–April 7.

**1947**

*121st Annual Exhibition of Contemporary American Painting, Sculpture, and Water Color and Graphic Art,* National Academy of Design, New York, January 4–22. Won Altman Prize for *Holiday.*

*Forty-fifth Annual Philadelphia Water Color and Print Exhibition, and the Forty-sixth Annual Exhibition of Miniatures,* Pennsylvania Academy of the Fine Arts, Philadelphia, November 9–December 14. Won Joseph Pennell Memorial Prize.

**1948**

*University of Illinois Competitive Exhibition of Contemporary American Painting,* College of Fine and Applied Arts, University of Illinois, Champaign, February 29–March 28. Won purchase prize for *Porch.* Also included in 1949.

**1950**

*The Pittsburgh International Exhibition of Paintings,* Carnegie Institute, Pittsburgh, October 19–December 21. Also included in 1955, 1958, 1964.

**1951**

*Abstract Painting and Sculpture in America,* Museum of Modern Art, New York, January 23–March 25.

*Ninth Street Show,* 60 East Ninth Street, New York, May 21–June 10.

*American Vanguard Art for Paris Exhibition,* Sidney Janis Gallery, New York, December 26–January 5, 1952, and tour to the Galerie de France, Paris, February 1952, as *Regards sur la peinture américaine.*

**1952**

*Expressionism in American Painting,* Albright Art Gallery, Buffalo, New York, May 10–June 29.

**1953**

*Abstract Expressionists,* Baltimore Museum of Art, March 3–29.

**1954**

*Younger American Painters,* Solomon R. Guggenheim Museum, New York, May 12–July 25.

**1955**

*50 Ans d'art aux Etats-Unis: Collections du Museum of Modern Art de New York,* Musée National d'Art Moderne, Paris, April–May. Coordinated by the International Program of the Museum of Modern Art, New York. Selections from exhibition were shown in Barcelona, London, and The Hague.

**1956**

*12 Americans,* Museum of Modern Art, New York, May 29–September 9.

*Recent Paintings by 7 Americans,* Sidney Janis Gallery, New York, September 24–October 20. Also in the following Janis group shows: *8 Americans* (1957); *10th Anniversary Exhibition* (1958); *8 American Painters* (1959); *9 American Painters* (1960); *10 American Painters* (1961); *10 American Painters* (1962); *11 Abstract Expressionist Painters* (1963); *Two Generations* (1964); *A Selection of 20th-Century Art of 3 Generations* (1964).

**1957**

*IV Bienal de São Paulo,* Museu de Arte Moderna, São Paulo, September–December.

**1958**

*Primera Bienal interamericana de pintura y grabado*, Instituto Nacional de Bellas Artes, Mexico City.

*Nature in Abstraction: The Relation of Abstract Painting and Sculpture to Nature in Twentieth-Century American Art*, Whitney Museum of American Art, New York, January 14–March 16, and tour.

*The New American Painting*, organized by the International Council of the Museum of Modern Art, New York, and circulated to eight European countries, 1958–59. Shown at the Museum of Modern Art, May 28–September 8, 1959.

**1959**

*Documenta II*, Museum Fridericianum, Kassel, West Germany, July 11–October 11.

*V Bienal de São Paulo*, Museu de Arte Moderna, São Paulo, September 21–December 31. The U.S. was represented by *Smith, Guston, Francis, Kadish, Frankenthaler, Goldberg, Kohn, Leslie, Marca-Relli, Metcalf, Mitchell, Rauschenberg*, organized by the Minneapolis Institute of Arts, Minneapolis, Minnesota. Guston showed 33 works.

**1960**

*The Image Lost and Found*, Institute of Contemporary Art, Boston, May–August.

*XXX Biennale Internazionale d'Arte*, Venice, June–October. The U.S. was represented by *Quattro Artisti Americani: Guston, Hofmann, Kline, Roszak*; organized by the Baltimore Museum of Art in collaboration with the International Council of the Museum of Modern Art. Also included in 1964.

**1961**

*Philip Guston, Franz Kline*, Dwan Gallery, Los Angeles, April 3–29.

*American Abstract Expressionists and Imagists*, Solomon R. Guggenheim Museum, New York, October 13–December 31.

*Modern American Drawings*, organized by the International Council of the Museum of Modern Art, New York, as the U.S. representation at the Festival of Two Worlds, Spoleto, Italy, and circulated to Europe and Israel, 1961–62.

**1962**

*Art since 1950: American and International*, Seattle World's Fair, April 21–October 21, and tour (of United States section only).

*Continuity and Change: 45 American Abstract Painters and Sculptors*, Wadsworth Atheneum, Hartford, Connecticut, April 12–May 27.

**1963**

*20th-Century Master Drawings*, Solomon R. Guggenheim Museum, New York, November 6–January 5, 1964, and tour.

**1964**

*Painting and Sculpture of a Decade: 1954–1964*, Tate Gallery, London, April 22–June 28.

**1965**

*Twelfth Exhibition of Contemporary American Painting and Sculpture*, Krannert Art Museum, University of Illinois, Champaign, March 7–April 11. Also included in 1967.

*New York School: The First Generation, Paintings of the 1940s and 1950s*, Los Angeles County Museum of Art, July 16–August 1.

**1967**

*Three Artists of Today: Philip Guston, Conrad Marca-Relli, James Rosati*, Colby College Art Museum, Waterville, Maine, April 14–May 14.

*American Painting: The 1940s*, University of Georgia, Athens, cosponsored by the American Federation of Arts, New York, April 19–May 10, and tour.

**1969**

*New York Painting and Sculpture: 1940–1970*, Metropolitan Museum of Art, New York, October 18–February 1, 1970.

**1970**

*Color and Field, 1890–1970*, Albright-Knox Art Gallery, Buffalo, New York, September 15–November 1, and tour.

**1973**

*American Art at Mid-Century 1*, National Gallery of Art, Washington, D.C., October 28–January 6, 1974.

**1975**

*Drawings by Five Abstract Expressionist Painters: Arshile Gorky, Willem de Kooning, Jackson Pollock, Franz Kline, Philip Guston*, Hayden Gallery, Massachusetts Institute of Technology, Cambridge, February 21–March 26, and tour.

**1976**

*A Selection of American Art: The Skowhegan School, 1946–1976*, Institute of Contemporary Art, Boston, June 16–September 5, and tour.

**1978**

*Art for the People—New Deal Murals on Long Island*, Emily Lowe Gallery, Hofstra University, Hempstead, Long Island, New York, November 1–December 31.

*American Painting of the 1970s*, Albright-Knox Art Gallery, Buffalo, New York, December 8–January 14, 1979, and tour.

**1979**

*Biennial Exhibition*, Whitney Museum of American Art, New York, February 6–April 1.

*New Painting/New York: Jake Berthot, Ross Bleckner, Alan Cote, Philip Guston, Elizabeth Murray, Jerry Zeniuk, Joseph Zucker*, Arts Council of Great Britain, Hayward Gallery, London, May 3–June 17.

*David McKee Presents Works on Paper by Franz Kline and Philip Guston*, Asher/Faure Gallery, Los Angeles, July 21–August 18.

*Poets and Painters*, Denver Art Museum, November 21–January 13, 1980, and tour.

**1980**

*Alexander Brook, Philip Guston, Clyfford Still*, American Academy and Institute of Arts and Letters, New York, November 17–December 21.

**1981**

*A New Spirit in Painting*, Royal Academy of Arts, London, January 15–March 18.

*Amerikanische Malerei, 1930–1980*, Haus der Kunst, Munich, November 14–January 31, 1982.

**1983**

*The Painterly Figure*, Parrish Art Museum, Southampton, New York, July 24–September 4.

*American Still Life, 1945–1983*, Contemporary Arts Museum, Houston, September 20–November 20, and tour.

*Social Concern and Urban Realism: American Painting of the 1930s*, Boston University Art Gallery, October 13–November 13, and tour. Organized by the Bread and Roses Project of the National Union of Hospital and Health Care Employees and the American Federation of Arts.

*The Modern Drawing*, Museum of Modern Art, New York, October 29–January 3, 1984.

*The First Show: Painting and Sculpture from Eight Collections, 1940–1980*, Museum of Contemporary Art, Los Angeles, November–March 1984.

**1984**

*American Art since 1970: Painting, Sculpture, and Drawings from the Collection of the Whitney Museum of American Art, New York*, La Jolla Museum of Contemporary Art, La Jolla, California, March 10–April 22, and tour.

*Painters' Painters: Milton Avery, Philip Guston, Giorgio Morandi*, University Gallery of Fine Art, Ohio State University, Columbus, March 26–April 15.

*Twentieth-Century American Drawing: The Figure in Context*, Terra Museum of American Art, Evanston, Illinois, April 26–June 17, and tour. Organized by the International Exhibitions Foundation, Washington, D.C.

*Content: A Contemporary Focus, 1974–1984*, Hirshhorn Museum and Sculpture Garden, Smithsonian Institution, Washington D.C., October 4–January 6, 1985.

*Gemini G.E.L.: Art and Collaboration*, National Gallery of Art, Washington, D.C., November 18–February 24, 1985, and tour.

*La Grande Parade: Highlights of Painting after 1940*, Stedelijk Museum, Amsterdam, December 15–April 15, 1985, and tour.

**1985**

*Dorothy C. Miller: With an Eye to American Art*, Smith College Museum of Art, Northampton, Massachusetts, April 19–June 16.

*American Drawing: 1930–1980*, Ecole Nationale Supérieure des Beaux-Arts, Paris, May 3–July 1.

# Public Collections

Albany, New York, State of New York,
South Mall
Amsterdam, The Netherlands, Stedelijk
Museum
Atlanta, Georgia, High Museum of Art
Austin, Texas, University of Texas at Austin,
Archer M. Huntington Art Gallery
Baltimore, Maryland, Baltimore Museum
of Art
Berkeley, California, University Art Museum,
University of California, Berkeley
Bloomington, Illinois, Illinois Wesleyan
University
Buffalo, New York, Albright-Knox Art Gallery
Cambridge, Massachusetts, Harvard
University, Fogg Art Museum
Canberra, Australia, Australian National
Gallery
Cedar Falls, Iowa, University of Northern
Iowa, Department of Art
Champaign, Illinois, University of Illinois,
Krannert Art Museum
Chicago, Illinois, Art Institute of Chicago
Chicago, Illinois, Museum of Contemporary
Art
Cleveland, Ohio, Cleveland Museum of Art
Denver, Colorado, Denver Art Museum
Detroit, Michigan, Detroit Institute of
Fine Arts
Hagerstown, Maryland, Washington County
Museum of Fine Arts, United States State
Department Collection
Honolulu, Hawaii, Honolulu Academy of Arts
Iowa City, Iowa, University of Iowa, Museum
of Art
Jerusalem, Israel, Israel Museum
Lincoln, Nebraska, University of Nebraska,
Sheldon Memorial Art Gallery
London, England, Saatchi Collection
London, England, Tate Gallery
Los Angeles, California, Los Angeles County
Museum of Art
Minneapolis, Minnesota, Minneapolis
Institute of Arts

Minneapolis, Minnesota, Walker Art Center
Montgomery, Alabama, Montgomery
Museum of Fine Arts
New Haven, Connecticut, Yale University
Art Gallery
New York City, New York, Grey Art Gallery,
New York University
New York City, New York, Metropolitan
Museum of Art
New York City, New York, Museum of
Modern Art
New York City, New York, Solomon R.
Guggenheim Museum
New York City, New York, Whitney Museum
of American Art
Omaha, Nebraska, Joslyn Art Museum
Pittsburgh, Pennsylvania, Museum of Art,
Carnegie Institute
Purchase, New York, State University of
New York at Purchase, Neuberger Museum
Richmond, Virginia, Virginia Museum of
Fine Arts
St. Louis, Missouri, St. Louis Art Museum
St. Louis, Missouri, Washington University
Gallery of Art
St. Paul, Minnesota, Minnesota Museum of Art
San Francisco, California, San Francisco
Museum of Modern Art
San Jose, California, San Jose State
University, Art Department Galleries
Utica, New York, Munson-Williams-Proctor
Institute
Waltham, Massachusetts, Brandeis University,
Rose Art Museum
Washington, D.C., Hirshhorn Museum and
Sculpture Garden, Smithsonian Institution
Washington, D.C., National Gallery of Art
Washington, D.C., National Museum of
American Art, Smithsonian Institution
Washington, D.C., Phillips Collection
Waterville, Maine, Colby College Museum
of Art
Worcester, Massachusetts, Worcester Art
Museum

# Selected Bibliography

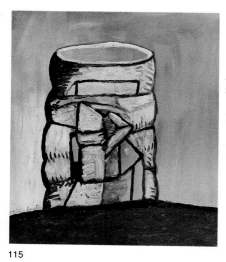

115

115. *Highball*, 1979
Oil on canvas, 36 x 32 in.
Estate of Philip Guston;
Courtesy David McKee Gallery, New York

## Interviews, Statements, and Writings

Berkson, Bill. "Dialogue with Philip Guston, November 1, 1964." *Art and Literature: An International Review* 7 (Winter 1965): 56–69. Interview.

Butterfield, Jan. "A Very Anxious Fix: Philip Guston." *Images and Issues* (Santa Monica, Calif.) 1 (Summer 1980): 30–35. Interview.

Guston, Philip. Statement in "Types—by American Artists." *Artnews Annual* 43 (December 1, 1944): 88.

————. Statement in *12 Americans*, exhibition catalog. New York: Museum of Modern Art, 1956, p. 36. Reprinted in Henry Hopkins and Ross Feld, *Philip Guston*, p. 40.

————. "Notes on the Artist." In *Bradley Walker Tomlin*, exhibition catalog. New York: Whitney Museum of American Art, 1957, p. 9.

————. Statement in *It Is* 1 (Spring 1958): 44.

————. Statement in *Nature in Abstraction*, exhibition catalog. New York: Whitney Museum of American Art, 1958, p. 69. Reprinted in Hopkins and Feld, *Philip Guston*, p. 40.

————. Statement in *The New American Painting*, exhibition catalog. New York: Museum of Modern Art, 1959, p. 40. Response to a questionnaire on the role of nature in abstract art, 1957–58. Reprinted in Hopkins and Feld, *Philip Guston*, p. 40.

————. "Piero della Francesca: The Impossibility of Painting." *Artnews* 64 (May 1965): 38–39. Reprinted in Hopkins and Feld, *Philip Guston*, p. 41.

————. "Faith, Hope and Impossibility." *XXXI Artnews Annual 1966*, October 1965, pp. 101–3, 152–53. Essay based on Guston's notes for a lecture given at the New York Studio School. Reprinted in Hopkins and Feld, *Philip Guston*, pp. 41–42.

————. "Philip Guston's Object: A Dialogue with Harold Rosenberg." In *Philip Guston: Recent Paintings and Drawings*, exhibition catalog. New York: Jewish Museum, 1966, pp. 5–11. Partially reprinted in Hopkins and Feld, *Philip Guston*, pp. 44–45.

————. "Boston University Talk." Unpublished, unedited dialogue with Joseph Ablow, Boston University, 1966. Excerpts of Guston's remarks are included in Hopkins and Feld, *Philip Guston*, p. 47.

————. Statement in *Art Now: New York* 2, no. 8 (August 1970): 3. Reprinted in Hopkins and Feld, *Philip Guston*, p. 41.

————. "Ten Drawings." *Boston University Journal* 21 (Fall 1973): 22–31. Reprinted in Hopkins and Feld, *Philip Guston*, p. 41.

————. "Philip Guston Talking." In Nicholas Serota, ed. *Philip Guston: Paintings, 1969–1980*, exhibition catalog. London: Whitechapel Art Gallery, 1982, pp. 49–56. Excerpts edited by Renee McKee from a 1978 lecture at the University of Minnesota.

Hunter, Sam. "Interview with Philip Guston." *Playbill* 1 (November 1957): 52–53.

Pavia, Philip, and Sandler, Irving, eds. "Philadelphia Panel." *It Is* 5 (Spring 1960): 34–38, 40. Edited transcript of "The Concept of the New," a panel discussion with Guston, Robert Motherwell, Ad Reinhardt, Harold Rosenberg, and Jack Tworkov.

Rosenberg, Harold. "Conversations. Philip Guston and Harold Rosenberg: Guston's Recent Paintings." *Boston University Journal* 22 (Fall 1974): 43–45, 48–51, 54–58. Interview.

Rosenberg, Harold, and Guston, Philip. "On Cave Art, Church Art, Ethnic Art and Art." *Artnews* 73 (December 1974): 36–41. Comments from a discussion led by Rosenberg at the New York Studio School.

Stevens, Mark. "A Talk with Philip Guston." *New Republic* 182 (March 15, 1980): 25–28. Interview.

## Selected Monographs and Solo-Exhibition Catalogs

Arnason, H. H. *Philip Guston*, exhibition catalog. New York: Solomon R. Guggenheim Museum, 1962. Includes brief chronology and selected bibliography.

Ashton, Dore. *Philip Guston*. New York: Grove Press, 1960. Evergreen Gallery Books, no. 10.

———. Preface to *Philip Guston: New Paintings*, exhibition catalog. Boston: Boston University, 1974.

———. *Yes, But. . . : A Critical Study of Philip Guston*. New York: Viking Press, 1976.

Buckley, John. *Philip Guston: The Late Works*, exhibition catalog. Melbourne: National Gallery of Victoria, 1984. Includes essay by Edward F. Fry and reprint of "Philip Guston Talking" from Nicholas Serota, ed., *Philip Guston: Paintings, 1969–1980.*

Feldman, Morton. *Philip Guston, 1980: The Last Works*, exhibition catalog. Washington, D.C.: Phillips Collection, 1981. Includes chronology.

Guston, Philip. *Philip Guston*. Los Angeles: Gemini G.E.L., 1980–83. Three booklets, originally issued separately and reissued together in a case, that reproduce twenty-three lithographs created by Guston between November 1979 and February 1980.

Hopkins, Henry T. *Philip Guston: Sens Ultimos Anos*, exhibition catalog. San Francisco: San Francisco Museum of Modern Art, 1981. Includes Portuguese translation of interview by Mark Stevens and an essay by Hopkins. Catalog published in Spanish, without Stevens's interview, for tour to Mexico and Colombia, as *Philip Guston: Sus Ultimos Años.*

Hopkins, Henry T., and Feld, Ross. *Philip Guston*, exhibition catalog. New York: George Braziller; San Francisco: San Francisco Museum of Modern Art, 1980. Essay by Feld outlines Guston's career and articulates his imagery. Several statements by Guston are reproduced in entirety; others are excerpted in Hopkins's essay, "Selecting Works for the Exhibition." Includes chronology; an extensive list of exhibitions, compiled by Louise E. Katzman; and an exhaustive bibliography, compiled by Eugenie Candau.

Hunter, Sam. *A V Bienal, Estados Unidos, 1959*, exhibition catalog. Minneapolis: Minnesota Society of Fine Arts, 1959.

———. Preface to *Philip Guston: Recent Paintings and Drawings*, exhibition catalog. New York: Jewish Museum, 1966. Includes transcription of lengthy taped dialogue with Harold Rosenberg and selected bibliography.

*Philip Guston: Drawings, 1947–1977*, exhibition catalog. New York: David McKee Gallery, 1978.

*Philip Guston: Recent Paintings*, exhibition catalog. New York: Marlborough Gallery, 1970. Includes chronology and exhibition list.

Seitz, William. *Philip Guston: A Selective Retrospective Exhibition: 1945–1965*, exhibition catalog. Waltham, Mass.: Brandeis University, 1966.

Serota, Nicholas, ed. *Philip Guston: Paintings, 1969–1980*, exhibition catalog. London: Whitechapel Art Gallery, 1982. Includes essay by Norbert Lynton; "Philip Guston Talking" (excerpts from a lecture given by Guston in 1978 at the University of Minnesota); selected bibliography; exhibition list; and chronology.

## Periodicals, Books, and Group-Exhibition Catalogs

Albright, Thomas. "A Survey of One Man's Life." *San Francisco Chronicle*, May 15, 1980. Review of exhibition at San Francisco Museum of Modern Art.

———. "Philip Guston: 'It's a Strange Thing to Be Immersed in the Culture of Painting. . . .'" *Artnews* 79 (September 1980): 114–16. Review of exhibition at San Francisco Museum of Modern Art.

Alloway, Lawrence. "Ashton on Guston." *Arts Review* (London) 13 (July 29–August 12, 1961): 17, 20.

———. "Notes on Guston." *Art Journal* 22 (Fall 1962): 8–11 and cover.

Ashton, Dore. "Art." *Arts and Architecture* 74 (June 1957): 8–10. Review of *8 Americans* at Sidney Janis Gallery.

———. "Philip Guston." *Evergreen Review* 4 (September–October 1960): 88–91.

———. "Philip Guston." *Metro* (Milan) 3 (1961): 33–41.

———. "Philip Guston: The Painter as Metaphysician." *Studio International* (London) 169 (February 1965): 64–67.

———. "Philip Guston: Different Subjects." *Flash Art* 105 (December 1981–January 1982): 20–25 and cover.

———. *American Art since 1945*. New York: Oxford University Press, 1982.

Baker, Kenneth. "Philip Guston's Drawings: Delirious Figuration." *Arts Magazine* 51 (June 1977): 88–89.

Benedikt, Michael. "New York Letter." *Art International* 10 (April 1966): 79–80. Review of Jewish Museum exhibition.

Berkson, Bill. "Art Chronicle." *Kulchur* (New York) 2, no. 7 (Autumn 1962): 26–28, 42.

———. "Philip Guston: A New Emphasis." *Arts Magazine* 40 (February 1966): 15–18. Review of exhibition at Jewish Museum.

———. "The New Gustons." *Artnews* 69 (October 1970): 44–47, 85. Review of exhibition at Marlborough Gallery.

———. *Enigma Variations*. Bolinas, Calif.: Big Sky, 1975. Cover and drawings by Guston. Published in an edition of 1,000.

*Big Sky* (Bolinas, Calif.). Issues 4 (1972) and 5 (1973) both contain drawings by Guston.

Brach, Paul. "New York: Affirmation." *Art Digest* 27 (January 15, 1953): 13. Review of Egan Gallery exhibition.

———. "Looking at Guston." *Art in America* 68 (November 1980): 96–101. Review of exhibition at San Francisco Museum of Modern Art.

———. "Paint Remover: The Late Guston." *Art in America* 72 (February 1984): 118–20. Review of 1983 exhibition at David McKee Gallery.

Brenson, Michael. "Art: Assessing Guston by His Late Paintings." *New York Times*, October 21, 1983, p. C28. Review of exhibition at David McKee Gallery.

Breuning, Margaret. "Philip Guston Impresses in New York Debut." *Art Digest* 19 (January 15, 1945): 12. Review of exhibition at Midtown Galleries.

Canaday, John. "Two American Painters." *New York Times*, January 3, 1960, p. B18. Reprinted as "Their Separate Ways: Jack Levine and Philip Guston," in *Embattled Critic: Views on Modern Art*, New York: Noonday Press, 1962, pp. 137–41.

Clark, John. "Philip Guston and Metaphysical Painting." *Artscribe* 30 (August 1981): 22–25.

Creeley, Robert. "Philip Guston: A Note." *Black Mountain Review*, Spring 1956, p. 170. Accompanied by four Guston drawings, pp. 171–74.

Feaver, William. "Load of Sprockets." *London Observer*, May 6, 1979.

Feld, Ross. "Philip Guston." *Arts Magazine* 50 (May 1976): 9. Review of exhibition at David McKee Gallery.

———. "Philip Guston's 'Wharf.'" *Arts Magazine* 52 (April 1978): 146–47.

Feldman, Morton. "Philip Guston: The Last Painter." *Artnews Annual 1966*, October 1965, pp. 97–100.

———. "Give My Regards to Eighth Street." *Art in America* 59 (March–April 1971): 96–99.

———. "After Modernism." *Art in America* 59 (November–December 1971): 68–77. Guston enters the discussion on page 72.

Frost, Rosamund. "Guston: Meaning Out of Monumentality." *Artnews* 43 (February 1, 1945): 24.

Genauer, Emily. "Guston's Switch from Meaning." *New York Herald Tribune*, May 6, 1962. Review of exhibition at Guggenheim Museum.

116. *Downward*, 1951
Quill and ink on paper, 23½ x 18½ in.
Mr. and Mrs. R. Swig

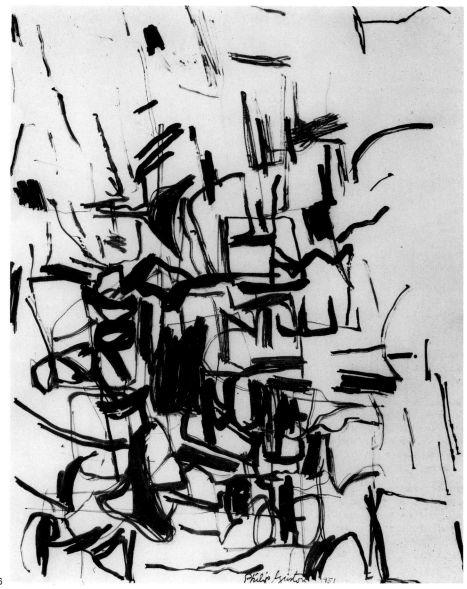

116

Glueck, Grace. "Philip Guston, Painter, 66, Dead: An Abstract Expressionist Leader." *New York Times*, June 10, 1980, p. D19. Obituary.

Gruen, John. "Demons and Daisies." *New York* 3 (November 9, 1970): 62. Review of exhibition at Marlborough Gallery.

Guston, Philip, illustrator. "Brave New World, F.O.B." *Fortune* 28 (August 1943): 124–27.

———. "Troop Carrier Command." *Fortune* 28 (October 1943): 130–35.

———. "The Air Training Program." *Fortune* 29 (February 1944): 147–52, 174.

Henning, Edward B. "Some Contemporary Paintings." *Bulletin of the Cleveland Museum of Art* 49 (March 1962): 46–47, 52–54, and cover.

Henry, O. "Gift of the Magi." *Artnews Annual 1946–47* 45 (December 1946): 69–76. Includes illustrations by Guston.

Hess, Thomas B. "The Abstractionist Who Came in from the Cold." *New York* 7 (December 9, 1974): 102–3. Review of exhibition at David McKee Gallery.

———. "Dumb Is Beautiful." *New York* 9 (March 29, 1976): 86–87. Review of exhibition at David McKee Gallery.

Hill, Andrea. "No Picnic: Philip Guston at the Whitney." *Artscribe* 30 (August 1981): 19–21. Review of exhibition at Whitney Museum.

Holmes, Mary. "Metamorphosis and Myth in Modern Art." *Perspective* (Louisville), Winter 1948, pp. 77–85.

H[ughes], R[obert]. "Ku Klux Komix." *Time*, November 9, 1970, pp. 62–63. Review of exhibition at Marlborough Gallery.

Hunter, Sam. "Philip Guston." *Art International* 6 (May 1962): 62–67. Review of exhibition at Guggenheim Museum.

Janson, H. W. "'Martial Memory' by Philip Guston and American Painting Today." *Bulletin of the City Art Museum of St. Louis* 27 (December 1942): 34–41.

———. "Philip Guston." *Magazine of Art* 40 (February 1947): 55–58. Reprinted in Spanish in *Indice de las Artes* (Madrid), October 1947, pp. 1–2.

Kingsley, April. "Philip Guston's Endgame." *Horizon* 23 (June 1980): 34–41.

Kozloff, Max. "Art." *Nation* 194 (May 19, 1962): 453–55. Review of exhibition at Guggenheim Museum.

Kramer, Hilton. "Art: Abstractions of Guston Still Further Refined." *New York Times*, January 15, 1966, p. 22. Review of Jewish Museum exhibition.

———. "A Mandarin Pretending to Be a Stumblebum." *New York Times*, October 25, 1970, p. B27. This outspoken review of Guston's exhibition of figurative work at Marlborough Gallery generated much commentary from the art world, including a response from Guston's daughter, Musa Jane Kadish, "Art Mailbag: 'A Personal Vendetta against Guston?'" *New York Times*, December 6, 1970, p. B30.

Larson, Kay. "From Abstraction to the Absurd: The Transformation of Philip Guston." *Real Paper* (Boston), April 3, 1974, pp. 20–21. Review of exhibition at Boston University.

———. "Painting from Ground Zero." *New York* 14 (July 20, 1981): 58–59. Review of exhibition at Whitney Museum.

Levin, Kim. "Philip Guston." In *Art USA Now*. Edited by Lee Nordness. New York: Viking Press, 1963, vol. 1, pp. 218–21. This two-volume catalog accompanied a U.S. Information Agency–sponsored tour of work in the S. C. Johnson and Son, Inc., Collection from Racine, Wisconsin.

Lynton, Norbert. "From Mandarin to Stumblebum." *Times Literary Supplement* (London), January 7, 1977, p. 5 and cover.

Morgan, Stuart. "Bread and Circuses." *Artforum* 23 (March 1985): 82–86. Review of *La Grande Parade* at Stedelijk Museum.

"Mural on WPA Building Judged Best Outdoor Art." *New York Times*, August 7, 1939, p. 3.

O'Connor, Francis V. "Philip Guston and Political Humanism." In *Art and Architecture in the Service of Politics*. Edited by Henry A. Millon and Linda Nochlin. Cambridge, Mass.: MIT Press, 1978, pp. 342–55.

O'Hara, Frank. "Growth and Guston." *Artnews* 61 (May 1962): 31–33, 51–52. Review of exhibition at Guggenheim Museum. Reprinted in *Art Chronicles 1954–1966*, New York: George Braziller, 1975, pp. 134–41.

———. *In Memory of My Feelings*. New York: Museum of Modern Art, 1967. Guston's drawings accompany the eighteenth poem in this portfolio, "Ode to Michael Goldberg ('s Birth and Other Births)."

Perreault, John. "Art." *Village Voice*, November 5, 1970, p. 26. Review of exhibition at Marlborough Gallery.

———. "Guston Winds." *Soho Weekly News* (New York), July 8, 1981, p. 51. Review of exhibition at Whitney Museum.

"Philip Guston: Carnegie Winner's Art Is Abstract and Symbolic." *Life* 20 (May 27, 1946): 90–92.

"Philip Guston." *New York Times*, June 10, 1980, p. D19. Obituary.

[P]orter, [F]airfield. "Reviews and Previews." *Artnews* 51 (February 1953): 55. Review of exhibition at Egan Gallery.

Ratcliff, Carter. "New York Letter." *Art International* 21 (July–August 1977): 73–74. Review of exhibition at David McKee Gallery.

Rickey, Carrie. "What Becomes a Legend Most?" *Village Voice*, October 22, 1979, p. 91. Review of exhibition at David McKee Gallery.

———. "Dreaming with His Eyes Open: Philip Guston 1913–1980." *Village Voice*, June 23, 1980, p. 73.

———. "Gust, Gusto, Guston." *Artforum* 19 (October 1980): 32–39.

Robins, Corinne. *The Pluralist Era: American Art 1968–1981*. New York: Harper and Row, 1984.

Rosenberg, Harold. "Liberation from Detachment." *New Yorker*, November 7, 1970, pp. 136–41. Reprinted in *De-definition of Art*, New York: Macmillan, 1972, pp. 132–40. Rosenberg explains the radical changes in the work Guston exhibited at Marlborough Gallery in 1970.

Russell, John. "Guston's Last Tape Mislaid." *New York Times*, November 23, 1974, p. 58. Review of exhibition at David McKee Gallery.

Sandler, Irving. "Guston: A Long Voyage Home." *Artnews* 58 (December 1959): 36–39, 64–65.

———. *The New York School: The Painters and Sculptors of the Fifties*. New York: Harper and Row, 1978.

Schjeldahl, Peter. "Self-Abuse on Parade." *Village Voice*, July 15–21, 1981, p. 72. Review of exhibition at Whitney Museum.

———. "Philip Guston." In *Art of Our Time: The Saatchi Collection*. London: Lund Humphries; New York: Rizzoli, 1984, pp. 12–14.

Seckler, Dorothy. "Reviews and Previews." *Artnews* 50 (January 1952): 44. Review of exhibition at Peridot Gallery.

Smith, Roberta. "The New Gustons." *Art in America* 66 (January–February 1978): 100–105 and cover.

———. "Philip Guston, 1913–1980." *Art in America* 68 (September 1980): 17–19.

"Special Issue: The New York School." *Artforum* 4 (September 1965): 4, 7, 27, 29, 30, 33.

Steinberg, Leo. "Month in Review: Fritz Glarner and Philip Guston among 'Twelve Americans' at the Museum of Modern Art." *Arts Magazine* 30 (June 1956): 42–45. Reprinted in *Other Criteria: Confrontations with Twentieth-Century Art*, New York: Oxford University Press, 1972, pp. 277–85.

Stevens, Mark. "Diamond in the Rough." *Newsweek* 95 (June 23, 1980): 88–89.

Storr, Robert. "Notes on Philip Guston (1913–1980)." *Harvard Advocate*, March 1981, pp. 4–13.

Sylvester, David. "Philip Guston: Luxurious." *New Statesman* 65 (February 15, 1963): 247–48. Review of exhibition at Whitechapel Art Gallery, London.

Talmer, Jerry. "'Creation' Is for Beauty Parlors." *New York Post*, April 9, 1977, p. 22. Review of exhibition at David McKee Gallery.

Tuchman, Maurice, ed. *The New York School: Abstract Expressionism in the 40s and 50s*. Greenwich, Conn.: New York Graphic Society, 1971, pp. 75–81. Revised edition of catalog for *New York School: The First Generation*, held at Los Angeles County Museum of Art, 1965.

Wohl, Helmut. "Philip Guston and the Problems of Painting." *Harvard Art Review* 2 (Spring–Summer 1967): 28–30.

Yates, Peter. "Philip Guston at the County Museum." *Arts and Architecture* 80 (September 1963): 4–5, 31–32. Review of exhibition at Los Angeles County Museum.

**Films**

*Philip Guston*. 1972. Directed by Michael Blackwood for Blackwood Productions, New York. 28 minutes, color, 16mm. The artist in his Woodstock studio traces the development of his work from the 1930s through the changes of the late 1960s and early 1970s.

*Philip Guston: A Life Lived*. c. 1981. Directed by Michael Blackwood for Blackwood Productions, New York. 58 minutes, color, 16mm. Earlier film expanded with footage shot during the last year of the artist's life and at the San Francisco retrospective, 1980.

# Index

**Photography Credits**

The photographers and the sources of photographic material other than those indicated in the captions are as follows: Sidney B. Felsen: endpapers; David McKee Gallery, New York: plates 1, 6, 20, 24, 26, 29, 32, 43, 44, 53, 66, 72, 75, 76, 85, 91, 104, 113; National Gallery of Art, Washington, D.C.: frontispiece; Douglas Parker, Los Angeles: plates 10, 28, 34; Steven Sloman, New York: plates 2, 18, 22, 23, 25, 30, 48, 49, 51, 54, 58, 59, 65, 90, 94, 107, 115; Robert Storr: plates 7, 9, 50.

RITTER LIBRARY
BALDWIN-WALLACE COLLEGE